TAYLOR SWIFT STYLE

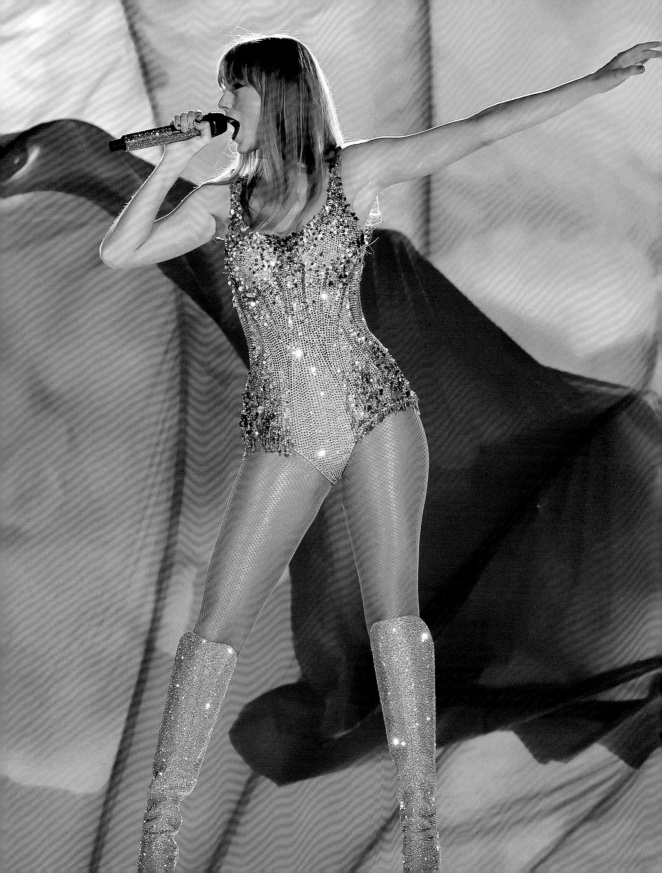

TAYLOR SWIFT STYLE

FASHION THROUGH THE ERAS

SARAH CHAPELLE

ST. MARTIN'S GRIFFIN
New York

First published in the United States by St. Martin's Griffin, an imprint of St. Martin's Publishing Group

TAYLOR SWIFT STYLE. Copyright © 2024 by Sarah Chapelle. All rights reserved. Printed in China. For information, address St. Martin's Publishing Group, 120 Broadway, New York, NY 10271.

www.stmartins.com

Book design by Shubhani Sarkar
sarkardesignstudio.com

The Library of Congress Cataloging-in-Publication Data is available upon request.

ISBN 978-1-250-90615-1 (paper over board)
ISBN 978-1-250-90616-8 (ebook)

Our books may be purchased in bulk for promotional, educational, or business use. Please contact your local bookseller or the Macmillan Corporate and Premium Sales Department at 1-800-221-7945, extension 5442, or by email at MacmillanSpecialMarkets@macmillan.com.

First Edition: 2024

10 9 8 7 6 5 4 3 2 1

For those who find themselves in the bridge of a Taylor song — and wear that identity with pride.

Contents

Part

III

THE POWERHOUSE SHE BUILT

Part

IV

FROM THE VAULT (BOOK VERSION)

"Going through different phases is one of my favorite things about fashion. I love how it can mark the passage of time. It's similar to my songs in that way— it all helps identify where I was at in different points of my life."

—Taylor Swift, *Vogue*, 2016

Prologue

TAYLORING AN IMAGE

I OFTEN JOKE THAT MY RELATIONSHIP WITH TAYLOR IS THE LONGEST ONE OF MY life (no offense to my husband). With just three years of age separating us, I saw Taylor as an older sister who was figuring out life and love just like me. Her early albums are like a scrapbook of my adolescence as both Taylor and I navigated our messy teens and early twenties. I saw my experiences reflected in all her songs—the high school love falling apart that first summer after graduation ("Tim McGraw"), the premature nostalgia of being "wiser" and looking back on freshman year of high school ("Fifteen"), the excitement and loneliness of moving out of your parents' home into your first apartment ("Never Grow Up"), the whiplash of dating someone who sent mixed signals ("Red"), and the pain that comes when you learn healing isn't linear ("Clean"). As she got older and her steps into adulthood became more sure and steady, our worlds continued to parallel and settled into new and nuanced pathways—discovering that home can be a person ("New Year's Day"), confronting the terrifying mortality of a parent ("Soon You'll Get Better"), and the painful realization after your thirtieth birthday that entering a new decade does not guarantee you the answer key to life ("Dear Reader"). Growing up and figuring out life as a young woman isn't easy, but I never felt like I was navigating this tumultuous time alone because, like so many Swifties, I had Taylor's music narrating my existence.

Taylor has always intrinsically understood the power of perception, especially through fashion. Over the years, her style went from being a subtle

tool for establishing an image to a strategic art form that communicated directly with those in the know.

I love that fashion represents a visual time capsule of our deepest selves. I can look back on photos of my life and identify when I discovered ballet (slicked buns and soft pastels dominated my wardrobe), when I was first made fun of for being "too girly" and massively overcorrected my outfit choices to be intentionally contrarian (overalls, baseball hats, and tone-on-tone blue ensembles), when I went through my punk rock phase (eyeliner, but only on the waterline—an inspired choice—band T-shirts, ripped-up jeans, Converse). And so on. Some could argue these clothes were costumes. But I'd rebut that they were accurate reflections of who I was (or wanted to be) at the time. They represented my interests and my priorities just as much as they acted as both my sword and my shield. Clothes were a way to cover my insecurities like armor and to project how I wanted to show up for other people—and also for myself.

Taylor's growing confidence in expressing her identity through fashion dovetailed neatly with my personal progression as a fan and admirer of her career. While earning my BA in journalism in 2011, I started the blog *Taylor Swift Style*. At the time, the only celebrity fashion coverage that existed was published by major print outlets or typically reserved for red carpet event credits. If you were interested in the cute blouse Taylor wore during her morning Starbucks run in Nashville, you were out of luck. It was a vastly different time from the oversaturated digital space we exist in today.

So, amid lectures that honed my interviewing and research skills and newspaper internships that helped me learn how to dive deep into what makes a human tick and how to tell their stories in compelling ways, I funneled my growing expertise into the blog. Through sheer force of will, a dream, and a strong internet connection, I began to familiarize myself with the major fashion houses. I learned how to see house codes in the cut of a bodice, the handle of a bag, or the heel of a shoe. I distinguished the differences between shirt cuffs and dress necklines. From a young age, I had always loved stories—reading them and telling them in equal measure. As a young reporter, I learned the power of details and the importance of accuracy. These facets formed the tenets of my approach to writing. This is how—beyond Taylor's lyrics authentically capturing the feminine experience for my generation—all my interests coalesced into a

blog and respective social channels. I began identifying Taylor's fashion and sourcing purchase links for her clothes for other eager and interested fans. I then took it a step further, weaving in commentary on the potential symbolism and messaging of her clothes along with my personal thoughts on the look she was presenting to the world.

> *"When I would create an album . . . I would start conceptualizing, 'What does this album look like? What are the colors[?] . . . What are the aesthetics? What do I want this to symbolize?' Because from a very early point in my career, I wanted to establish each album as its own era."*

—Taylor Swift, Toronto International Film Festival, 2022

The content I was scrappily producing bridged the gap left open by established fashion publications. The digital space felt like the Wild West, where everyone was trying to navigate what presence they wanted to establish. In the world of fashion, where the urge to be cutting, to even be catty, felt like the norm, I wanted to carve out a space that was critically kind in thought and in manner. I felt my place was in combining journalistic accuracy with a thoughtful, stalwart voice of opinion—like the friend who will save you from your own outfit choices before you head out the door and be the first line of defense should any cruel comments from a stranger be lobbed your way. I also believed that in the great vastness of the internet, where it is all too easy to find trolls, it would be possible to connect with people through authentic, shared passions. Taylor's music taught me that. I wanted to find people who found the fun in nuanced conversations about fashion and lyrics and who saw style as a medium through which we speak our motivations and thoughts.

And I did.

I found hundreds of thousands of people whose passions and interests intertwined with mine. We became a tightly woven community of TSSers—a niche fandom within a fandom of people who fluently spoke both fashion and "Swift-lish" and could hold a critical conversation with differing opinions without devolving into key-smashing or name-calling. A true internet utopia.

As I built out the archives of the blog, Taylor's fashion story really started to take shape. I could neatly trace the timeline from country music teen ingénue to powerful, self-made woman through the transformation of her clothes.

In one flick of her coiled ringlets as a country music starlet, Taylor inspired an onslaught of young female lyricists to pick up a guitar, make use of a three-quarter-inch Conair curling iron, and add a summer dress and cowboy boots (including this half-Filipino Canadian in the Pacific Northwest, which is a bit off the mark of the local aesthetic).

In an industry overrun by middle-aged men, Taylor's unabashedly young and feminine fashion choices made her stand out that much more. It was a risky strategy to call attention to everything that made her different instead of attempting to fit in to the existing country music scene. Her first step, of course, was getting people to know her name. In June 2006, Taylor did just that in one brilliant move by naming her debut single after one of the biggest names in country music: Tim McGraw.

Getting her name uttered in the same breath as one of the most famous male artists in country music captured a lot of eyes and ears instantaneously. And once she had her foot in the door, she doubled down on crafting an image that capitalized on all that set her apart from the previous generation of country. Her reliable formula of BCBG sundresses paired with cowboy boots was the sartorial equivalent of an elevator pitch. And anywhere she could, she made sure people remembered her name, opening every—and I mean *every*—performance and appearance with the phrase, "Hi, I'm Taylor."

As Taylor fashioned her identity and paved her path from country starlet to country/pop princess to full-fledged international pop superstar, her style continued to reflect her career choices. As she set about widening her audience from country music loyalists to broader pop listeners, her fashion became less "country" singer and more just singer. With the release of her sophomore album *Fearless* in 2008, her style took on a more classically feminine shape. She swapped her cowboy

boots for peep-toe pumps, sundresses made way for skater minis, windswept curly hair smoothed to become more defined ribcage-length coils, and she gravitated toward a shinier and more paillette-filled palette. As her music took on a dreamier quality inspired by fairytales and epic romances, her fashion followed suit.

It's no wonder that when she swept the Country Music Association Awards clean in 2009, winning every award she was nominated for—a total of five, including Album of the Year for *Fearless*—she was wearing a glittering strapless tulle confection by Reem Acra. The starburst sequined design of the bodice made her look every inch the shiny rising star that she was. I remember thinking she really looked like a modern Disney princess and wasn't surprised in the least when, the following prom season, many girls purchased replicas of her dress for their evening's fairytale festivities.

Taylor's approach to songwriting is why fans cherish her work so deeply and intimately. Her songs aren't just music to listen to; they feel like the whispered secrets exchanged in the wee hours of a slumber party between only the closest of friends. It's her authenticity, and the notes of truth that can't be manufactured, that draw fans into her vivid world. Her early work is filled with unabashed teenage-girl earnestness that rang true because it was. At first, her record label wanted Taylor to omit details from her songs to make them more relatable. But Taylor knew that just the opposite was true. She specifically chose to leave the names of boys in her songs (Cory in "Stay Beautiful," Drew from "Teardrops on My Guitar," and the eponymous crush in "Hey Stephen"), to include the ages and dates when things happened to her ("Fifteen," "22," July 9 of "Last Kiss," April 29 of "High Infidelity"), and to pinpoint details as simple and vivid as the hair color (red) of her best friend (Abigail). These details didn't make her work feel like an island—they created a drawbridge inviting listeners into the emotional world of a teenage girl. One of her most famous true-to-life details also happens to be a fashion one, a symbolic scarf from the deep track "All Too Well" off her 2012 album *Red*. The song traces the journey of a simple scarf through the timeline of a relationship from innocent beginnings to casually cruel undoings. In 2021, I tracked down the scarf: Gucci. And if it were me, I'd want that scarf back too.

In 2014, two major life events coincided to bring about Taylor's then most dramatic fashion change. She moved from the country music hub of Nashville to the bustling metropolis of New York City and buckled down on creating *1989*, her

first entirely pop produced album. Both decisions culminated in what I like to refer to as Taylor's "New York Fashion Takeover" era. I remember that time vividly because it was also the culmination of two of my own major life events: graduating with my bachelor's degree and subsequently moving away from all my family and friends to start my first job as a newspaper reporter; and being invited to the *1989* Secret Sessions in New York. That summer, as I unpacked my things in a dated little apartment and dealt with coin-operated laundry for the first time ever, photos of Taylor surfaced every day as she went out and about in the city in a fresh and exciting new outfit. Her quiet confidence and smirks to the hordes of paparazzi that amassed in a frenzy outside her Tribeca apartment and nearby Pilates studio were proof that her new aesthetic was drawing attention. That fall, I got to tell her in person how her music had changed my views on life, love, and friendship after listening to her watershed pop album *1989* while ensconced in her cozy and candlelit living room. Her style was an enviable mix of high street and designer brands, making her appear approachable and friendly, but also like she could buy her own private jet to fly direct to a secluded island resort on a whim. She also made it her personal mission to ensure that the co-ord set (a chic hot-girl combination of matching crop top and skirt) reached maximum fashion saturation.

Music has always had the ability to transport a person in time, to create a sense memory that binds you to a particular moment or experience or feeling. Taylor knows this better than anyone, having built a career making the personal feel universal. She once said her biggest hope was "saying things in songs that people will care about." But for me, the iconography of Taylor's fashion has done that too. I can very often place where I was in my life based on Taylor's outfits—which speaks either to her strength at creating and sending messages through her fashion, or to my one-track mind's obsession with documenting her wardrobe in vivid detail. Or both. Possibly both.

Probably both.

I remember sitting in front of my parents' desktop computer and freaking out over Windows Live Messenger with my friends (a sentence that's sure to divide generational cohorts) the day Taylor launched her first perfume, Wonderstruck, at Macy's in October 2011. I remember running a load of laundry, laden down with quarters, in my first apartment building postgraduation and returning to my suite to discover that Taylor had worn a stunning green Michael Kors gown to the

2014 American Music Awards. And I specifically remember the day in November 2017 that the *reputation* tracklist was posted.

I was sitting on a beach in Hawaii, hair still salty and dripping, reveling in my first international solo trip in celebration of my twenty-fifth birthday. My heart skipped a beat seeing a song on the tracklist with a fashionable title: "Dress." I spent nights in my hotel room (after eating my weight in pineapple whip and Spam musubi) posting Marc Jacobs and Vetements looks from the edgy and grungy *reputation* album photo shoot. Her previously feminine style was mostly replaced by harsher, edgier, oversized silhouettes filled with black, olive green, and camouflage. It was a completely unexplored fashionable territory that was so unlike anything we had previously seen from Taylor, but no doubt a result of the unprecedented criticism and highly public celebrity feuds she had lived through in the summer of 2016. It was like observing the live reincarnation of a pop star: a red carpet funeral for the girlish style of the past and the emergence of a reborn powerhouse.

If further proof was needed that life, indeed, does imitate art and that Taylor's fashion is not just a mirror but an extension of her career, we need only look to her more recent eras as we turned the corner into the 2020s. At the same time that Taylor established a new recording contract to own the masters to all her future music, she also set about styling herself for the first time ever. She dove into the cottagecore aesthetic and styled her natural curls into sweet space buns or a single unfussy French braid. She leaned into the imagery of the British countryside, mysterious and moody, and detached from prying eyes. Rare appearances were captured on film in fuzzy images by a trusted photographer. Her closet was pared down to a few chic plaid wool coats by Stella McCartney, paired with ruffled Victorian nightgowns and chunky Dolce & Gabbana boots—a look that was cozy and unbothered, at peace and comfortable in her own skin and power.

For all this time, I've been documenting every one of her major red carpet moments—and all the smaller, but no less significant, moments in between. I see Taylor's fashion as a natural extension of her music, the visual counterpart to her lyrics. It's my goal to interpret the subtext of her clothes with the same level of specificity she communicates in her songs.

Just as important, I also want it known that when you think of "Style," I really do hope you think of me.

Part
I

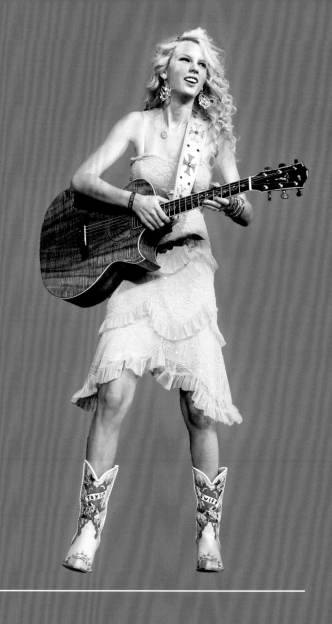

A SWEET START
FOR COUNTRY'S
SWEETHEART

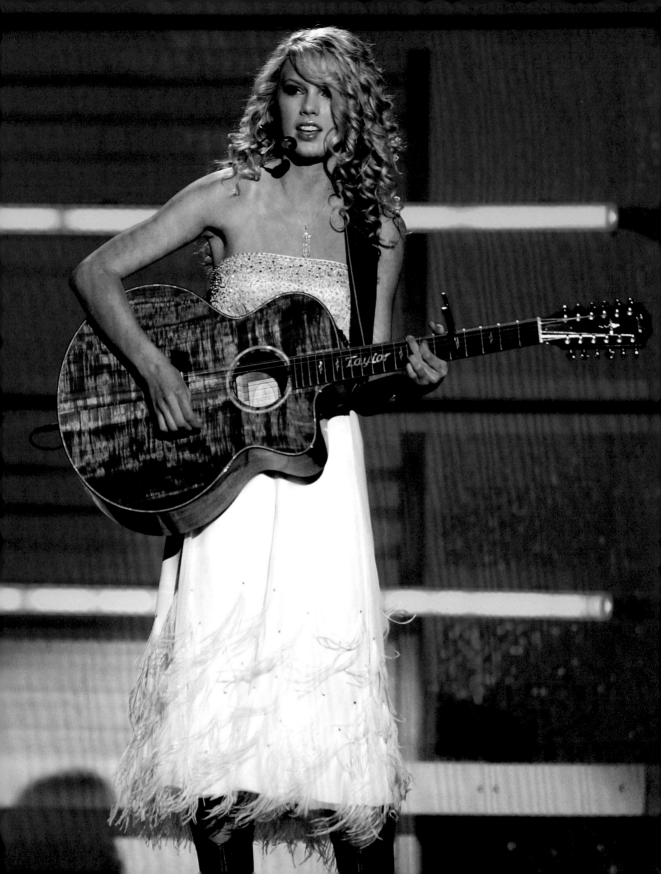

1

Taylor Swift

THE MAKING OF A HOUSEHOLD NAME

TAYLOR SWIFT CAME ONTO THE MUSIC SCENE IN 2006 WITH HER EPONYMOUS country album. When her debut single, "Tim McGraw"— cleverly named after one of the most famous country artists of the time—hit the airwaves, it should have been everyone's first indicator that they were dealing with a marketing savant.

But Taylor's introduction to the world itself was in Pennsylvania, seventeen years prior. On a quiet and cold December 13, 1989, Andrea Swift, a mutual fund marketing executive, and Scott Swift, a stockbroker for Merrill Lynch, welcomed their firstborn baby girl, Taylor Alison Swift. Her earliest years instilled an undying love of Christmas—a natural extension of both being a winter baby and growing up on a Christmas tree farm. (Yes, really.)

Her next and most significant love and passion soon became apparent. When Taylor was twelve, a computer repairman fixing the Swift family's desktop computer (a charming relic of the time) spotted a guitar in her room. He taught her a few chords, and the rest, as they say, is history. Taylor learned to play until her fingers bled and then kept going until a line of calluses formed. She soon discovered that it wasn't enough to play guitar—it was even better to write songs. Her schoolgirl poems and short stories, full of a young girl's dreams and feelings, came to life in a new medium: songwriting.

Very quickly, her hobby became an obsession. She started taking weekend trips with her mom, Andrea, to New York and Nashville, where she would drop off DIY demo CDs to any recording label with an open door and a kindly receptionist. Then, either believing deeply in their daughter's talents or simply succumbing to the endless begging, the entire Swift family relocated from Pennsylvania to be closer to the heart of the country music scene: Nashville, Tennessee.

Despite the fact that Taylor's burgeoning songwriting talent clearly catalyzed the family's move, the Swifts tried to deflect pressure from their preteen daughter. "I never wanted to make that move about her 'making it,'" Andrea explained to *Entertainment Weekly*. "What a horrible thing if it hadn't happened, for her to carry that kind of guilt or pressure around. . . . We've always told her that this is not about putting food on our table or making our dreams come true. There would always be an escape hatch into normal life if she decided this wasn't something she had to pursue. And of course that's like saying to her, 'If you want to stop breathing, that's cool.'"

The bet, however, paid off not long after when Taylor signed a one-year development deal with RCA Records as a songwriter—the youngest ever on their roster at just thirteen years old. Shuttling between high school and the label's headquarters, she spent her days learning algebra and biology and her evenings writing songs with people two or three times her age. She began establishing country music connections that would serve her career for years to come, including a partnership with Liz Rose, whose cowriting credits on future Taylor albums would include iconic hits like "You Belong with Me" and what many consider to be Taylor's magnum opus, "All Too Well," the blistering five-and-a-half-minute ballad (re-recorded a decade later at a staggering ten minutes) from 2012's *Red*.

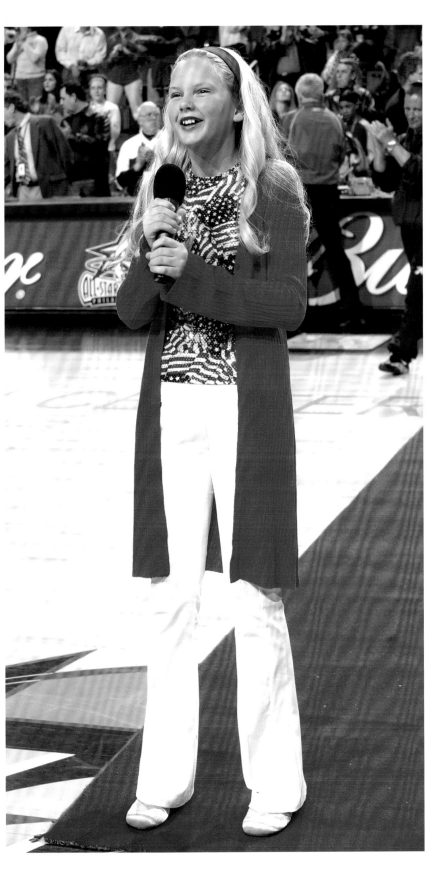

Miss Junior Americana. One of Taylor's earliest gigs when pursuing her musical dream was the coveted spot of singing the national anthem at the top of a local sports game. Here, at thirteen, she does so for the Philadelphia 76ers in a match against the Detroit Pistons. I appreciate Taylor's honor-roll-student commitment to any bit—as seen here in the overboard level of patriotism displayed by this outfit.

At the end of her one-year deal, rather than sign on again for another short-term stint, Taylor boldly walked away from RCA (early aughts rainmaker for heavy pop hitters like Christina Aguilera), choosing instead to take a chance on someone who wanted to take a chance on her. That someone was Scott Borchetta, who in 2006 was leaving Universal to start his own record label, Big Machine Records.

Scott first heard Taylor during an acoustic set she played at the Bluebird Cafe in Nashville—a stomping ground renowned for its intimate and careful attention to live musicians. Founded by Amy Kurland as a place for songwriters to "feel at home," the Bluebird has launched the careers of well-known country acts including Vince Gill, Keith Urban, and, of course, Taylor Swift. Little did she know it at the time.

In joining Scott's roster, Taylor became the first artist signed to Big Machine Records. Over the course of a decade, she released six studio albums under the label's masthead and transformed from country music darling to iconic pop superstar.

In 2006, the fairytale dream of a budding songwriter in Nashville began to take shape—as did, of course, her personal style.

Hi, I'm Taylor

Taylor's debut album set the bedrock for her niche take on songwriting, and visually it established her identity in the musical landscape. Her innate ability to notice small details and find wonder in the mundane captured a sharp microcosm of the young, female experience that uniquely resonated with other teen girls. In many ways, it set the blueprint for her entire career.

Taylor's songs are often labeled as "diaristic"—even to this day. While there is an inarguable intimacy in her lyrics, to ultimately equate her lyrical finesse to an adolescent diary page is to diminish the strategic skill of songwriting itself. There is nothing happenstance about a hook or arbitrary about a word choice. Like her style, Taylor's wordplay is always intentional and carefully crafted.

Her debut single, "Tim McGraw," launched her not only as a songwriter and a fledgling fashionista, but as a savvy marketer with an eye for the long game. By tightly weaving her name with the name of one of the biggest artists of the time, she created an instant talking point for interviewers as well as an intriguing entry point for country listeners looking for new music. Myself

included. I can still vividly recall stumbling across the song on LimeWire (an ancient and highly questionable platform for listening to music in the early aughts, offering a fifty/fifty chance of downloading the new song you wanted or a deadly virus that would kill your desktop computer) and being filled with curiosity over what it was all about. The song bears all the hallmarks of Taylor's songwriting—a confessional track anchored by highly personal details that make the song both uniquely hers and also universally relatable. Like other teenagers back then, Taylor used MySpace to share the latest goings-on in her life. Her life just happened to include home-edited vlogs of her time on the road and talking with fans her age about the music she was making.

Similar personal nuggets of information are scattered elsewhere throughout Taylor's debut effort. The trauma of lonely lunch tables and the search for connection and identity get their first glance on "The Outside" and "A Place in This World." She introduces lyrical motifs that would reappear in her work—like rain in the impeccable (and personal favorite) "Cold as You," and the sacred hour of two a.m. in "Mary's Song." She broadens her worldview to include her take on the experiences of secondary characters in her life (that arguably touch a personal nerve she wasn't ready to address yet in the first person), like a friend's eating disorder in "Tied Together with a Smile" or her elderly neighbors' childhood meet-cute, also memorialized in "Mary's Song" (a two-for-one lyrical prototype). Meanwhile, the big, swinging singles "Picture to Burn" and "Should've Said No" were like musical target practice, early iterations of how sharp her pen could be when aimed at those she felt had wronged her. In live performances, she'd preface the former by saying, "Before I sing this song, I always try to tell the audience that I really do try to be a nice person, but if you break my heart, hurt my feelings, or are really mean to me, I'm going to write a song about you." She had audiences (and her ringlets) wrapped cheekily around one finger. Her penchant for conversational lyrics and pop-leaning, addictive hooks is spotlighted in the album's finisher, "Our Song." Written originally as a ninth-grade talent show submission, the banjo-led ditty went on to top *Billboard*'s Hot Country Songs list for six weeks and made her the youngest solo writer of a song to hit number one on that chart. Cheekily, Taylor noted she had intentionally made it the album's closer because its final chorus line subliminally invited listeners to start the album over again. "Our Song" is

meant to fill a gap for a couple who doesn't have a quintessential song they can definitively call their own. It also serves, in a way, to distill the core tenets of Taylor's debut album: a scrappy DIY mentality that says if the existing material doesn't fit, you start from scratch and remake the material into your image.

> *"I really do try to be a nice person, but if you break my heart, hurt my feelings, or are really mean to me, I'm going to write a song about you."*

The Art of Dressing the Part

In the chorus of "Tim McGraw," Taylor tells everyone in no uncertain terms to think of her when you think of that classic fashion item every girl should have in her closet: the little black dress (faded blue jeans are also a wardrobe staple, but let's focus on the LBD). Dresses became a key component of her style early on. Specifically, printed sundresses. And even more specifically, printed sundresses paired with cowboy boots. It was a distinct but easily repeatable fashion formula that afforded seemingly endless combinations. As she kickstarted her career, crafting an easily recognizable identity was vital. This ensemble created a succinct visual brand that communicated her place in the world. Like a math equation, the easy formula spelled it out for everyone: sundress + cowboy boots = teenage girl + country star. (If all math made as much sense as fashion to me, I would have done better in high school algebra.) The combination proved to be a distillation of her easiest brand identifiers, even if you hadn't heard a single line of her self-penned music.

At the time, she truly had no other contemporaries who were singing from the viewpoint of a teenage girl while also trying to relate specifically to other

teenage girls. Within country music, her peers were mostly adult men catering to blue-collar woes. Her resumé as an opening act speaks to that clearly as she racked up country credit playing to crowds who had paid for tickets to see George Strait, Rascal Flatts, Tim McGraw, and Brad Paisley. And on the other side of the genre spectrum, the women of pop music were playing into adult men's fantasies of teenage girls, not writing for teen girls themselves. Where the idea of the "schoolgirl" had become fetishized in music videos like Britney Spears's ". . . Baby One More Time," it felt revolutionary and like a stark contrast that Taylor embraced the authenticity of actually being, and dressing like, a high school girl. Her curly hair also set her apart in an industry that favored sleek, polished blowouts—for once making curls seem cool, even desirable and worthy of imitating. I myself can recall hours spent with a curling iron or sleeping uncomfortably with a head full of foam rollers to force my otherwise pin-straight hair into corkscrews just like hers.

In a way, Taylor's uniform not only established her place but also served as a shield that comforted her in her isolation. To *Vogue* in 2012, Taylor described her early feelings of loneliness in chasing after her dreams. "As soon as I left school, when I was 16 . . . all that mattered was music and this dream that I'd had my whole life. It never mattered to me that people in school didn't think that country music was cool, and they made fun of me for it—though it did matter to me that I was not wearing the clothes that everybody was wearing at that moment. But at some point, I was just like, 'I like wearing sundresses and cowboy boots.'" It wasn't just about fashioning an identity to the world, but also about proving a point to herself as a personal validation of her music dreams being realized.

Her choices in dresses were soft and girlish, in vibrant colors that popped onstage and nearly always in age-appropriate baby-doll or A-line shapes with hemlines that typically hit at the knee. It was a look that, by design, underlined her youth and made her appear approachable and accessible. Rather than being sucked immediately into designer garments, she most often selected dresses off the rack from high street brands like BCBG Max Azria. These ready-to-wear pieces could be easily found in the closets of many teenage girls across the country who saw the designs as the "fancy" formalwear of their age demographic.

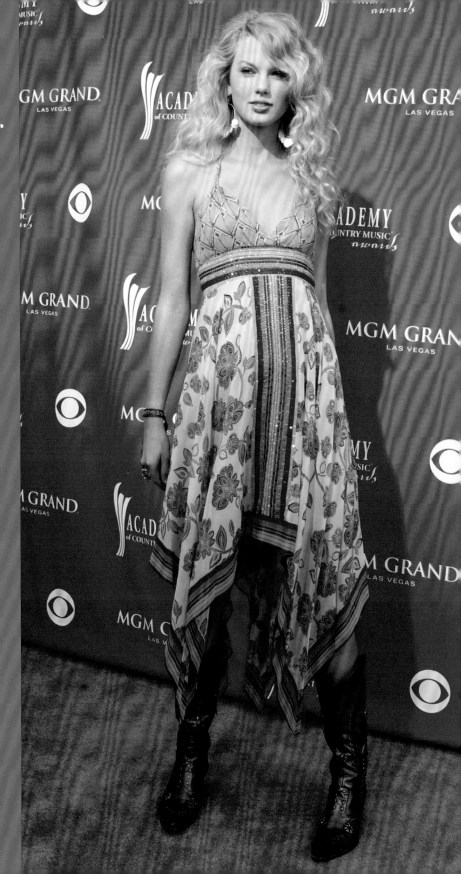

"When you pair a dress with cowboy boots, there's kind of a cool irony to the outfit."

These Boots Were Made for Branding

While her dresses played their part in communicating her youthful femininity, her cowboy boots said, "Yeehaw, I sing country music." Not very adroit or poetic, but it got the job done.

"When you pair a dress with cowboy boots, there's kind of a cool irony to the outfit," Taylor said to *Life & Style* in 2009. I get what she means. There's an inherent juxtaposition between the girlish nature of a dress with the toughened, rustic energy of a western boot. Combined, these two disparate fashion elements symbolized Taylor herself, a sweet and earnest young singer whose scathing lyrics could kick harder than a boot with spurs.

Her go-to brands at the time included Old Gringo and Liberty Boots, primarily in varying hues of worn black or brown leather—she even had a python-leather pair. As a cheeky nod to her youth, one pair of her cowboy boots by Liberty stands out: bright red with contrasting black toes. But their most distinguishing element was a skull emblazoned on the front of each boot, each festooned with a powder-pink bow. The boots' great final detail? "Rock On" stitched in a quintessential punk rock font on the back. At a time when Avril Lavigne's pink extensions, kohl-rimmed eyes, and skater punk aesthetic were reigning supreme with young girls, these particular boots felt like Taylor's countrified version of teen rebellion.

Taylor spoke at length in interviews about how some of the most formative memories of her youth were defined by loneliness and isolation. She distilled this in the song "The Outside" on *Taylor Swift*. To *EW* in 2008, she described the song as being "about the scariest feeling I've ever felt: Going to school,

(OPPOSITE) Committed to the bit. For her first appearance at the prestigious Academy of Country Music Awards, Taylor held strong to her uniform of sundress and cowboy boots. Her multiprint dress was, of course, by BCBG Max Azria—a go-to brand for almost all her dresses at the time—with matching BCBGirls cowboy boots. The floral print, brushed-out curls, and fluttering handkerchief hem combine to create a very soft, approachable, and young look. The colors of the dress even expertly complement the backdrop and carpet so that she appears to gently make her debut at the awards show rather than screaming for attention. The paillettes on her oversized hoops give me throwbacks to the days of puka shell necklace popularity.

walking down the hall, looking at all those faces, and not knowing who you're [going] to talk to that day." She continued, "People always ask, 'How did you have the courage to walk up to record labels when you were 12 or 13?' It's because I could never feel the kind of rejection in the music industry that I felt in middle school." In a way, her "Rock On" boots, style name "Brody Rocks" after Brody Dalle, the frontwoman for The Distillers, felt like a reference to being an outsider but now owning that label fully—because it was her differences that had led her to the stage and created a link for fans to feel like friends. "It's so cool to be sitting in my tour bus watching these girls show up to my concerts wearing dresses and cowboy boots," she told *Country Weekly* in 2008.

(LEFT) In the late '90s to early 2000s, *Total Request Live* was a mecca of the teenage music experience. Broadcast by MTV, *TRL* popularized the music video countdown and played an early, key role in encouraging online fan voting to rank the most popular music of the day. Its format had a cult-like following, which arguably played a role in launching the careers of the era's boy bands (NSYNC and Backstreet Boys), pop princesses (Britney Spears), and rock stars (Green Day, Good Charlotte). It was the weekday teen equivalent to childhood Saturday morning cartoons: an after-school must-watch to keep you apprised of the latest in music, and one of the rare opportunities in a pre–social media world to see your favorite musical artists, unfiltered. During a weeklong takeover of the now defunct *TRL*, Taylor stuck to her tried-and-true fashion formula of dress and cowboy boots—a commitment to her countrified aesthetic even when promoting herself outside that musical niche. Taylor kept things repetitive but recognizable in toned-down, paisley-free halter dresses and cowboy boots. That particular shade of teal has forever branded itself in my memory as one I associate with the debut era.

(RIGHT) At the 2007 American Music Awards, where Taylor was outside the safety provided by a familiar country music audience, this all-black ensemble quietly sticks to the hallmarks of her debut style—but in a refined way that's less obviously "country" for a general music audience. I appreciate how the halter dress, by Catherine Malandrino, feels sweet and youthful, but the cutouts give it a country tinge. I think a half-up hairdo with a charming satin ribbon would have been a jaunty finish, but I also respect that the curls are like Taylor's version of the Bat Signal: an immediately recognizable signature that lets everyone know she is there.

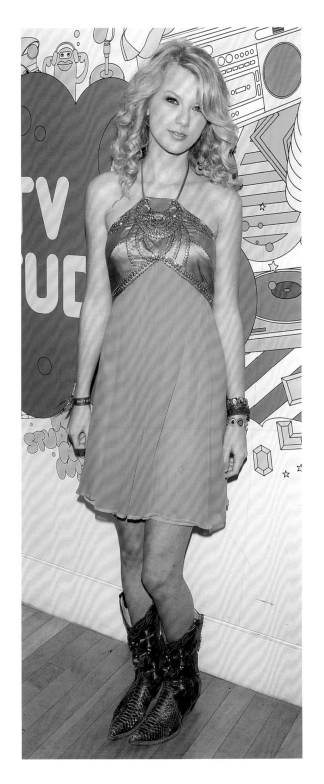
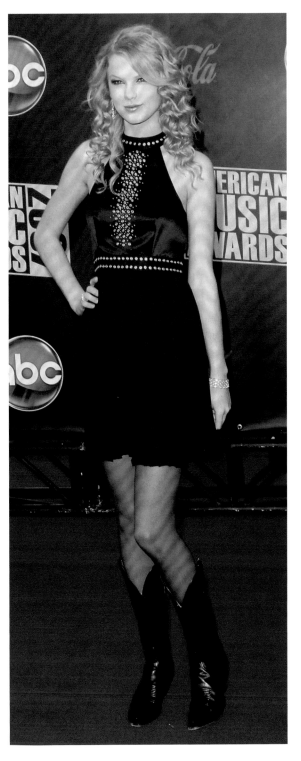

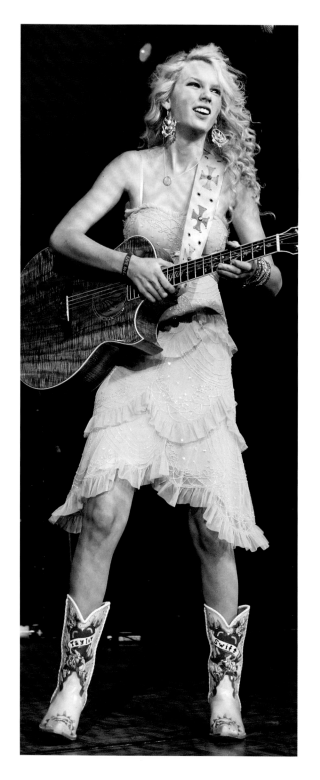
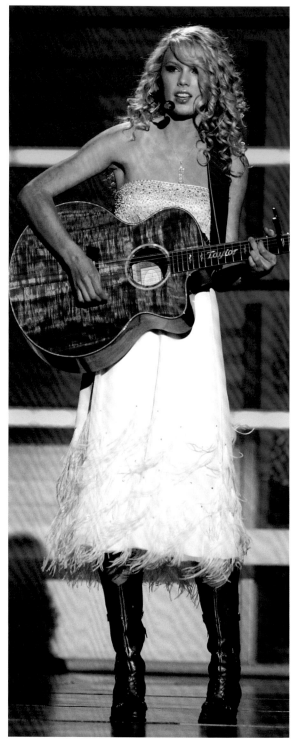

Taylor Swift Style

Me, Myself, and My Label Maker

The debut era was also, appropriately, her eponymous era. Taylor tactfully chose accessories and fashion items with her name emblazoned on them to market herself as a new artist making a name (literally) for herself in country music.

Her guitar brand of choice during that time period was Taylor Guitars. As a result, every instrument she strummed helpfully had her name inlaid into its neck or headstock, often in eye-catching mother-of-pearl. "When I'm playing guitar and you see on the end of it it says 'Taylor,' that's not because I make the guitars— that's because he makes the guitars," Taylor once joked at a Taylor Guitars conference in 2008. The "he" being Taylor Guitars founder and luthier Bob Taylor.

(LEFT) The key to becoming a household name is first making sure people remember it. The soft color, demure length, and ruffles of her periwinkle BCBG Max Azria dress all continue to check the boxes of sweet and approachable teenager. But her accessory choices worked like an unavoidable country music business card. Custom boots by Liberty were emblazoned with her name across the front. Originally, this "Love & Peace" style only retailed in black and pink, but Liberty Boots CEO Maria Torres told me Taylor herself requested bespoke boots in powder blue with white braiding to match her BCBG dress. "From the very beginning, [Taylor] was thinking about the image she wanted to project," said Andres Villalpando, Liberty spokesperson. And, of course, her koa wood Taylor Guitar conveniently had her name inlaid into it. Even if you had no idea who she was, even without a handy caption (like this one!), you would be able to deduce she was a country singer named Taylor Swift.

(RIGHT) Performing her debut single, "Tim McGraw," onstage at the 2007 Academy of Country Music Awards was intimidating enough. But to really add to the pressure, Taylor sang the song directly to the man it was named after. During her performance, Taylor made her way down from the stage to the first row of seated guests, and during the quiet echoes of her final guitar strum, she stuck out her hand and formally introduced herself to McGraw himself with a plucky "Hi, I'm Taylor." This particular stage outfit combines many integral debut-style calling cards. Her Taylor Guitars koa wood twelve-string was her signature and most distinctive instrument—a calling card that kept her name literally close to her heart. The strapless, embellished, and feather-hem-festooned dress is sweet and youthful (if charmingly dated to the early aughts in case the Britney Spears-approved mic headset didn't give it away), the white color evoking a pure innocence and the subtle sparkle a premonition of the princessy styles she would soon come to favor. The juxtaposition of those crocodile-skin cowboy boots, though, squarely sends a "country musician" message.

Using these guitars was like built-in advertising for Taylor, who typically favored the brand's koa wood instruments, which struck a distinctive look on stage. To further foster the relationship, she appeared on the brand's website and played at Taylor Guitars trade shows as an ambassador. In an interview in 2008, Bob Taylor spoke highly of the natural working relationship his company had with her: "What's really exciting to us is we work with a lot of artists, and when they first start out they're excited to be involved with the guitar company they use. But then when their rising star just shoots over the moon there's bigger and better things to take care of. But Taylor has always remembered us."

In 2009, she worked with Taylor Guitars to design her own Baby Taylor model—an homage to the pint-sized kid's guitar she herself first learned to play. "I wanted to share my passion for playing guitar with my fans," she said upon its release, fondly reflecting, "I used to sit in the back seat of the rental car while I was on my radio tour at 16, writing songs on my Baby Taylor guitar." In addition to the Taylor Guitars logo, her version of course featured her own name, "Taylor Swift," and a botanical rosette with what was then her signature sign-off—"Love Love Love"—arcing in cursive around the sound hole.

She was also not above going the customization route. One of my favorite accessories was a pair of powder-blue Liberty cowboy boots that were emblazoned with hearts and flowers. Over each heart, in mirroring, curled sashes, appeared her name: "Taylor" (on one boot) and "Swift" (on the other), evocative of traditional tattoo stylization (the design was indeed a riff on Liberty CEO Maria Torres's first tattoo). "I loved the design so much I wanted it on a boot," Torres told me. "The essence of Liberty is very 'rock star,'" she explained, adding that their unique approach to a high-end western aesthetic is what made their designs so popular with celebrities.

I Was Young and I Needed the Outfit

Much of Taylor's debut style was about setting a precedent and a tone. And the notes she hit with tremendous consistency were: young, saccharine, girl-next-door. For performances and general appearances, Taylor's tried-and-tested combination of sundress and cowboy boots worked well. But for more formal red carpet appearances, the box shifted slightly to: teen girl en route to prom.

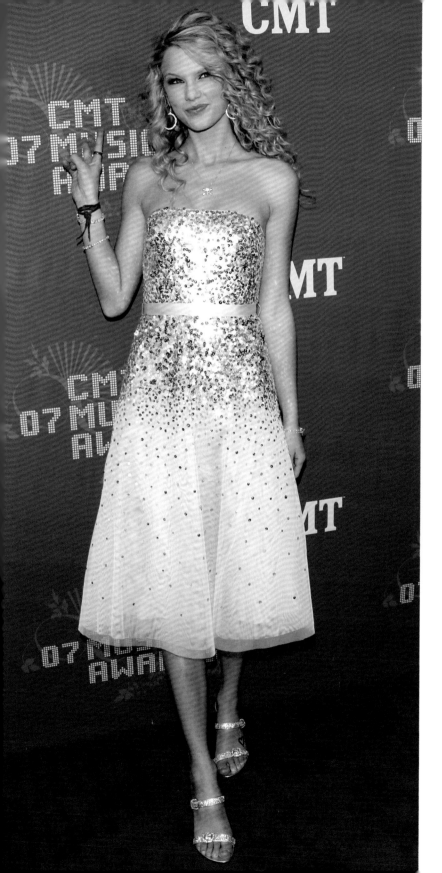

Flashing a juvenile peace sign for the crowd, Taylor wore a glittering strapless BCBG Max Azria dress as a fresh-faced newcomer to the 2007 CMT Music Awards. It's a fizzy party look worthy of any girl's sweet sixteen and bears the classic hallmarks of eagerly overaccessorizing. I can imagine her throwing on another bracelet to "complete" the look on her way out the door. Her tiny concession to teenage rebellion was inking a heart on her foot in Sharpie (her dad adamantly said no tattoos)—in addition to the very punk rock skull necklace. Also in place is the trusty leather "Love Love Love" bracelet she wore everywhere and was selling as merch (I still have mine, tucked away in a drawer).

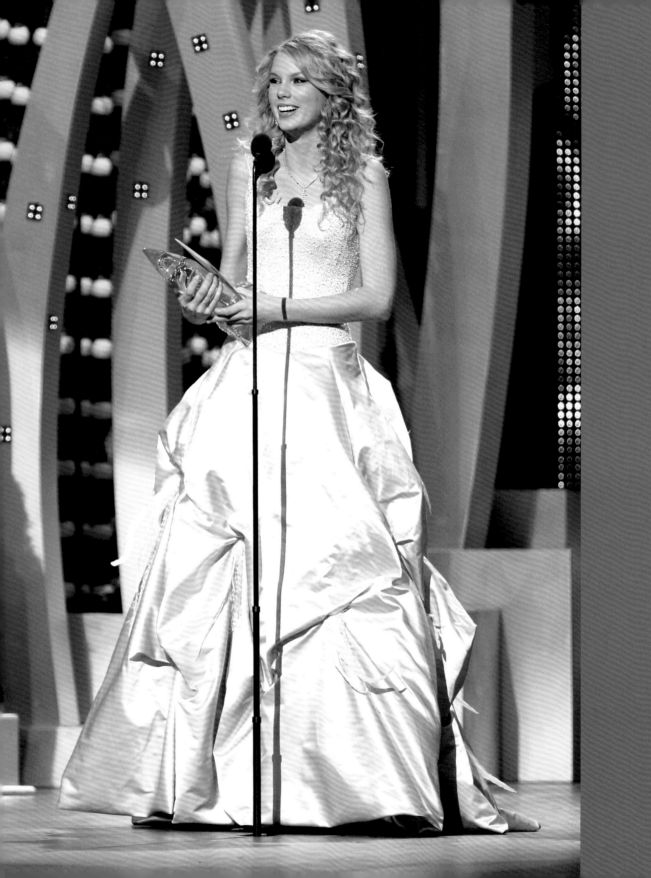

Perhaps the choice was simply to let a teenager live her fantasy of a high school student's biggest night despite her status as a newly minted country star. Or perhaps it was an intentional tactic to emphasize Taylor's sweet and approachable demeanor. Given Taylor's savviness, I can certainly imagine both factors working in her favor and in tandem.

Though a teenager, Taylor clearly had a strong vision for how she wanted to present herself to the world through the lyrics she wrote, but also through the clothes she wore. Despite her vision, she didn't quite have the notoriety to draw big-name designers to work with her just yet. While her label head, Scott Borchetta, was heading up the sound side of things to promote her music in all the right country circles, in the absence of a professional stylist on her team to assist in wardrobe, Scott's wife, Sandi Spika, took up the style side of things.

Sandi would go on to design a handful of gowns for Taylor at the infancy of her career, all bearing a similar corseted and puffy look that called to mind the borderline gaudy and shiny prom dresses of the time. The effect, in retrospect, is almost charming—if not cringe. It carries with it the endearing nostalgia of grimacing at one's own high school yearbook or prom pictures. To Yahoo! in 2013, Taylor astutely remarked, "I started walking red carpets when I was 16. I think I missed prom too many times, so I would wear dresses that looked like you would wear them to prom."

For me, the most memorable, and emotionally charged, Sandi Spika gown Taylor wore was the one she wore on November 7, 2007, at the Country Music Association Awards. It was Taylor's second appearance at the awards show—her debut album having been released just thirteen months prior—and she was nominated in the Horizon Award category. "This is an award that means you have truly arrived in country music," said announcer Carrie Underwood, who had won

(OPPOSITE) Darling but dated. A teenage Taylor won her first Country Music Association award in 2007 wearing a prom-like custom gown by Sandi Spika—the wife of her then label head Scott Borchetta. This particular watery shade of yellow is not the most warming tone for Taylor's complexion and curls. I would call the effect "couture butter stick." But for me the ultimate double-whammy hit to the eyes comes from the bejeweled corset bodice and the sheen from the skirt. Those pickups in the skirt also vividly plant me into an early 2000s episode of *Say Yes to the Dress*.

the category herself in 2006. Taylor was the youngest nominee, naturally, slotted against artists like Kellie Pickler, Jason Aldean, and Little Big Town.

When Carrie announced her as the winner, an already teary-eyed Taylor clutched at the skirted pickups of her buttermilk-yellow gown to make her way to the stage, hugging her mom and then fellow nominee Rodney Atkins before toddling up the steps, earnestly breaking into a full-on run to receive her award. The slightly drop-waist (and bedazzled, of course) bodice of the dress was heavily boned and tied up the back in a ribboned corset—classic early 2000s prom fashion.

"This is definitely the highlight of my senior year."

Her speech, delivered in her teenage voice, never fails to make me cry. Winning the award was, as Carrie had astutely said, a formal acceptance letter from country music that Taylor had broken into the industry and a symbol that all her hard work was starting to pay off. "I can't even believe that this is real," she twanged breathlessly, holding her trophy in shaking hands. In pure disbelief, she said, "I want to thank my family for moving to Nashville so that I could do this . . . and I want to thank country radio—I will never forget the chance you took on me." The secondhand pride I felt as her wide-eyed dreams of making it in country music became realized was often strong enough to send me over the edge.

"This is definitely the highlight of my senior year," she blubbered to raucous, and charmed, laughter from the crowd.

(OPPOSITE) At the 2007 CMT Music Awards, Taylor paid homage to her song "Teardrops on My Guitar" by wearing the same Sandi Spika gown she wore in the song's music video. We love a scrappy fashionista on a budget. The fluttering ties around her arms do add a certain whimsy and softness, especially because they continue the cascading effect of her signature ringlets. Iridescent, sea-green, and with a very dramatic extended train—the only gown fit to wear in bed while tears cinematically fall on your guitar, right?

Taylor Swift Style

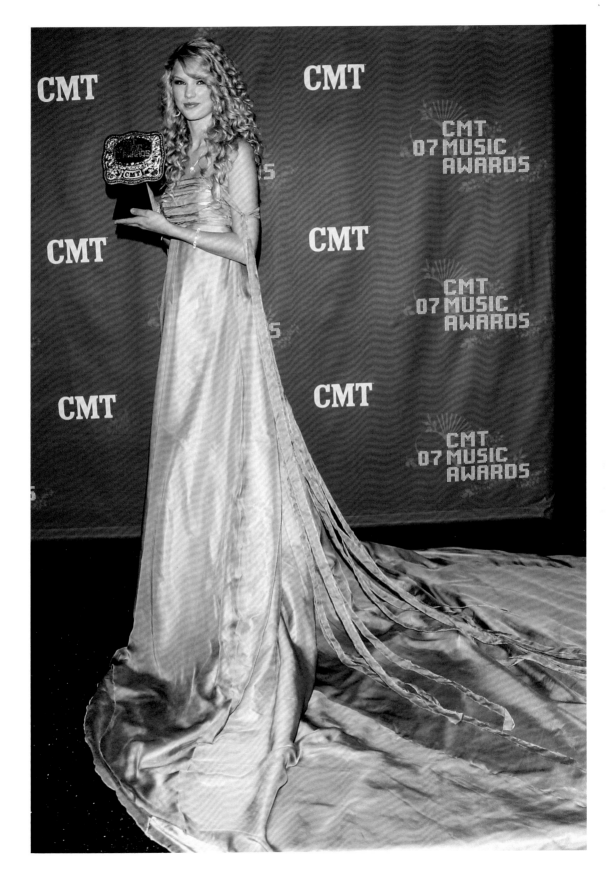

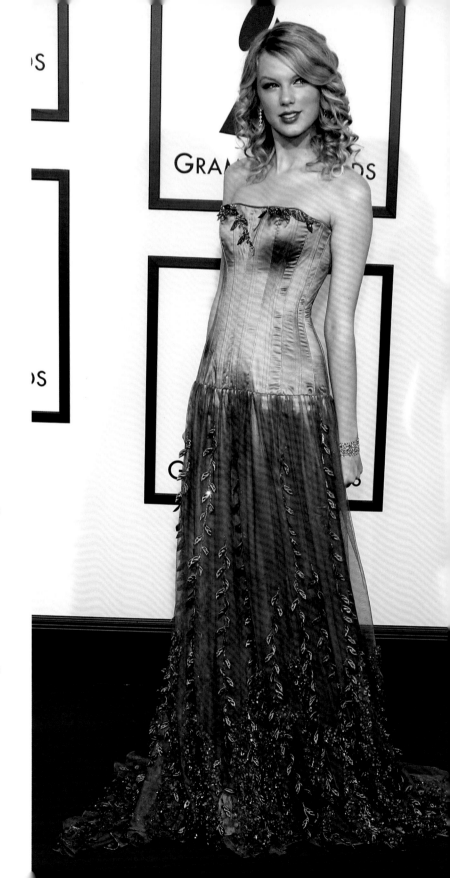

Without a formal team working to acquire pulls from the latest designers' runways, Taylor's main wardrobe designer during her debut era was Sandi Spika, the wife of her record label head. Besides the convenience of keeping things "in the family," Sandi had a strong history of working with female country music icons—including Faith Hill, Trisha Yearwood, and Reba McEntire. Her most famous gown, worn by Reba to the 1993 CMAs, was known simply as "The Red Dress." Its deep plunge, sheer neckline, and matching sheer sleeves caused a stir in Nashville; the gown was considered quite scandalous at the time. Sandi once joked that she thought the dress's saucy design might get her fired. While working with Taylor early in her career, Sandi tailored her creations to be more age appropriate and reminiscent of a teenage girl's first prom dress—like the gowns Taylor wore to her first Grammy Awards appearance, in 2008, and to the 2007 Academy of Country Music Awards. The luster fabrics, the drop-waist silhouettes, the boning, the corsetry—all evoked a certain "sharing a limo en route to the big dance" energy.

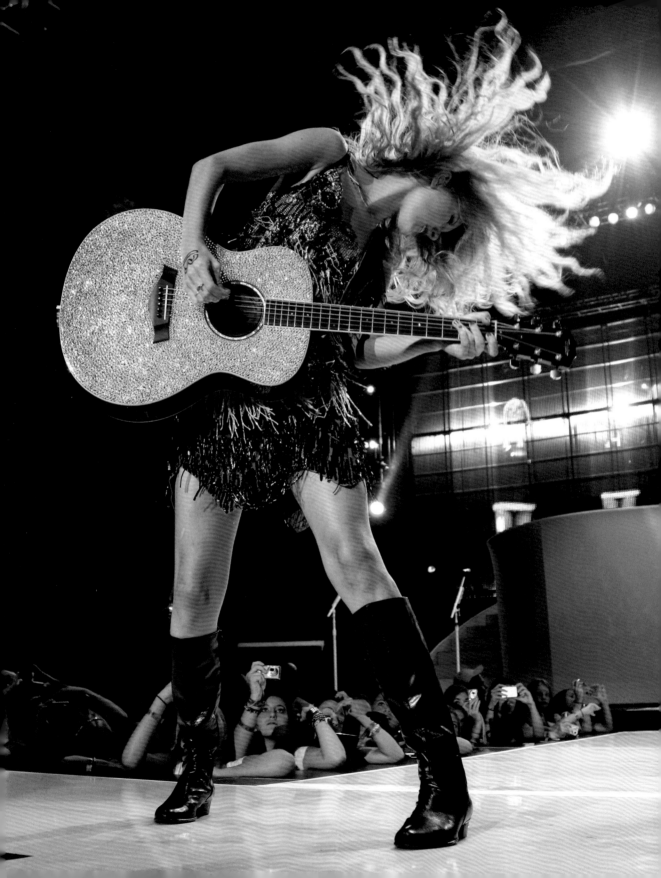

2

Fearless

THE POP PRINCESS NEXT DOOR

FOR AN ARTIST, ESPECIALLY ONE WHO HAD MADE SUCH A SPLASH UPON ENTERING the music scene, there's a delicate balance between excitement at the initial taste of success, and anxiety at the staggering expectations for the sophomore effort. Almost more than one's debut, being able to transcend the sophomore slump is a great determiner of cementing their status in the industry. So it was with Taylor's second album, *Fearless*, released in 2008, when we saw the beginnings of several patterns that would define this leg of Taylor's career—both in her music and also, of course, in her fashion.

Having established her roots as a country act, Taylor's second album and era signified her slow transition to a wider, mainstream, and more pop-oriented audience. The banjo instrumental of the album's lead single,

"Love Story"—a modern plot-twist retelling of *Romeo and Juliet*—had a flavor of twang that satisfied her initial country fan base. However, it was also released in tandem with an alternatively produced version completely denuded of any plucky southern-twinged charm. Instead, the banjo was replaced with sharper percussion, electric strings, and crisp guitar in a remix that was serviced to pop radio. Unless you were living under a rock or have not been a guest at a wedding since 2008, you know of course that "Love Story" went on to become what's defined now as Taylor's breakthrough crossover hit. The writing was on the wall when "Love Story" hit number one on both the country music and pop charts, toppling Shania Twain's 1998 record as the highest-charting country crossover for "You're Still the One." To date, "Love Story" has gone 8x Platinum in the United States, tied with "Blank Space" for Taylor's second-highest certified single ("Shake It Off" being her number-one, and only, Diamond-certified single).

Many were already placing bets on how much longer country music would benefit from Taylor's youth and energy before she jumped ship entirely to pop. An article in *Entertainment Weekly* documenting her sophomoric rise opined, "Can country fans and programmers—who tend to be a little bit territorial—expect to keep [Taylor] to themselves?" It further asked, "Will the pop crossover success get to her?" Astutely playing defense, Taylor was quick to characterize her multigenre success as a "spillover"—not a crossover. She would go on to repeat this line faithfully on radio tours for country and pop stations alike as part of *Fearless*'s promotional schedule. In a review that lauded her lyrical strength if not her youthful, inexperienced singing pipes, *Slant* magazine praised Taylor's ability to structure a pop song, stating that "nearly every track

(PRECEDING PAGE) It's not a Taylor Swift concert without some glitter and a dramatic hair flip. There's a part of me that wonders if the album cover for *Fearless*, which shows Taylor's curls fanned out, was partially inspired by these magical moments in the live setting, when Taylor is probably at her freest and happiest. I can imagine the sense memory she must feel in every hair follicle, distilling these moments of living out her dream into a single, powerful flip. Physically, I can also imagine that her pull toward tassels and fringe, like those on this ombre Mandalay dress, must have been to create a consistent "swish" factor from her hair to her wardrobe styling. Not to mention it coordinated perfectly with the sparkle of her Taylor Guitar. As an example of her DIY streak, Taylor hand-glued thousands of crystals onto the guitar's face to transform it into an extension of her sparkly style.

Taylor Swift Style

on *Fearless* follow[s] time-tested narrative conventions and, more often than not, build[s] to massive pop hooks."

The third single off *Fearless*, "You Belong with Me," cemented Taylor's pop prowess even further by becoming not only Taylor's first number-one single to top *Billboard*'s all-genre Radio Songs chart but the first country crossover single to do so as well. The song's lyrics and accompanying music video firmly place Taylor on the "overlooked nice girl" side of an unrequited high school crush: a girl who wears sneakers, looking on in envy from the bleachers at the idealized popular cheerleader who wears short skirts and heels to school and is the object of said crush's attention. In the video, Taylor plays both characters, donning a brunette wig and *Mean Girls*–approved plaid micro miniskirt to fill the role of catty hot girl, and dressing as herself—albeit with the requisite oversized black-framed eyeglasses—to represent the pining nerdy girl. While a fun bit of costuming, it also felt like playful, meta foreshadowing to her future metamorphoses in fashion and a subtle wink to closely observing fans that the "true" Taylor is still there underneath it all.

At its core, *Fearless* takes homespun romance and overlays it on a foundation of fairytale. *Fearless* validated the wistful, hopeless romantic notions—always central to Taylor's brand and identity—that every teenage girl believes in for a time. It was a simple yet radical idea that normalized the rite of passage of getting to the age where your first brush with childhood fairytales can actually become reality: the idea that somewhere past all the high school heartbreak, a prince awaits to take your hand—and perhaps provide true love's first kiss. *Fearless* was also the start of what would come to be an inside joke within the industry that one could reliably expect Taylor Swift to churn out a new album in the last quarter of every even year. This pattern lasted for five whole album cycles, spanning eight years.

As her sound began to incorporate more elements of mainstream pop to appeal to the masses, so too did her fashion. The niche accessories that had once been anchors of her debut style—like her signature cowboy boots— were used more sparingly and incorporated alongside closet newcomers like metallic high-heeled pumps (peep toe, with a platform) and knee-high boots (black, typically leather). Her casual sundresses also became less frequently interspersed among more frilly, girly, and sparkly frocks.

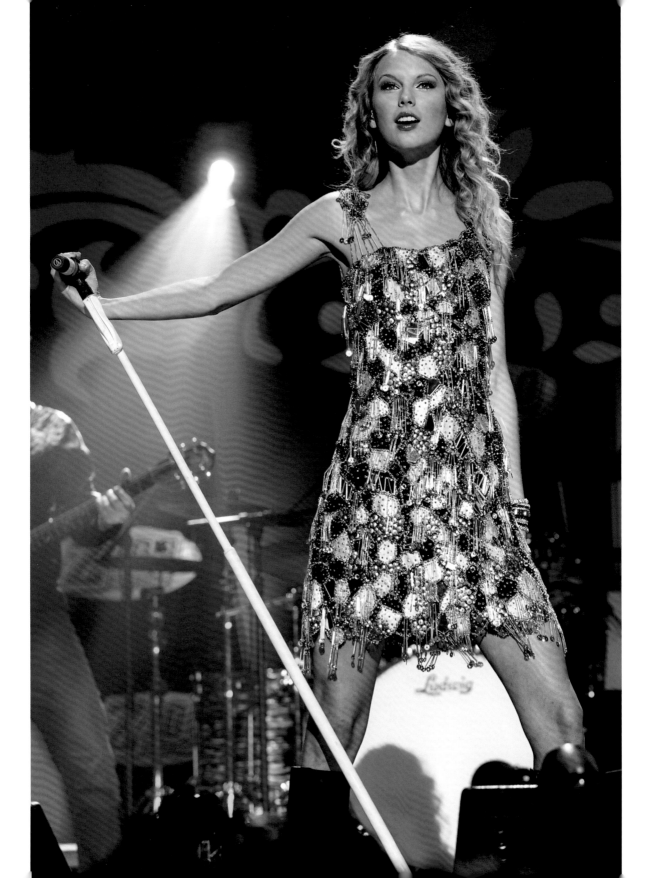

To tie in to the theme of *Fearless*, an album that explored the ideas of fairytales and love—simultaneously verifying the reality of true love's existence ("Love Story") as much as its fictitious fabrication ("White Horse")—Taylor often played the part of a damsel in distress or an overlooked romantic interest using theatrical costuming. Her styling began to skew more whimsical, with garments that evoked a modern take on the Shakespearean age.

Her love of a prom-like ball gown quickly became more elevated as she began turning to higher-end designers for red carpet looks. One such look that I think of with great fondness is the one she adopted for her appearance at the 2008 Academy of Country Music Awards—the night she won her very first statuette from the academy in the New Female Vocalist category. The awards took place six months before the release of *Fearless* and four months before the world was about to be swept up in the wide-eyed whimsy of "Love Story." Looking back, it also felt like a hint about what was to come.

Her signature curls were swept into a soft updo that was more brushed out and—to use a technical term—swoopier than the stiffer, defined ringlets of her debut era. Her strapless Marchesa gown was gathered at the bodice, with a white chiffon skirt that summoned the aesthetic of a flowing Grecian style. The gown's only embellishments were the subtle floral appliqués and gold trim at her sweetheart neckline. The effect was more polished princess than fresh-faced small-town dreamer. Taylor had officially parted ways with the strip-mall prom store of her past.

(OPPOSITE) This Jenny Packham dress, worn to open the Fearless Tour during a quick on-stage costume change (next page, far right), acts as a bridge between the previous era's countrified sundresses and the *Fearless* era's affinity for more streamlined and sparkly dresses. Those spangled appliqués remind me of a western shirt with fringe and tassels, but retrofitted for a teenage girl's closet. The overall silhouette is familiar (a dress and boots), but the effect is sleeker and fashion-forward, particularly in comparison to the paisley and corsets of years past—which we're now permitted to (lovingly) shudder at in fond (but gratefully distant) memory.

(RIGHT) The exact origins of the hand heart are murky, but Taylor definitely played a role in its popularization (in any event I'm thanking Taylor for its convenient emoji form now). It became a signature of hers during the *Fearless* era, beamed out during tour performances and interviews to a happily reciprocating crowd. "The heart-hand symbol means something between 'I love you' and 'thank you,'" Taylor said to the *New York Times* back in 2011. "It's just a sweet, simple message that you can deliver without saying a word." This particular Marc Bouwer dress was a sparkly (and therefore Taylor-approved) take on a classic little black dress. It survived getting drenched every night during her rain-machine performance of "Should've Said No," which she first iconified at the 2008 Academy of Country Music Awards. That performance was so good and so memorable that its live iteration also served as the song's official music video. The theatrics of the performance were indeed so unforgettable that Taylor herself deemed it worthy of a cheeky self-reference and gave it a revival in the "Anti-Hero" music video, released as the lead single for her 2022 album, *Midnights*.

(FAR RIGHT) What is high school if not a breeding ground for dramatic love stories worthy of a Shakespearean play? Costuming is a cornerstone of *Fearless*, as seen in the juxtaposition of campy band uniforms, like this one by Tommy Keenum, which opened the Fearless Tour, and the gigantic hoop-skirted ball gowns that would follow. It's the progression of a teenage girl obsessed with the concept of an idyllic storybook romance but whose reality with one-sided crushes as a high school student just wasn't stacking up. If Taylor's debut fashion was about creating a visual uniform, her sophomore effort was about donning various costumes. *Fearless* saw Taylor, having already effectively communicated a visual identity, beginning to feel comfortable enough with her image to play, to masquerade, and to step into different characters as a way to illustrate her music—a trend she would come back to later in her career when exploring more fabled avenues of storytelling.

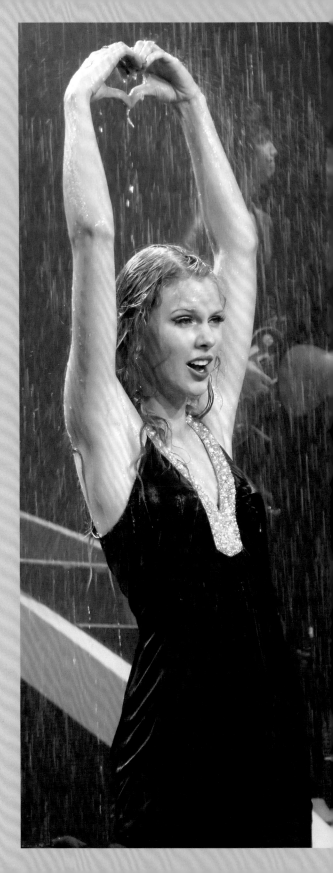

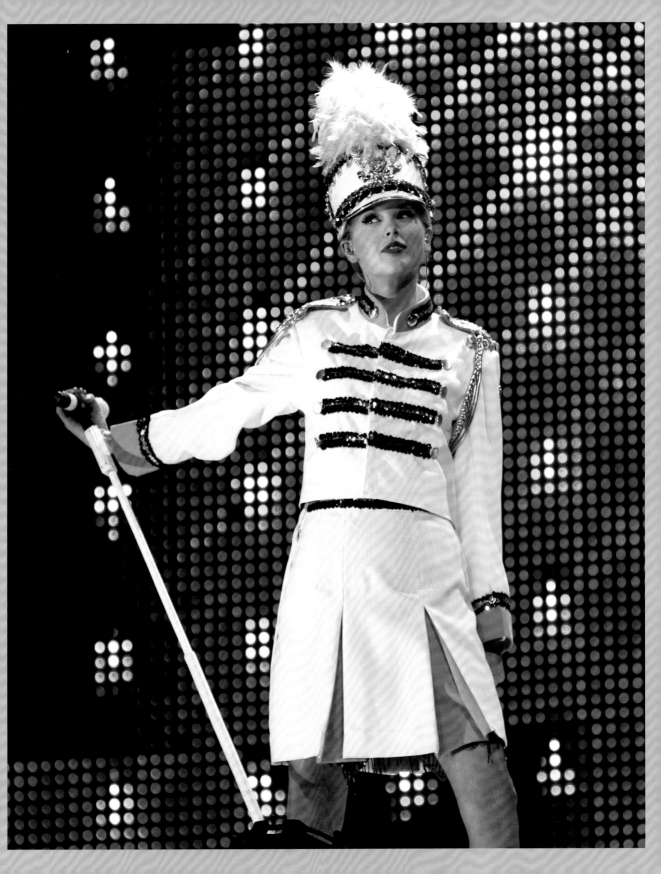

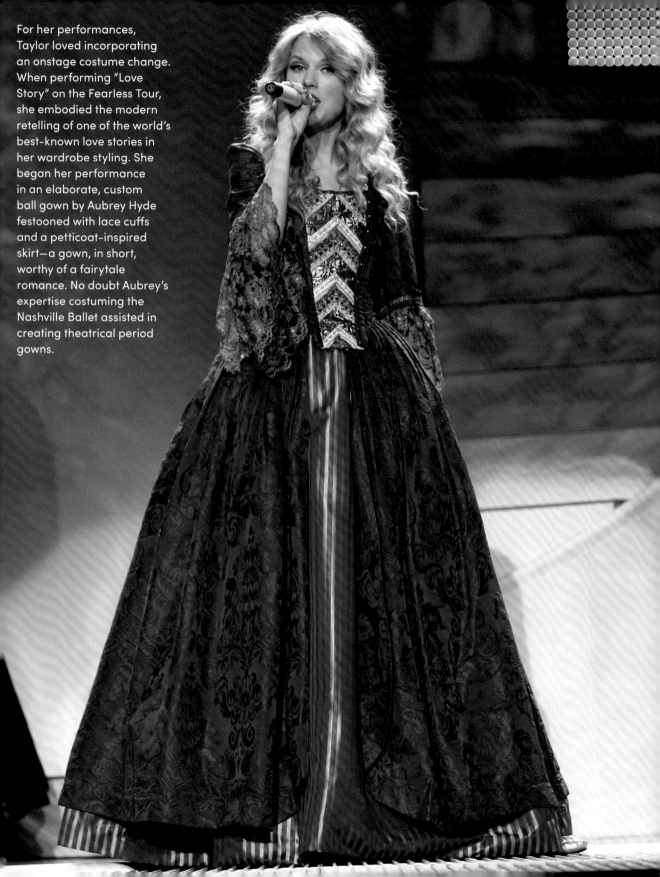

For her performances, Taylor loved incorporating an onstage costume change. When performing "Love Story" on the Fearless Tour, she embodied the modern retelling of one of the world's best-known love stories in her wardrobe styling. She began her performance in an elaborate, custom ball gown by Aubrey Hyde festooned with lace cuffs and a petticoat-inspired skirt—a gown, in short, worthy of a fairytale romance. No doubt Aubrey's expertise costuming the Nashville Ballet assisted in creating theatrical period gowns.

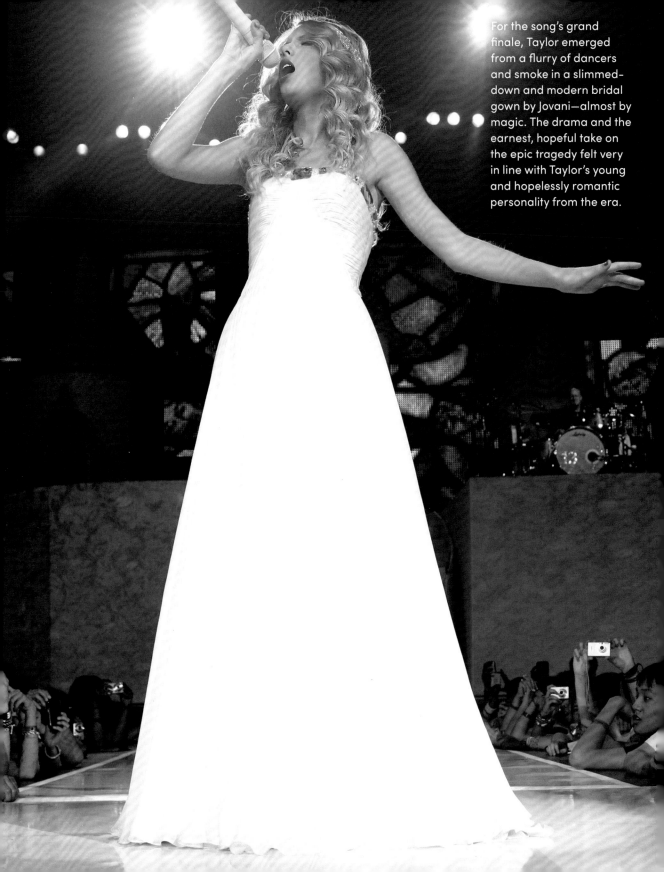

For the song's grand finale, Taylor emerged from a flurry of dancers and smoke in a slimmed-down and modern bridal gown by Jovani—almost by magic. The drama and the earnest, hopeful take on the epic tragedy felt very in line with Taylor's young and hopelessly romantic personality from the era.

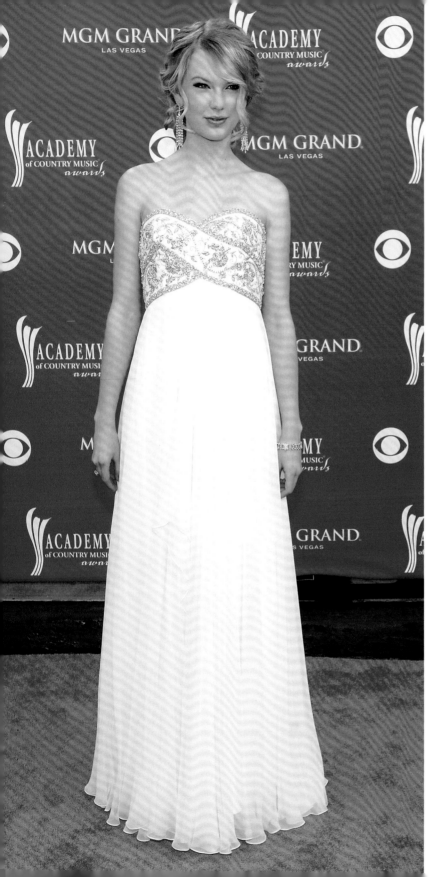

To accept her very first Academy of Country Music Award win, Taylor stepped up her fashion game from the year's previous outing, when she had worn a custom—and tragically prom-like—Sandi Spika gown. This Marchesa gown, while also strapless, was a slimmed-down and less literal translation of her princess-style dreams. Everything about it, from the neckline to the hair, feels softer and more refined. Her eyeliner is applied with a lighter hand, her curls more diffused. And all the fussy details of the corset and train and boning from the Spika dress are hacked away for a pared-back, but no less regal, look.

Her teary acceptance speech quickly reminded everyone that she was still just a girl on the precipice of her career taking off. She kept it short and sweet, shakily and adoringly saying, "There are so many people that deserve to be thanked for this, but I'm just going to thank one. And that's the person that used to love to go to lunch with her friends, and cook dinner for her family, and sleep in her bed every night. And she gave that all away and left it all behind to go on the road with her sixteen-year-old daughter." Looking out into the audience, she finished, "Mom, thank you so much. I love you. This is for you."

During the *Fearless* era, Taylor hired Joseph Cassell as her dedicated stylist to formally coordinate her fashion choices. Filling this role was a significant part of transitioning her image, and she still works with him to this day. Joseph's relationship with Taylor was sparked by their mutual overachieving work ethic. Having left the music business in 2008, the former artist and repertoire director had set his sights on starting his own business in wardrobe styling. At the time, his agent had procured him a rudimentary job, steaming and pressing garments on the set of a shoot for an unassuming young country singer. To *The Hollywood Reporter*, in a 2013 article documenting the year's most powerful stylists, Taylor noted, "Joseph arrived with a full wardrobe of options and shoes, which was a good thing because the stylist at the shoot had dropped the ball."

She described him as someone constantly anticipating her needs ("He's always two steps ahead of me"), with multiple backup plans and options, so it's not a surprise that two masterminds anticipating any number of scenarios and crafting solutions for them would find one another.

Under his direction, Taylor's garments began to include more pieces fresh from designer runways. These were mixed in with the high street brands she already knew and loved to maintain her approachable image and transition her style more carefully into its new, elevated status. With his dedicated oversight, the shift signaled an approach to her fashion that was more curated and reflected the level of intention and care for each respective era's visuals that Taylor had already been developing, but raw and unformed, in her earliest years.

Taylor's candid style during the *Fearless* period often included schoolgirl-esque silhouettes. These youthful outfits felt like fresh air that spun the grossly sexualized "schoolgirl" costume of the time back to its rightful place. Rather than catering to the male gaze, her schoolgirl looks were cute, smart, and modest. Items like lace-up brogues, opaque tights, knee-high socks, pleated skirts, double-breasted coats, blazers, and crisp white button-ups with crest insignias all projected an image of youth and naivete. It was the image of a young teenager attending a private prep school à la *Gossip Girl* . . . one who also happened to be performing at the Grammys on weekends. Designer accessories like Christian Louboutin oxford heels were brought down to earth with more affordable pieces like a green leather hobo bag by French Connection. A simple dot shirt by Bassike was elevated with a flippy Ted Baker skirt, cropped Hanii Y blazer, and heels. Or a crisp white button-down by Ralph Lauren was mixed with a chambray skirt and chic tall leather boots. This kind of high/low mixing continues to this day and is part of what makes Taylor's fashion so interesting to watch (and possible for some fans to replicate). It's a careful balance that keeps her style both aspirational and imitable for fans.

(Forever &) Always Accessorizing

Stepping into a new phase of her career took a more literal turn as she carefully and consciously reframed her footwear. Both on- and offstage, the chunky cowboy boots that she had been known for reformed into sleeker leather boots on stage and heeled pumps on the streets. The heel felt like a watershed accessorization choice. It delineated the growing confidence, curiosity, and desire to establish a new identity and shed girlish first impressions. Taylor noted to *InStyle* in 2009, "I went through a phase where I wouldn't wear [high heels] because I felt like a giant giraffe. Now I love to wear heels." It also was a symbol of country sentiments metamorphosing to pop.

(OPPOSITE) The platform peep toe, typically by the likes of Christian Louboutin or Jimmy Choo, was a favored silhouette for Taylor to pair with sweetheart mini dresses like this one. This transition feels like one any teenage girl with limitless fashion brands at her disposal would jump at the chance to play with—like a high-stakes game of dress-up come to life. The dramatic fan of the false eyelashes, the gold lamé foil finish of her Rebecca Taylor mini, the adorably outrageous bow detail, and the complementary gold platforms are small details that evoke the joy of playing with fashion and as a result fill me with such delight.

"I went through a phase where I wouldn't wear [high heels] because I felt like a giant giraffe. Now I love to wear heels."

—Taylor Swift, *InStyle*, 2009

(LEFT) Upping the stacks. In Taylor's early days of accessorizing, she was prone to layering on an armful of bracelets that maintained a country tinge to her outfits thanks to textural interplays of natural materials that were woven, beaded, or leather. In later years, her bracelet lore would expand to include homemade friendship bracelets worn by fans to her concerts. They were typically worn on her left wrist so as not to impede the strumming of her twelve-string guitar. During a CMA Music Festival interview in June 2008, her accessories also acted as a built-in billboard for her next musical endeavor three months before dropping the lead single "Love Story." Can you spot it?

(RIGHT) The varsity stripes on Taylor's comfy Rag & Bone cardigan are sweet and collegiate, but the best moment of this outfit is the blue satin flats by Urban Outfitters that she wore on repeat in the spring of 2009. These shoes retailed with the phrase "fairytales are true" scrawled on the inner sole—which I'm sure captured Taylor's romantic-at-heart nature and carries with it proof of Taylor's intentional and highly personal approach to style, even down to minute details.

(FAR RIGHT) Taylor paid homage to country icon George Strait as part of an Artist of the Decade tribute concert. Her cover of his song "Run" is still one of her most underrated live performances. She had opened for George at age sixteen, so this performance was very much a full-circle moment for her. She wore a sweet bell-sleeved mini dress and cowboy boots (a classic debut-era combination), but gave it that subtle, *Fearless* touch via bohemian sparkle thanks to a crystal headband—one of Taylor's favored accessories during that time period.

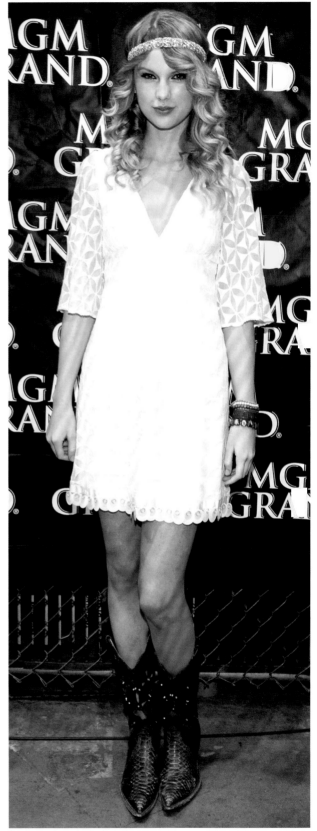

"I think it's kind of fun when the spotlight hits you and your dress, for a millisecond, blinds people."

All That Glitters Is in Taylor Swift's Wardrobe

Taylor Swift has yet to meet a sequin she has not loved. It is a simple, consistent fact that if it is shiny, Taylor will probably wear it. Appropriately, as her star began to shine more brightly on a wider stage, her love for anything that glittered ascended to a new level. *Vogue* once sagely asked, "Has anyone ever made more of the sparkly little dress?" Taylor concurred, telling the magazine, "I just love them. Especially onstage, because I think it's kind of fun when the spotlight hits you and your dress, for a millisecond, blinds people."

Being nominated among, and winning against, men multiple times her age was not foreign to Taylor. At the 2009 Country Music Association Awards, she not only swept in all the categories she was nominated for; she also took home the night's biggest award: Entertainer of the Year. Taylor's fellow category nominees, Kenny Chesney, Brad Paisley, George Strait, and Keith Urban (median age at the time: 41.5 years old), applauded Taylor's win as the chorus of "Fifteen," a song written about the memories and lessons learned in her freshman year of high school, played out. Her gown emphasized her youth and femininity while also tying into the fairytale precedent of *Fearless*'s fashion. In a cloud of golden tulle, she hiked up the fluffy skirt of her Reem Acra gown to climb onto the stage to accept the award. The win made her the youngest person to ever be nominated for—and win—that award.

This gown brings up, in the best possible way, saccharine visions of sparkly cupcake liners or bubbly champagne flutes fizzing. It bottles the feelings of potential and sweetness, which seems only right as a way to embody what was just the start of her domination of country music and beyond. Enveloped by the live musicians who accompanied her on the Fearless Tour, Taylor said, "I will never forget this moment. Because in this moment everything that I ever wanted has just happened to me. . . . And the fans who come to the shows with the shirts you make yourself and the looks on your face, that's why I do this." The shirts she mentioned are a reference to the very popular DIY tour costume fans created as homage to the Sharpied T-shirt in the "You Belong with Me" music video. Even on one of the biggest nights of her career, she threaded the connection she has with her fans and her lovingly imitated fashion into her speech.

"I love things that sparkle."

Taylor has gone by many nicknames over the years. Tay. Tay Tay. T-Sweezy or T-Swizzle, depending on your preference. To her fans, Blondie. To her brother, Teffy. But it's possible her least well-known nickname is Magpie. And it's possible that's because I'm the only person who calls her that, and I only do it inside my head. And it's because Taylor Swift, much like a magpie, has always been drawn to all things that sparkle. This love manifested itself most fully in her *Fearless* fashion when she (mostly) put to rest (thankfully) those, ahem, pastoral paisley prints and embraced her love of all that glitters. To replace BCBG Max Azria, Jenny Packham and Jovani entered her rotation for performance dresses. To *M* magazine in 2008 (add one point to your total score if they joined the ranks of *J-14* and *Tiger Beat* poster pullouts on your walls), Taylor said about finding the perfect outfit, "The dresses that I look for need to pop. The dress has to be a great color and it has to have sequins. I love things that sparkle."

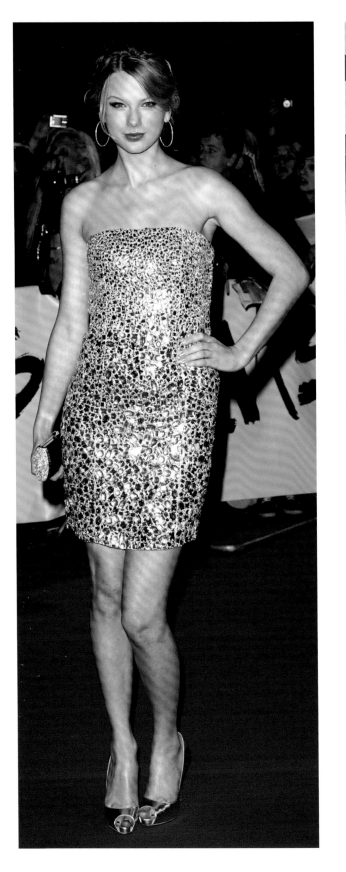
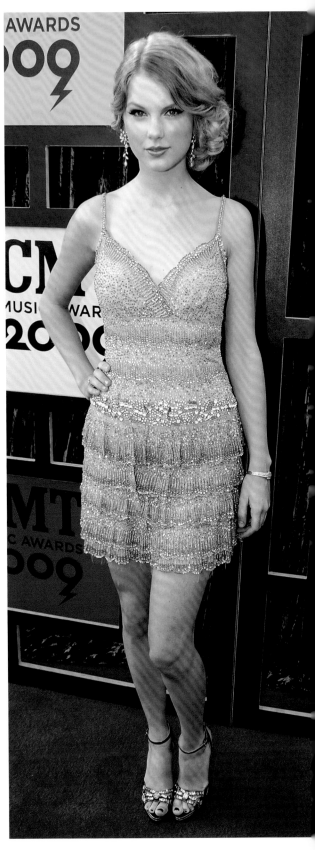

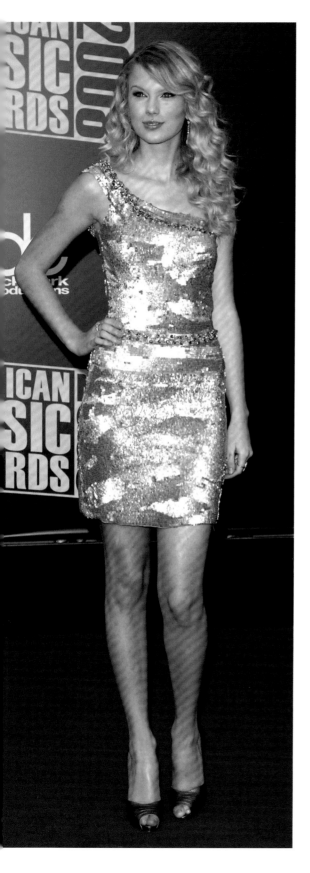

Tell me your pupils didn't just dilate staring at the effervescent joy of all this sparkle. Flirty, sparkly mini dresses became a reliable formula for Taylor, typically rendered in silver or gold metallics and often with a correlating pair of Christian Louboutin peep-toe pumps. These frocks to me bubble with the effort to always appear exuberant and happy. To *Us Weekly* in 2008, she would admit, "I always like to be dressy. The only time I'm insecure in an outfit is if I feel like I'm underdressed." Her 2022 song "mirrorball," a song that Taylor described as "a metaphor for [feeling] like [you] have to be different versions of [yourself] for different people," also seems to reference these iridescent styles and throws these seemingly fun party dresses and innocuous admissions of questioning her place in a new, refracted light. In her 2020 documentary, *Miss Americana*, during a montage of sequined and celebratory moments just like these, Taylor reflected on the fickleness of growing up female under the scrutiny of fame. "Everyone is a shiny new toy for like two years," she noted. "Female artists have reinvented themselves twenty times more than the male artists. They have to or else you're out of a job. Constantly having to reinvent, constantly finding new facets of yourself that people find to be shiny." In retrospect, I wonder to what extent she felt the performative pressure to "sparkle" in the spotlight— and dressed accordingly—and how much was simply a teen magpie naturally drawn to wearing pretty, sparkly things. Taylor wears: Kaufmanfranco dress with Christian Louboutin heels; Collette Dinnigan dress with Prada heels; Collette Dinnigan dress with Christian Louboutin heels.

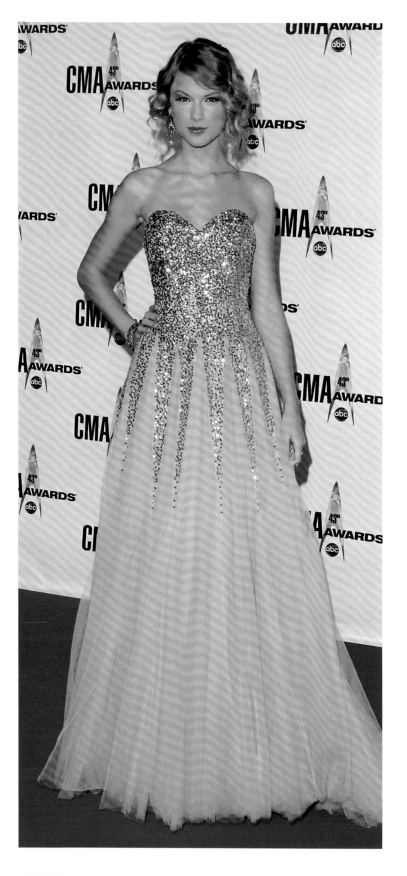

(LEFT) A leveled-up princess look that continued to embody the themes of sweet, soft, and fairytale whimsy so present during the *Fearless* era. The overall warm, golden tones of this Reem Acra gown also feel like a nice thematic nod to the amber-tinged album cover and the golden-yellow hue fans typically associate with the *Fearless* era as a whole.

(OPPOSITE) Some purists say you shouldn't mix metals. But Taylor Swift built her career on defying odds and expectations. She's a rare breed who (of course) looks good in both gold and silver. During the *Fearless* era she not only wore every sequined mini she could find; she also wore some noteworthy metallic floor-length gowns as well. For her first-ever appearance at the famed Costume Institute Gala (a fundraiser held at the Metropolitan Museum of Art's Costume Institute in New York City, and often regarded as the most important fashion event of the calendar year), Taylor wore a shimmering Badgley Mischka gown from the designer's Fall 2008 collection. She would have significantly more remarkable outings at this particular event in later years—but for a first-timer, her glam curls and the ombré-like gold effect of the gown is nice enough if barely on-theme (attendees were supposed to comply with a "superhero" motif that evening). Her custom silver gown, by Kaufmanfranco, at the 2008 CMAs was, in my opinion, more successful. The decision to go relatively bare on jewels (with the exception of some understated diamond studs) was the right call to let all the sparkle get delivered by the gown itself. Decidedly less prom-like than her red carpet appearances in the past, and slightly more daring thanks to mesh details at the strap and sternum as well as a fully open back, this gown, to me, signified a princess seeking to party.

Mama Swift

Taylor and her mother, Andrea, share an incredibly close bond that is practically Gilmorian. Although Andrea was chaperone to Taylor's famously spunky walks into Nashville studios to hand her childhood demo CD to recording-studio receptionists, an overbearing stage mom she was not. Andrea's omnipresence in Taylor's career and her appearances in Taylor's music over the years are driven purely by the genuine mother/daughter connection they have.

Taylor's early interviews are dotted with anecdotes of her mom championing her musical aspirations. To *Entertainment Weekly* in 2008, Taylor recalled, "When I was 10, or younger than that, even, I would watch these biographies on Faith Hill or [The] Chicks or Shania Twain or LeAnn Rimes, and the thing I kept hearing was that they had to go to Nashville. I took my demo CDs of karaoke songs, where I sound like a chipmunk—it's pretty awesome—and my mom waited in the car with my little brother while I knocked on doors up and down Music Row. I would say, 'Hi, I'm Taylor. I'm 11; I want a record deal. Call me.' They didn't." In that same interview, Andrea commented, "[Taylor is] just very

sure of who she is. She's been that way since she was tiny. I don't know why; it's nothing I did, and when I was her age I was doing everything I could to fit in. It's not stubbornness, just sureness. And she's self-governed because she chooses to be."

More important, Taylor's relationship with her mom often acted as the levee that staved off middle school bullying and isolation. "My mom and I have always been really close. . . . There were times when, in middle school and junior high, I didn't have a lot of friends. But my mom was always my friend. Always," she told the GAC network in 2008. Like all relationships in Taylor's life, the one she has with her mom has been documented in her music. "The Best Day," off *Fearless*, was written and played for her mom as a Christmas present. The accompanying video, made with self-edited family home movie clips, would later serve as the song's official music video. To *Seventeen* magazine in 2008, Taylor recalled the real-life events that inspired the song, describing an ill-fated trip to the local mall, where Taylor and her mom ran into girls from her school who had used fake excuses to rebuff Taylor's invitations

(OPPOSITE) Taylor has had many "best" days with her mom, but chief among them have been when Andrea gets to stand by and watch her daughter shine under stage lights while accepting yet another accolade. At any given awards show over Taylor's career, one of the most consistent and satisfying games to play is Where's Waldo (Andrea's Version). She is most often spotted somewhere in Taylor's row, usually wearing a mostly black outfit, her own sartorial method of letting her daughter take center stage.

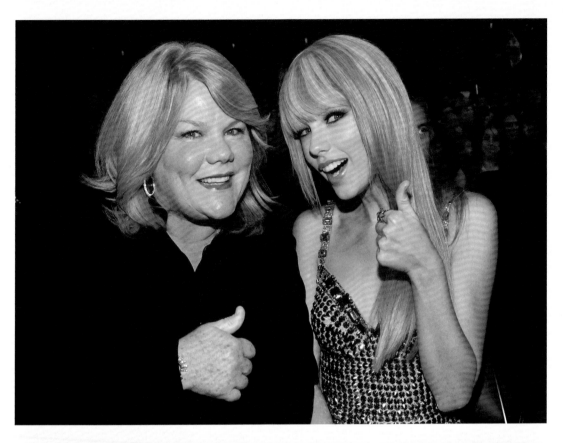

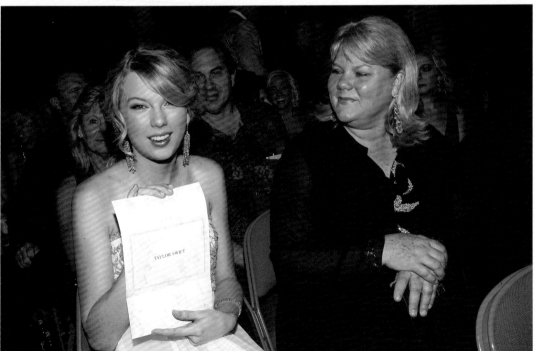

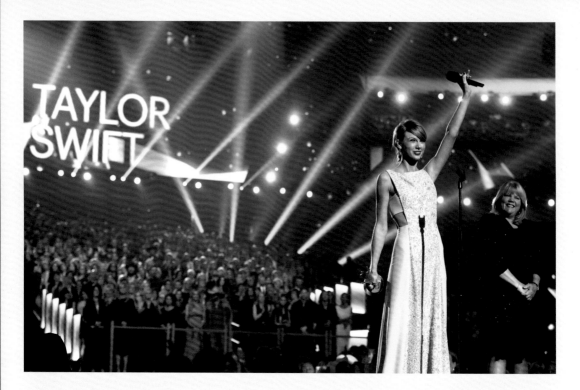

TAYLOR SWIFT

Taylor, ironically, received her Fiftieth Anniversary Milestone ACM trophy in 2015, the year after she released her first exclusively pop-billed album, *1989*. The country music industry, in desperate *Godfather* mode, was doing all it could to pull her back in. Her pale-blue Reem Acra gown subtly alluded to her new pop persona (and its associated crop-top sets) with its side cutouts and bandeau-like detail. The deeply side-parted updo was an incongruous and overly mature styling choice. She's one aggressive back-comb hair tease away from Karen territory.

to hang out. The initial humiliation of being intentionally ostracized by her peers was quickly turned around when Andrea tactfully changed plans and suggested going to the King of Prussia mall instead. "[It's] the best mall in the whole state. We drove an hour to get there, and we had the time of our lives!" Taylor said. "I realized my mom was the coolest person in the world for not making me stay in that mall and suck it up and go on with things. She let me run from my pain for a little bit, and I thought that

was the nicest thing that she ever could have done."

In 2015, Andrea gave the keynote speech to present Taylor with the Academy of Country Music's Fiftieth Anniversary Milestone Award—an honor given to a country act for outstanding achievement in the field of country music during the preceding calendar year. "I've watched this milestone artist from the time she was a tangle-haired little girl growing up on our farm, full of imagination and creativity.

Until right now as she prepares for her next world tour. And ever since then, her favorite thing in the world to do has been to write a song, tell a story, play a guitar, or piano. I've seen those things carry her through every emotion, every experience in her life. Good or bad," said Andrea, eyes shimmering with tears, shots of her interspersed with cutaway close-ups on Taylor's face—looking every bit a bashful teacher's pet being crowed about in class amid their peers. You could practically see the mewling "Mom, you're embarrassing me" protestations in her mind.

"For many years, I was her constant companion and I witnessed a young girl with very few friends become a young woman with many. . . . Like many of you tonight with children of your own, I am a very proud mom," she said. When Andrea finished with a reference to fans, expressing gratitude to them for loving Taylor as she loves her, it was like a call to arms for every fan willing and ready to jump in the line of any fire to be on Taylor's side.

Taylor's connective tissue through her maternal line extends to her grandmother Marjorie Finlay, the namesake inspiration behind *evermore*'s "marjorie." Andrea's mother was an opera singer, so Andrea walks through this world sandwiched between musical talent, a simultaneous product and creator of it. In an interview with Zane Lowe, Taylor expressed being a "wreck" during both the writing and the recording of "marjorie" over the unwavering kinship she felt for her grandmother and the quiet presence Marjorie had continued to exert on Taylor's life ever since she passed when Taylor was thirteen—incidentally

while Taylor was on a trip to Nashville handing out CDs of her demo to record labels. Taylor observed, "My mom will look at me so many times a year and say, 'God you're just like her' when I'll exhibit some mannerism that I don't recognize as anything other than mine. . . . I've always felt like she was seeing this"—"this" being Taylor's continuation of the dreams her grandmother first had of musical greatness. Marjorie is a credited vocalist on the song, her operatic vocals ascending in the third verse. "My mom found a bunch of old vinyls of her singing opera, and I sent them to Aaron [Dessner] and he added them to the song. It's moments like that on a record like your whole heart is in this whole thing that you're doing. It's all of you that you put into these things."

Andrea is a constant North Star in Taylor's fandom, beloved and instantly recognizable even in a stadium full of devotees. When you're around her, it's not a chore to imagine where Taylor gets her warmth and magnetism. Andrea is a fixture during tour season, playing a huge role in hand-picking the most excited of fans for meet-and-greets following a show. It's no doubt that the allure of the postconcert party—which shifted over the years in name for most of Taylor's headlining tours (T Party to Loft '89 to rep room), but not in experience (a cozy, homemade-cookie-filled backstage cove for one-on-one time with Taylor)—is a driving factor in the presence of costumes, fairy light–festooned posters, and decibel-breaking screams that define the Taylor Swift live experience.

Fearless, as an album, narrates the progression of a young, hopeless romantic coming into her own and discovering the hard truths and flat-out falsehoods of the fairytales she believes in. As they do in any fairytale, both hardships and happy endings play equal roles in the story.

Like sparkling bookends, two gowns in particular provide the backdrop representing the highs and lows of Taylor's life during this time period—both of which happen to be by the same designer, Kaufmanfranco.

The first she wore to the MTV Video Music Awards in September 2009, where she showed up on the red carpet in a horse-drawn carriage seemingly ripped from the pages of *Cinderella*—a true fairytale come to life. Her gown for the evening was a one-shoulder piece from Kaufmanfranco's Resort 2009 collection with silver sequins rippling across a taupe lining and a single strap pulled diagonally across the back to create a draped cowl—the effect like a modern Greek statue, only glittery. Her signature red lip even perfectly complemented the red carpet and signage of the VMAs. It was a night that would go on to live in infamy when Taylor won Best Female Video for "You Belong with Me," and Kanye West made his differing opinion known for millions to hear when he interrupted her mid–acceptance speech to announce that he thought Beyoncé should have won instead for "Single Ladies."

Time slowed. Acknowledgment sank in. Applause turned to jeers. Taylor stood limply in disbelief, microphone in hand—but with no words left to say. The clock struck midnight, and her carriage turned back into a pumpkin; a fairytale failed.

To *GQ* in 2015, Taylor recalled the feeling of that moment. "When the crowd started booing, I thought they were booing because they also believed I didn't deserve the award," she admitted. "That's where the hurt came from. I went backstage and cried, and then I had to stop crying and perform five minutes later. I just told myself I had to perform, and I tried to convince myself that maybe this wasn't that big of a deal."

Four months later, a new year in a new dress at a new awards show. Taylor eschewed her usual gold or silver metallic options and appeared instead at the 2010 Grammys in a fitted, off-shoulder, navy sequin Kaufmanfranco gown with a notch cutout at the neckline and a completely open low back, slashed across the shoulders by a modern strap reminiscent of her previous Kaufmanfranco at

"When the crowd started booing, I thought they were booing because they also believed I didn't deserve the award."

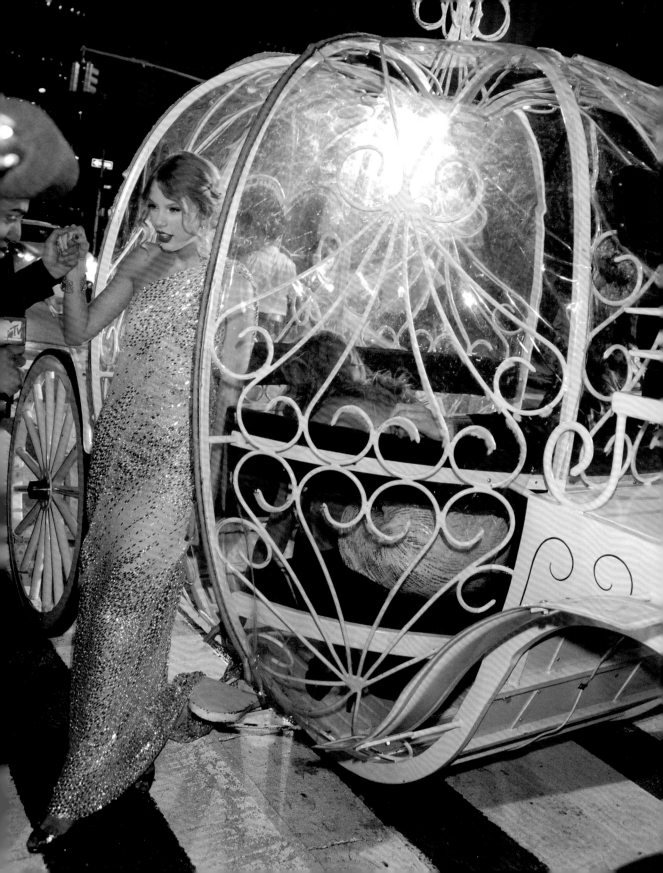

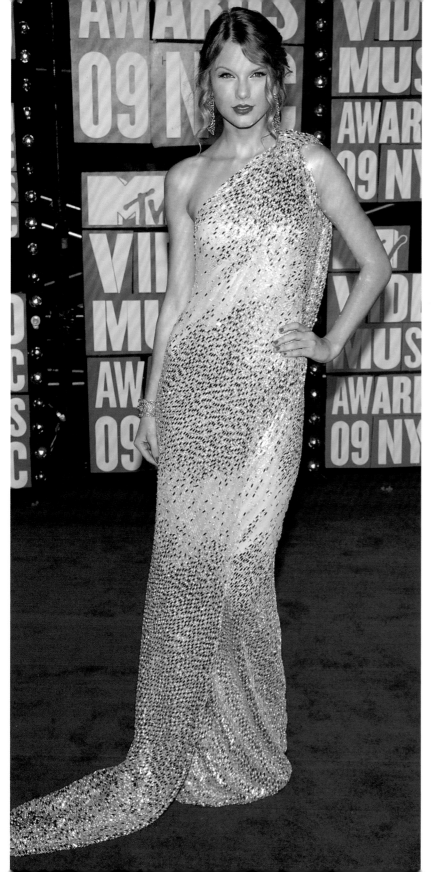

That day *was* a fairytale—just past tense. Up until the confusing heartbreak when her moment became forever tainted, there was the warm rush of a whimsical arrival and the delighted triumph of winning her first MTV Video Music Award.

the VMAs. It was a gown that was custom made for her, but reproduced in later years in a classic black. In this gown she not only broke her expected sartorial patterns; she also broke a record and became the youngest recipient of the Grammy Award for Album of the Year for *Fearless*. (This record was broken by Billie Eilish in 2020.)

When accepting the award, Taylor understandably gushed over the honor. But her words subtly carried the foresight of someone determined to write her own history. There's a quiet sense of empowerment and hope for the future that one day her successes would eclipse her darknesses—like that humiliating moment just a few months prior. "This is the story that all of us, when we're eighty years old and we are telling the same stories . . . to our grandkids, this is the story we're going to be telling over and over again," she said. In that moment of victory, she chose to idealize her life's story as one of hard work and perseverance paying off.

(OPPOSITE) This blue gown is forever solidified in Taylor's fashion history as the one she wore when she was awarded her first Grammy for Album of the Year. It's sequined, as expected. But its off-shoulder neckline, geometric cutout, and dramatically low back feel simultaneously restrictive and confining yet also open and vulnerable—an interesting contrast to think about for a tenderhearted singer-songwriter at the outset of pushing the boundaries of what it means to be a country singer. The color is also unexpected—neither gold or silver metallic nor a soft pastel nor even a sepia-toned yellow (for a thematic callback to the *Fearless* album cover). In every way, this gown feels as unprecedented as her historic win from that night.

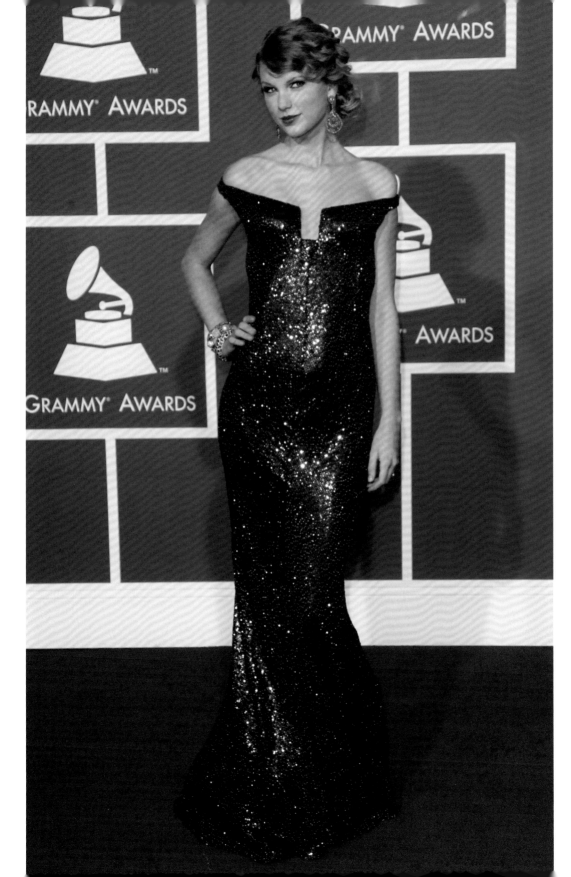

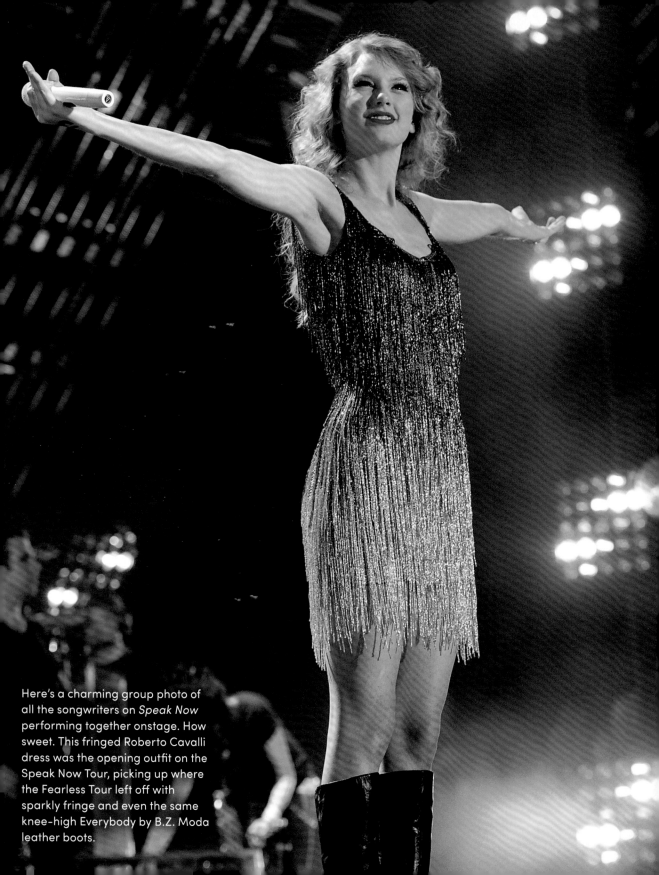

Here's a charming group photo of all the songwriters on *Speak Now* performing together onstage. How sweet. This fringed Roberto Cavalli dress was the opening outfit on the Speak Now Tour, picking up where the Fearless Tour left off with sparkly fringe and even the same knee-high Everybody by B.Z. Moda leather boots.

3

Speak Now

SYMBOLICALLY WEARING THE PANTS, PHYSICALLY WEARING A DRESS

SPEAK NOW IS AN ALBUM OF DEFIANCE WRAPPED IN TULLE AND PRESENTED IN an ultrafeminized package. It feels like the work of an artist beginning to earnestly push back against public comment (and critique) in a way that is uniquely whimsical and innately girlish.

The lead single for *Speak Now*, "Mine," is a great example. At first listen, it sounds like a classic cotton-candy-spun song of a mistrustful girl finding true love—and taking a leap of faith to follow it. Its music video even includes a picture-perfect church wedding, complete with Taylor in a strapless white Reem Acra bridal gown. "Mine" takes the fairytale precedent set in "Love Story" and adds modern window dressing and a poppier production. It begins to chisel at the round pop music peg that could no longer be contained by the square

hole of country music. The next single, "Back to December," is a confessional piano ballad. A first for her, it's a musical apology where she admits her own missteps that brought about the end of a relationship, flying in the face of accusations that she exclusively defaults to playing the victim. The twangy, almost satirically countrified, banjo-led "Mean" is a snappy retort to criticism about her vocal ability in live settings. The lyrics from *Speak Now* reveal a sense of self-awareness that is more nuanced and more mature; they show a level of introspection that seems appropriate to the time of life the album documents: that unsettling period between girlhood and womanhood. The real thesis of the album is buried halfway in the tracklist on the standard version with the plaintive "Never Grow Up"—an acoustic letter mournfully penned to the inner child she lost in the events leading up to recording the album.

> *"It's fine to infantilize a girl's success and say, . . . 'How cute that she's writing songs.' But the second it becomes formidable? . . . That wasn't as cool anymore."*

Originally, the album was going to be titled *Enchanted*, but under advice from her label head, Scott Borchetta, Taylor pivoted and changed the name. Scott spoke about the decision to *Billboard*: "We were at lunch, and she had played me a bunch of the new songs. I looked at her and I'm like, 'Taylor, this record isn't about fairy tales and high school anymore. That's not where you're at.'" And frankly he was right. *Speak Now* captures growth and themes about love that had evolved past the fantasy trappings of *Fearless*. It's an album defined by the loss of faith in fiction—the sort exemplified by a desperate clinging to the broken promises of happy endings. In my view, *Speak Now* is Taylor's definitive singer-songwriter album.

When she was a fresh-faced teen, her confessional lyrics were charming, but according to critics they lacked real bite. Now, lauded with hardware from the Recording Academy that solidified her writing skills and the overall quality of her work, her personal stories written in looping, fountain-penned handwriting were a nuisance—annoying public ploys for attention. "It's fine to infantilize a girl's success and say . . . 'How cute that she's writing songs.' But the second it becomes formidable? . . . That wasn't as cool anymore," she observed to *Vogue* in 2019.

At the ripe age of twenty, Taylor sensed the shiny appeal of her early-teen ingénue years waning and heard the whispers of doubt about the provenance of her songs—and whether she was the one who actually wrote them. Ahead of the release of *Speak Now*, *Billboard* wrote that the project would be pivotal to proving her creative prowess and progress. "Music history is littered with teen stars who were unable to maintain their commercial pace once they hit their 20s," they wrote. Rather than playing it safe, Taylor took a leap with *Speak Now*, leaving behind the cowriters and collaborators of her past to write the album entirely by herself. During her acceptance speech for *Billboard*'s Woman of the Decade Award in 2019, Taylor observed that she didn't know it at the time, but she felt in retrospect that those public murmurings were a result of "just what happens to a woman in music if she achieves success or power beyond people's comfort level." This business-forward positioning was neither new nor unspoken by Taylor. When she was recognized as the then-youngest Woman of the Year by *Billboard* in 2011, she made reference to having always been in the driver's seat of her career and projecting months—if not years—into her future. "I know exactly where I'm going to be next year at this time," she said. "That's because I'm sitting there in those management meetings every single week and scheduling everything and approving things, or not approving things, based on what I feel is right for my career at this point."

The tracklist for *Speak Now* makes it evident that the album reflects an artist creating art in response to something. "This was the decade when I became a mirror for my detractors. Whatever they decided I couldn't do is exactly what I did," she said to *Billboard*. "When *Fearless* did win Album of the Year at the Grammys and I did become the youngest solo artist to ever win the award, with that win came criticism and backlash in 2010 that I'd never experienced before

as a young new artist. All of a sudden people had doubts about my singing voice, was it strong enough? Was I a little bit pitchy? All of a sudden they weren't sure if I was the one writing the songs because sometimes in the past I had had co-writers in the room."

The key defensive strategy she employed with *Speak Now* was to create a rebuttal so complete it would silence any questions about her songwriting. "I've had several upheavals in my career. When I was 18, they were like, 'She doesn't really write those songs.' So my third album I wrote by myself as a reaction to that," she said to *Rolling Stone* in 2019. In a live web chat with fans to announce the album in July 2010, she said, "I wrote all the songs myself for this record. . . . I'd get my best ideas at three a.m. in Arkansas, and didn't have a cowriter around, and I'd just finish it. And that would happen again in New York; that would happen again in Boston; that would happen again in Nashville." The result is a loose concept album, each song a personalized message to a single recipient. "I think [the title is] such a metaphor, that moment where it's almost too late, and you've got to either say what it is you are feeling or deal with the consequences forever. . . . And this album seemed like the opportunity for me to speak now or forever hold my peace," she explained to Yahoo! Music of the album's conceptualization. On being direct with her words, Taylor told the *New York Times*, "I can say them at a business meeting. But . . . saying them to a person that I really care about . . . is a little tougher, because it doesn't have a first verse, second verse, and bridge." As her own best storyteller, Taylor defaults to (and excels at) monologues over dialogues. Without a cowriter to mince her words, *Speak Now* is a dense, unfiltered account of a young woman's diary pages. Most of the album's songs are well clear of the four-minute mark, a testament not only to how much she wanted to say with this album, but also to the loyal and attentive audience she had cultivated who were ready and willing to listen.

"This was the decade when I became a mirror for my detractors. Whatever they decided I couldn't do is exactly what I did."

The Girl in the Dress

As a visual accompaniment to her first solo-written album, her fashion could have drawn strength from tailoring and sharp silhouettes, or from brash colors that naturally drew the eye. But instead of placing her power in borrowed-from-the-boys suited looks, she chose to lean in to being that "mirror" for her critics. The assumption was that a teenage blonde could not possibly be in charge. Couldn't possibly be—literally—writing her own destiny. In response, she redefined and rerooted her image in soft, girlish femininity, gravitating toward anything tulle and rendered in desaturated tones of purple, yellow, or peach. If it looked like a cake topper, Taylor Swift would wear it.

The most iconic is the purple chiffon halter dress she wore on the Speak Now Tour that she paired with demure Arika Nerguiz T-bar dance heels and a kicky ponytail that emphasized her face (and didn't interfere with the frock's tie straps). The dress was a creation of costume designer Eric Winterling, whose past credits include *Wicked* and more recently *The Marvelous Mrs. Maisel*. Working with stage artisans including tour designer Susan Hilferty on some of the Speak Now Tour costumes helped bring to life the whimsy and the theatrical drama that is so present on the album—and by extension its tour production. Eric told me that "a vintage dress was the source material" for the design.

If one could register this particular shade with Pantone, it would be called "Speak Now Purple"—such is the universal association of this outfit with that era (for me and for other fans). The custom dress by Eric Winterling played an integral role in the theatrics of the Speak Now Tour, where Taylor wore it for both her acoustic set—strumming a guitar in the shade of a slowly spinning luminescent tree on a B-stage while tens of thousands sang her words back to her, normal girly stuff—and also during the searing and pyrotechnic production of "Dear John," *Speak Now*'s signature and most eviscerating ballad. This is a song that would make lesser mortals find the nearest hole to lie in for a decade or five, but which instead made its thinly veiled namesake subject, John Mayer, write a song called "Paper Doll" a few years later that contained what seemed to be references to their love affair. The lyrics of "Dear John" are centered on an article of clothing (in a way that is criminally underrated compared to references to a certain scarf): a dress. At first, the dress reflects youth, inexperience, and naivete. It tells the story of a young girl taken advantage of and manipulated by an older man. But by the song's pronoun-swapping conclusion (Taylor quietly switches from "I" to "you"), the dress is refashioned as a symbol of femininity and power. It also looks super cute when framed by huge exploding fireworks—which was a bonus for the tour performance.

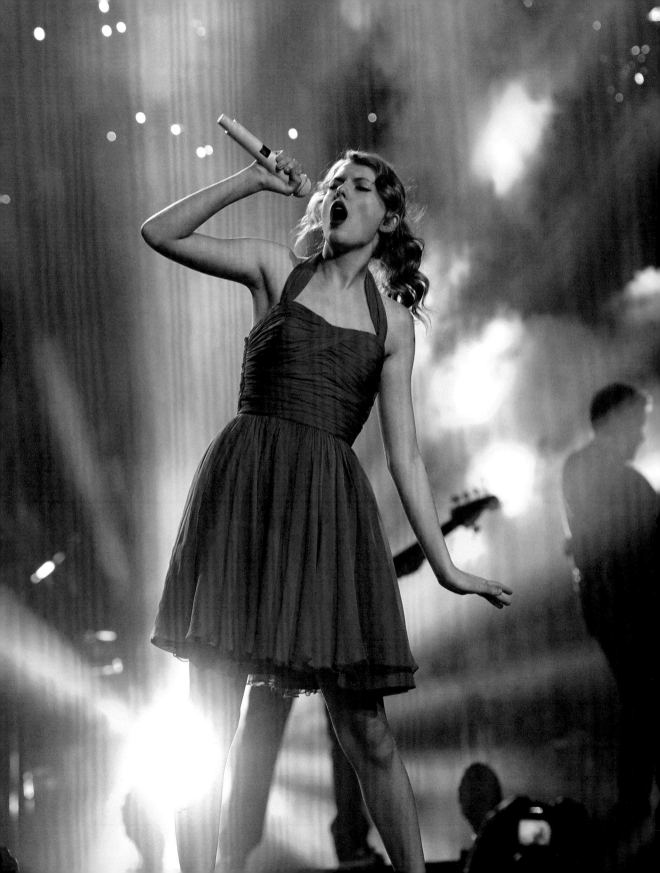

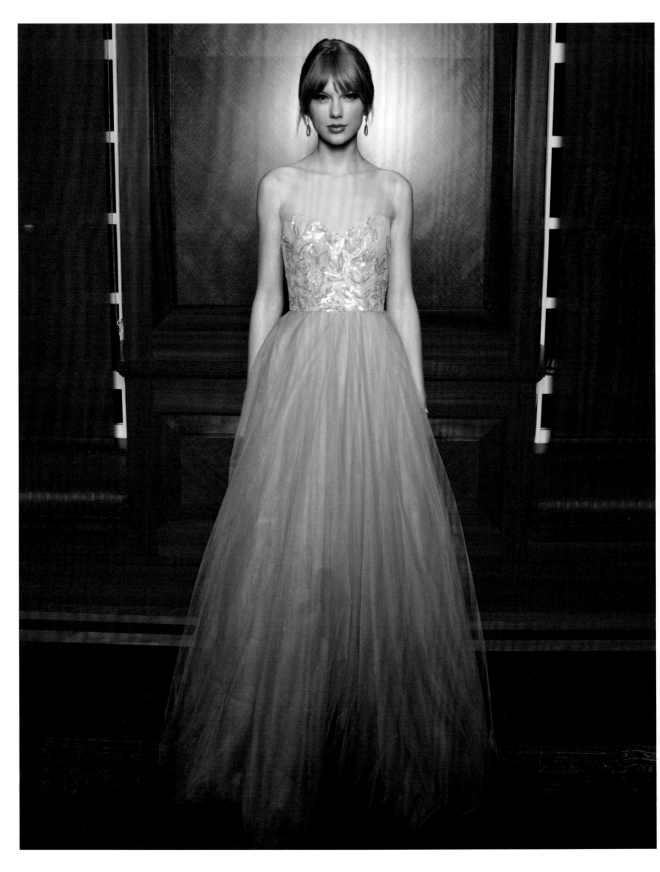

(LEFT) Reem Acra is one of Taylor's favorite designers for a sweet and feminine red carpet look—as seen here in the floaty tulle skirt and sparkly bodice of this ball gown. At the 2011 Symphony Ball in Nashville, Taylor wore the designer's flawless illusion-neckline gown, which gave the appearance of a sweetheart strapless silhouette. Taylor was bestowed with the Harmony Award, an honor given to artists recognized for their ability to harmonize between many different genres of music. It feels appropriate that this gown pulls in similar colorways that characterized her first two albums: an oyster blue and a warm golden taupe. Plus a little of that Swift Sparkle. I am also a proponent of the bare neckline because I find admiration in restraint.

(RIGHT) This Valentino ballgown served as the Speak Now Tour's closing ensemble—a fizzy and sweet final grasp of girlhood idylls on love. As an album, *Speak Now* begins the rabbit hole descent from wide-eyed girlhood notions of romance into the disillusionment brought on by the first forays into adult-sized heartbreak. But for one moment, this glitter and tulle couture confection swathes Taylor in a protective, wispy cloud worthy of a princess's happy ending, which Taylor confirmed to *Teen Vogue* in 2011 citing this as one of her favorites—"a total princess dress."

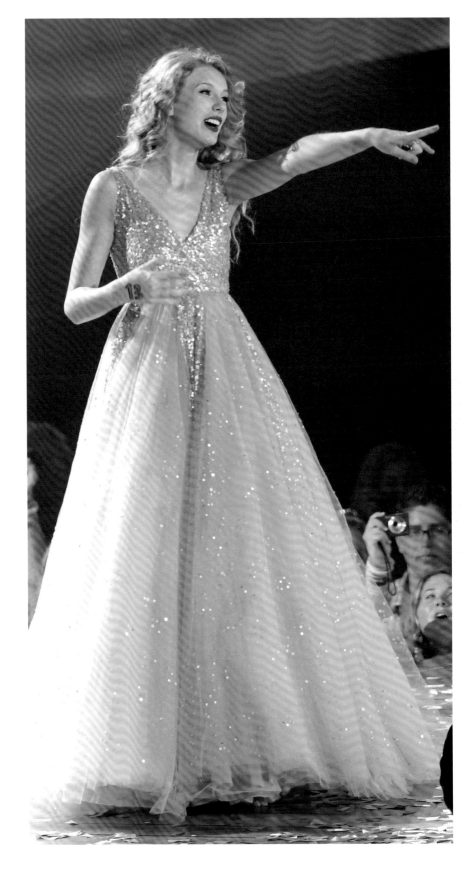

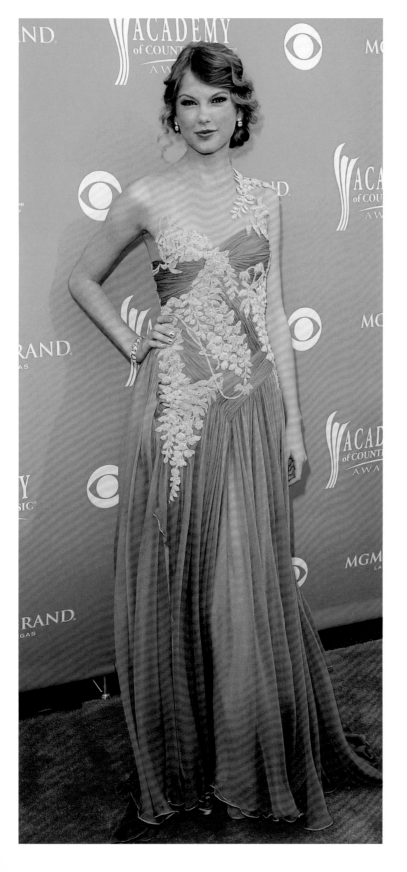

(LEFT) Extra lace panels were added to the original runway design of this Marchesa gown (in Speak Now Purple) to provide Taylor with more coverage across her midsection at the 2010 ACMs. On the original, the negative space created easy movement for the eye to trace the lovely embroidery from the top of the left shoulder down to the right hip, but Taylor still makes this modified version look dreamy and effortless and also entirely her, as she was known to occasionally alter a look to add modesty. The choice for minimal jewels was the smart one to avoid interfering with the blooming lace across the neckline.

(RIGHT) Bake at 350 for thirteen minutes until a toothpick comes out clean. Sweet-as-a-cupcake mini dresses in floaty fabrics and mellow pastels, like these by J. Mendel, were a key (and twee) look to communicate softness throughout the *Speak Now* era. I particularly like the addition of the floral headpiece she wore to the 41st Annual Songwriters Hall of Fame Awards (right, light purple).

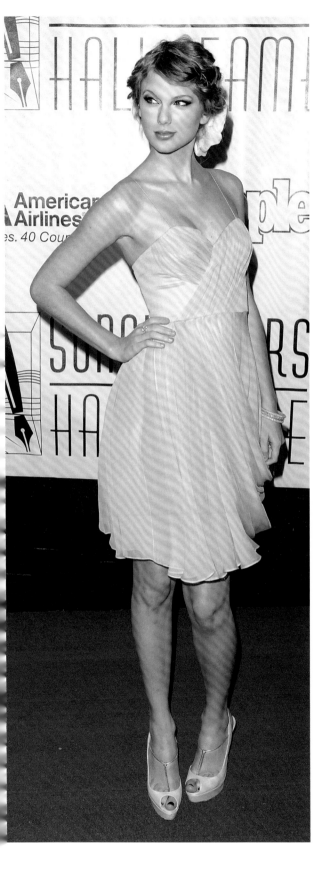

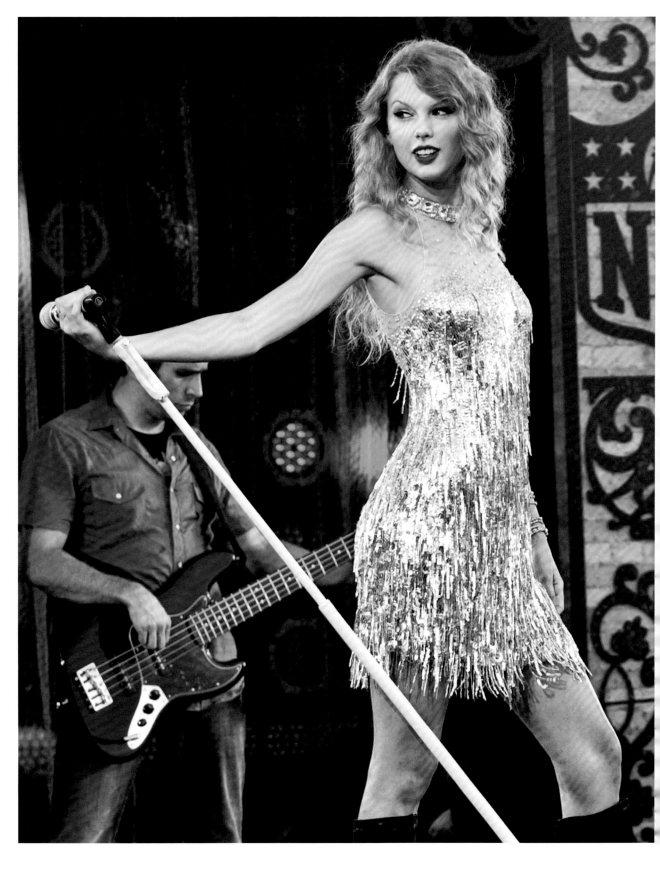

Old-Hollywood waves, flapper fringe, and a faux bob. Tinges of retro beauty lifted Taylor out of her own timeline and cemented her status as a timeless icon while adding her signature sparkle to classic looks. Taylor wears a Jenny Packham dress and Everybody boots to the 2010 NFL Kickoff Concert (go sports!) (left), and a Zuhair Murad dress (right) and Jimmy Choo accessories to the 2011 Vanity Fair Oscar Party.

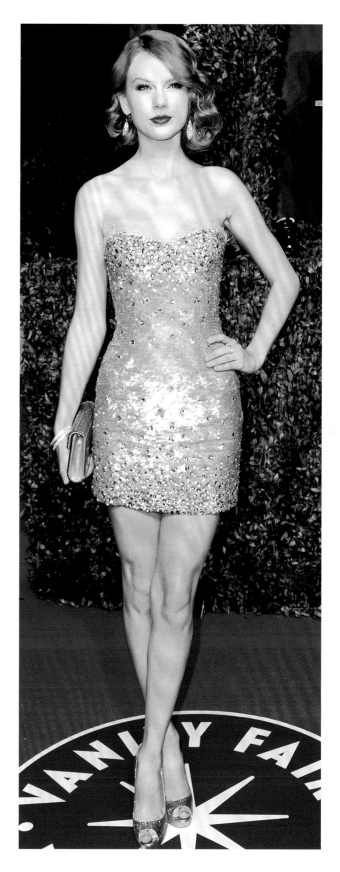

From the Very First Blog Post

I posted my first identification of a Taylor Swift outfit on October 13, 2011, while she was on a promotional campaign for her fragrance Wonderstruck. Taylor would go on to release four more perfumes as part of her contract with Elizabeth Arden: a remix of the original called Wonderstruck Enchanted; Incredible Things (the superior fragrance); one called, simply, Taylor; and a remix of Taylor titled Taylor Made of Starlight. For posterity, my own dusty (and completely empty) bottle of Wonderstruck still occupies a permanent place on my vanity. We've both come a long way since then.

This outfit has a lot of charming vintage-like qualities to it. The nude slip underneath her striped Tracy Reese dress creates a nice base for the tinsel stripe overlay to pop—but it also offers a bit of a sensual pinup bustier vibe to what could otherwise be a very prim look. Her earrings are by a sadly defunct LA-based jeweler, House of Lavande, which specialized in vintage and estate pieces. The black Miu Miu peep-toe heels are a timeless finisher. So much so that they would make reappearances in Taylor's wardrobe in 2015 and 2016—proof that Taylor really does retain much of her wardrobe and isn't afraid to pull an old favorite back out as she sees fit.

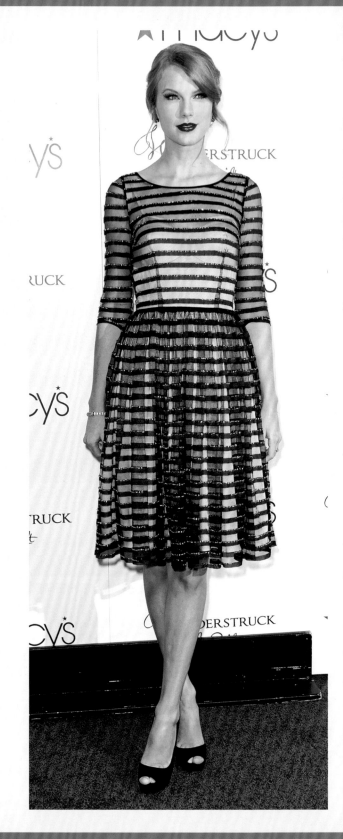

In 2011, Taylor impressively took the top prize of Entertainer of the Year at both the Academy of Country Music Awards and the Country Music Association Awards. It was a power move and career accomplishment to hold the title from both prestigious country music award organizations in the same year, a feat not accomplished by a female solo act since Shania Twain in 1999 and not repeated since Taylor's double-header. The only other female musician to take home both titles simultaneously was Barbara Mandrell in 1980. At twenty-one years old, Taylor was also the youngest female act to do so.

The gowns she wore to both events featured dramatic trains and a gentle color palette, with minimal jewels save for similar diamond-drop earrings. Brushed-out curls that offered more swoop than structure also worked to create a soft, angelic vision of strength in those moments of immense accomplishment.

(FOLLOWING PAGE, LEFT) One of the most underrated red carpet moments Taylor has ever served. This dove-gray J. Mendel gown is unique to Taylor's typical color palette and is an exercise in both restraint and quiet drama. Unlike previous red carpets, where standing out meant high-wattage attire, this muted moment felt like its own form of glowing confidence. While nearing the end of the North American leg of her sold-out Speak Now Tour, Taylor picked up her second Entertainer of the Year award at the 2011 CMAs. Befitting her understated gown, Taylor felt comfortable not occupying the fullness of the spotlight. In her speech, she let the accolade speak for itself and spread the credit of the tour's success and joy by thanking a long list of artists who had guest spotted at various tour dates. Their names were sprawled on her forearm in Sharpie (another homage to a unique tactic she employed on the tour itself when she wrote a fresh lyric from a song of her choosing on her arm every night).

(FOLLOWING PAGE, RIGHT) Fashion has a lot of arbitrary rules dictating the best or most flattering color to wear based on hair color or skin tone. Rather than viewing them as lost in a monochromatic sea, I love seeing blondes in yellow. This golden-buttercream moment at the 2011 ACMs is so cheerful but elegant and is a nice companion to Taylor's warmer-toned curls. The intricate embellishment details are indicative of its couture craftsmanship by Elie Saab (and a marked improvement from the "couture butter stick" gown of 2007).

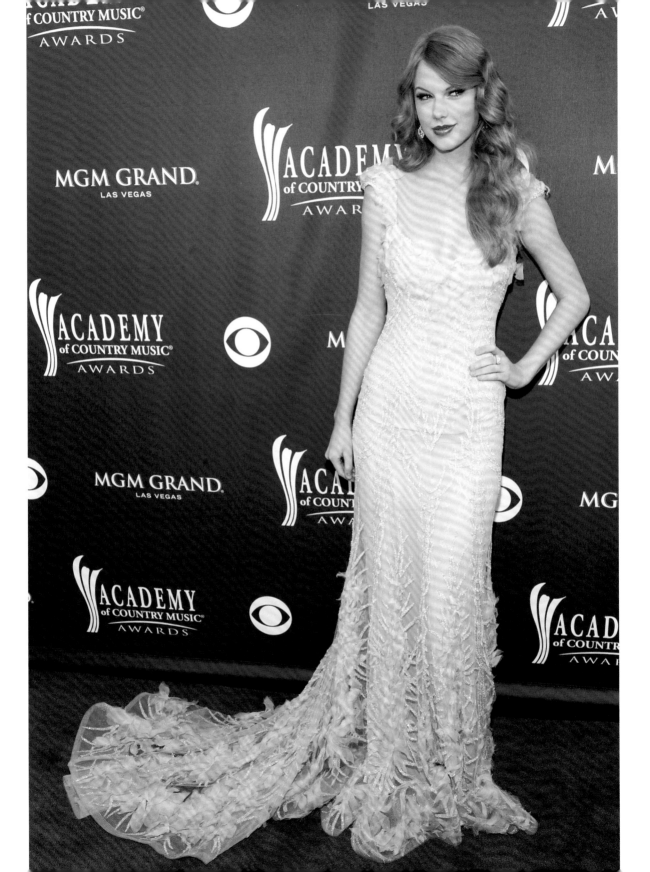

*"I think about my next move
10 steps ahead. I'm always
planning three awards shows
ahead. For me, planning is a
productive way of stressing out
about your life."*

—Taylor Swift, *Marie Claire*, July 2010

Taylor's first foray into hiding her forehead from the world came via a sassy set of clip-in bangs she wore to the 2010 American Music Awards. Her dramatic choice to forego her signature curls and swoopy bangs for something more polished and sleek had many wondering if this was a classic postbreakup chop. To which I'd say at least these fake bangs aren't a bouffant courtesy of a Bumpit—another popular hair piece of the time. Her embellished Jimmy Choo sandals were the perfect choice to complement the sparkles of her Collette Dinnigan mini. In accepting the award for Favorite Country Female Artist, Taylor said, "I think it's something really wonderful and rare to feel understood. To my fans, I want to say you get me and you know where I'm coming from and I can't thank you enough for that." It strikes a particularly heartwarming note for me that despite looking unrecognizable to many without signature aspects of her appearance, she still felt seen by her fans.

Vintage—So Adorable

It was at this time that Taylor began to sprinkle vintage items into her off-the-rack and designer finds, perhaps as a way to elevate her perceived identity above that of a flash-in-the-pan, country-turned-pop star and to claim her status as an icon whose career would transcend the present moment. Some may call it her initial flirtation with "granny" fashion, but I'm mostly just jealous that Taylor is someone so earnest and sincere that she can make heeled oxfords, cap-toe brogues, antique watches worn on chains, and horrifically floral-printed pussy-bow blouses work in her favor. Taylor described her closet to *Teen Vogue* in 2011: "My personal style is very girly. And what I seem to be fascinated by is fashion throughout history. I love to play around with vintage throwback looks and retro styles."

I like to think that the 2010 Met Gala theme, American Woman: Fashioning a National Identity, felt incredibly relevant to where Taylor was in her life. Like many celebrities, Taylor leaped at the chance to channel Old Hollywood. While some went the glamorous, high-shine route, Taylor went more subtle in a cold-shoulder creamy gown by American designer Ralph Lauren. She bonded with him over their similar scrappy starts—his by selling ties store to store, hers by

(OPPOSITE, LEFT) Dresses continued to play a key role in Taylor's style, typically hovering at an "appropriate" length just above the knee. During the *Speak Now* period, she began to incorporate vintage-leaning elements into her style, either through actual vintage pieces or by borrowing retro-like prints or fabrics such as lace—like on this doily-worthy dress by Reiss. She often paired these items with kitschy shoes, like Mary Janes, or lace-up, cap-toe brogues.

(OPPOSITE, RIGHT) Perhaps Taylor's most understated and underrated Met Gala appearance—and a personal favorite of mine because it felt like a moment when her fashion evolved from the gut-instinct squeal of a sparkle into something stylish that still spoke volumes. She was learning new ways to communicate and converse with fashion that were more nuanced but no less intentional—like upgrading from a language taught in the classroom to testing your fluency in the country itself. What I think makes this simple moment shine is the styling. The single dripping diamond bracelet at her wrist combined with the negligee quality of the gown and slightly mussed updo feels very "I wear Tiffany's to bed." Breezy luxury at its finest. The red lip was the perfect finisher.

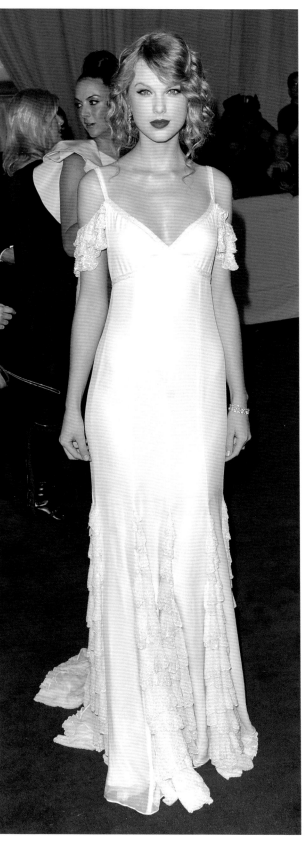

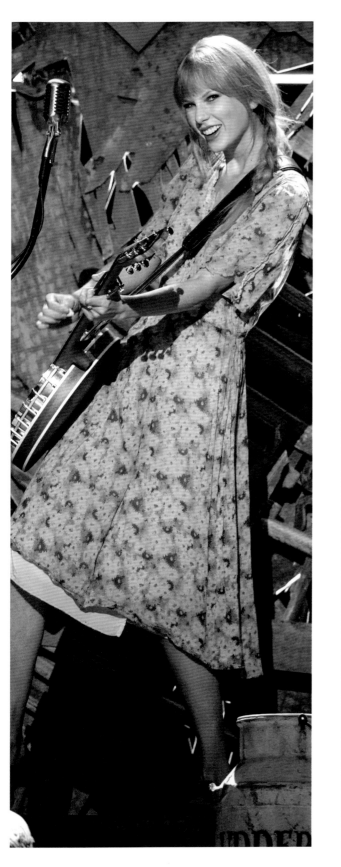
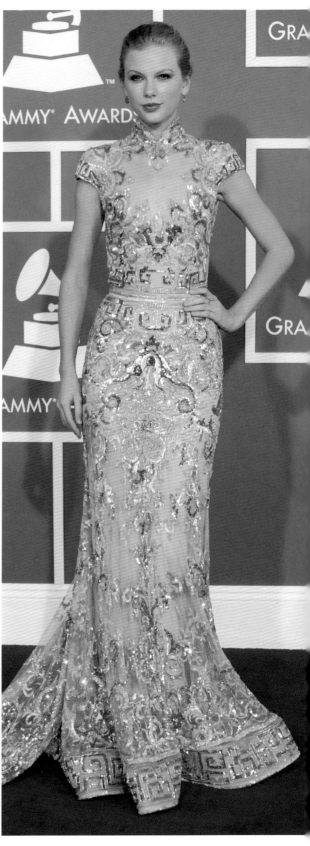

giving every receptionist in Nashville her demo CD. To *Allure* in December 2010 she said, "He had this genuine, sincere, real personality, this love for what he does—I was able to really relate to him on that issue, about loving what we do."

The most satisfying vintage moment of the *Speak Now* era was delivered at the 2012 Grammys when Taylor sang the twangy country ditty "Mean." Decked in a knee-length floral dress and a scraggly side braid with a banjo slung around her neck against the backdrop of the dusty set decor—the whole scene calls to mind a country milkmaid wandering into a western saloon. Throughout the performance, there's a flinty look of defiance in her eyes. No doubt she was envisioning patting the last shovel of dirt onto the imaginary grave of music analyst and reviewer Bob Lefsetz, who, two years prior, had called her performance with Stevie Nicks at the 2010 Grammys "dreadful." He opined that she had killed her career overnight. "In one fell swoop, Taylor Swift consigned herself to the dustbin of teen phenoms. Who we expect to burn brightly and then fade away," he wrote. Brutally, he called her "too young and dumb to understand the mistake she made. And those surrounding her are addicted to cash and are afraid to tell her no."

So it makes all the sense in the world why a gleeful smirk would play around Taylor's lips as she delivered lyrics rumored to respond to Lefsetz's critiques. He really got his comeuppance at the song's climax, when Taylor changed the lyrics to, "Someday I'll be singing this at the Grammys." That night, "Mean" won two Grammys: Best Country Solo Performance and Best Country Song. He could be mean all he wanted. She was a Grammy winner.

(OPPOSITE, LEFT) Taylor's vocal performance singing "Rhiannon" at the 2010 Grammys with Stevie Nicks was, shall we say, ill received by music critics and viewers. Two years later, the scrappy barmaid vintage ensemble sourced from LA-based Palace Costumes that she wore while performing her coup de grâce was, shall we say, ill received by me specifically. Although the styling intentionally matched the countrified aesthetic, the rural milkmaid look and dingy floral pattern felt forgettable and unflattering. Thankfully, her best accessory is that triumphant grin—and, of course, by night's end, Recording Academy trophies.

(OPPOSITE, RIGHT) Panning for gold. Having missed the 2011 Grammys ceremony due to her tour schedule, Taylor's 2012 appearance was staged as a triumphant return. Her gold Zuhair Murad gown felt like a manifestation of some complementary hardware. The demure details of the slight mock neck and cap sleeves are modest foils to the heart-shaped illusion cutout at the chest and the gown's dramatic, low, cut-out back.

Taylor's other major full-circle moment in vintage was at the 2010 MTV Video Music Awards, just a year following Kanye's infamous onstage mic grab. Her curls were pinned under in a faux retro bob, and she went barefoot, with little jewelry or embellishment to speak of save for a pair of understated drop earrings. Her wardrobe reflected this pared-back vulnerability. Wearing a strapless Dolce & Gabbana dress from the archives, its nude tone and gently rippling chiffon skirt giving the image of softness, Taylor herself became a white flag of forgiveness and peace. Having skipped the red carpet and having completely ghosted for the rest of the awards show, Taylor let her first performance of the song "Innocent" be her singular communication of the evening. To *Billboard* in October 2010, she said, "It took a while to write that song. . . . A lot of times in my life, when I don't know how I feel about something, I say nothing. And that's what I did until I could come to the conclusion that I came to in order to write 'Innocent.' . . . I still don't really talk about it. I just thought it was very important for me to sing about it."

Some took the lyrics of "Innocent" to heart as an olive branch. Others labeled it "petty" (*New York Times*) and "hypocritical" (*Slant*) to call out someone's negative actions when Taylor herself had built a discography vilifying former paramours in song. Taylor responded in 2010 in an interview with *Allure*, saying, "I've always believed in forgiveness once someone has the courage to apologize and does so with sincerity." To know Taylor is to know she never does anything half-heartedly— and if there's an opportunity for theatrics, she will opt for it. Sure, a certain smoky-saloon melodrama was lent to this performance by the pinned faux bob and corseted Dolce & Gabbana dress—a combo that can seem trite on some but is contrite on Taylor. Here, she puts her whole heart (and her shoeless feet) into extending a genuine pardon.

"I've always believed in forgiveness once someone has the courage to apologize and does so with sincerity."

The Duality of Fashion

"In Taylor Swift's world . . . Urban Outfitters T-shirts and $900 Christian Louboutin stilettos are embraced with equal fervor," *Marie Claire* observed in its July 2010 issue. As Taylor's career blossomed, the dichotomy between her approachable image and growing fame grew alongside it. She was simultaneously reaching an unfathomable level of renown, sporting designer heels and bags en route to industry events while also writing incredibly relatable, confessional lyrics and popping into Topshop for jeans on weekends.

While thoughts of starting her own high-end collaborative fashion line were not in the cards at the time, Taylor's interest in the world of designer fashion began to take shape. A front-row girl (the fashion equivalent to the center-court season-ticket holder) Taylor is not, but during the *Speak Now* era she did attend two runway shows for Roberto Cavalli and Rodarte that offered a glimpse into her take on high fashion. The events gave her a chance to play, to experiment. Almost like donning a temporary costume, they allowed her to try on a new identity and see how it felt to be in that skin.

(OPPOSITE) In September 2010, Taylor attended Roberto Cavalli's Spring 2011 show in typical Taylor fashion: on her own terms and with her own take. For a designer who is mostly known for their scant approach to fabric and attention-grabbing animal prints, it only makes sense that she would bunch as much fabric as possible into all. the. ruffles. for an outfit with maximum contrarian coverage. Reviewer Tim Blanks described the show to *Vogue* as "creating a spectacle out of the bare necessities" with suggestively webbed crochet, sheer chiffon, and strategically placed fringe dominating the pieces that walked down the runway. I think an outfit like this could have been disastrous on so many people, but on Taylor it strikes the exact right balance between fussy grandmother, fashionable front-row girl, and optimistic Shakespearean romantic. With a little dash of whimsical pirate thrown in. The balance of patterns, ruffles, colors, and textures is masterful. My favorite juxtaposition is the flouncy, tiered bell sleeves of her blouse (the way they precisely hit the last few tiers of her skirt!) against the harsh laces of her boots. This is still a memorable favorite that sticks out in my mind.

(ABOVE) On paper, the romantic kitsch, the artistic whimsy, and the fact that Rodarte had recently designed the ballet costumes for the film *Black Swan* all combine to feel like a fashion moment aligned with Taylor and the ethos of *Speak Now*. Attending their show afforded an opportunity to select a look that embraced the soft, chiffon-like, feminine image that shrouded a period filled with mental barbed wire. But what we got was a dress upcycled from vintage doilies that should have stayed in the hermetically sealed chest it was stored in. The limp faux bob and incongruous modern platform heels didn't help the styling. This fashion raincloud did have a silver lining, though. It connected Taylor to *Vogue* editor Anna Wintour, who would go on to use many of the runway looks seen in this Spring 2012 show in the fashion spread that would debut Taylor's now-beloved full fringe for the *Red* era.

Taylor Swift, You Are an Accessory Repeater

An iconic scene in the beloved Disney sitcom-turned-full-length-film *The Lizzie McGuire Movie* is when antagonist Kate Sanders calls Lizzie out for being an "outfit repeater." The term was meant to be scornful. Wearing an item of clothing more than once? How positively pedestrian. But much like the style of Hilary Duff's titular character, what makes Taylor's fashion so beloved and remarked on is her accessibility—especially in proportion to her level of celebrity. Her masterful mix of high-end designers with high street retailers (think a Dolce & Gabbana leather handbag with an Urban Outfitters dress) keeps at the forefront clothing items that her regular fans can actually attain. In conjunction with her vulnerable lyrics, what makes her so relatable is just how often she rewears items—especially accessories. Taylor has said, "It's the relatability factor. If you're trying too hard to be the girl next door, you're not going to be."

(BELOW AND OPPOSITE) In 2014, Taylor had a cycle of Dolce & Gabbana leather handbags on rotation: the Agata, Sara, and Sofia styles, to be exact. These were mostly rendered in neutrals, like timeless black or classic taupe, but infrequently extended to include chic shades of TSS-approved green. All three shared Taylor's preference for a top-handle silhouette, which she balanced on her right forearm while strutting the streets of New York.

(OPPOSITE) This nude Tod's Sella tote cut a curvy silhouette against the bevy of sweet and prim summer dresses and pastels that Taylor wore in 2014. At a time when Taylor's popularity as a pop icon was rising exponentially, fashion like this worked in contrast to her shiny, patented image. Namely, it underscored her noteworthy "unsexy" taste in handbags. While there's a certain sector of celebrity fan culture that worships at the altar of an iconic Hermès Birkin bag (a leather effigy of luxury) or a Loewe Puzzle bag (a modern feat of fashionable architecture), it's charming that Taylor has generally steered clear of overly lavish or trendy styles—even when her bags of choice still have the average person seeing dollar signs. Her lane is in the delightfully dull, the beautifully bland. Proof that even a high-powered yacht needs an anchor.

(RIGHT) When you deem a bag worth stealing, you tend to try and get a ton of wear out of it. Taylor confirmed in an interview with *Nightline*—which captured her on the set of her third *Glamour* cover shoot in 2012—that she had pilfered this leather Mark Cross bag from the designer wardrobe provided by the magazine. "I needed a bag to hold my sandwich . . . to take my lunch home," she jokingly demurred. With its generous proportions and timeless shade of cognac, I can see why she'd want this particular bag. It's versatile enough to work with basically any outfit—and to hold a plethora of snacks.

Wearing Your Heart on the Sleeve
of Your Affordable Sweater

One *Speak Now*–era candid in particular rules them all. It's a crisp fall day in New York City, fallen leaves litter the sidewalk—it's so cinematic you're sure Nora Ephron is yelling "Action!" somewhere off-screen. Taylor is in town for her tour date at Madison Square Garden (best friend Selena Gomez would delight the crowd by making a surprise appearance to duet "Who Says" with Taylor onstage), and she echoes the key styling elements of her most recognizable performance from the tour. Her curls are pulled up into a kicky ponytail, a glittery turquoise "13" is inked on the back of her right hand. It felt like a delightful sartorial tie-in to that exact moment in her life, with all the most era-appropriate fashionable dominoes falling into place—naturally.

The navy, goldenrod, and burgundy color palette evoked a modern nod to Snow White. In terms of materials, touchable cashmere and swishy pleats provided the delicate foil to stronger, structural textures like patent leather—the dichotomy of finding strength in softness. And, of course, she mixed online retailer Modcloth (known for their mod, vintage-inspired designs) with high-fashion brands Fendi and Marc Jacobs—big "country/pop superstar + girl-next-door" energy.

(OPPOSITE, LEFT) Photographed en route to the Rugby Ralph Lauren boutique in New York City wearing an on-brand RL cashmere sweater (natch!). This outfit is whimsical, soft, feminine, with a little hint of vintage from those demure red bow pumps. It is *Speak Now* for the streets.

(OPPOSITE, RIGHT) A great example of the whimsy of the era that could take a street-style moment involving a plain white tee from high street brand Free People into something dreamy and fanciful. The tonal ruffles of her Speak Now Purple skirt (also by Free People) provide an on-brand jolt of color, while the crystal headband, pendant necklace, and Chelsea Crew T-strap heels offer a vintage tilt. Her Urban Outfitters bag and her leather belt offer up nice repeat elements (ah, the wistful memories of randomly choosing to belt things in the mid-aughts).

(LEFT) Performing for fans in Central Park ahead of *Speak Now*'s official release, Taylor wears a borrowed-from-Romeo dolman tunic by Alice + Olivia—subtly writing herself into the role of her own Prince Charming to coincide with her self-written album's breakdown of the myths of fairytale love. The addition of Paige Denim skinny jeans and knee-high Cole Haan boots keep the modern-drama theme going.

(RIGHT) Softer fabrics and garments rendered in equally soft colors (like pastels) were ongoing themes for Taylor's *Speak Now* fashion. Knit beanies quickly became a go-to accessory for adding a harmonizing textural touch as well as a casual and laid-back element to her fashion. The weave knit of her beanies complemented the loose side braid she often wore during this time period, a style that's girly and easy. These outfits gave that Ralph Lauren saddle bag and the long pendant necklaces a canvas on which to "pop" as more structured elements of her look. From 2010 to 2012, Taylor rotated through a cycle of brown leather saddle bags by Ralph Lauren—their sizing differences making them something like a Goldilocks and the Three Bags situation. She switched things up between a large pony-hair, suede bag with contrast stitching; a medium, curvy, double-buckle Tremont style; and a small, accordion, calfskin-leather crossbody with a cute center buckle. I personally think they're all just right. Please note also that she is wearing, and fully getting away with, a silver whistle on a chain (right).

Charming graphic sweaters like these by Topshop (panda) and Wildfox Couture (Love Potion) added a touch of youthful, and affordable, whimsy to Taylor's outfits. Other repeated motifs include layered jewelry, denim, a romantic braid plaited to the left, leather boots, and a leather-accented shoulder bag. To the *Associated Press* in 2010 Taylor said, "I go through phases. When I was recording my new album, I wore a side braid on the left side every day. It just seemed to be the only style that seemed like the right one at the time." It's these kinds of outfits that underscore Taylor's approachable and friendly image, and are so easily imitable by fans, even those who may not be able to access her exact brands. An oversized cozy knit with fall layers, leather shoulder bag, boots, and a sweet plait are something anyone could mirror—and feel cute doing so! It only took me a decade to track down one of those Ralph Lauren saddle bags secondhand. I just love its curved-top flap and the double buckle detail. It's one of my few Taylor closet exacts, and I cherish it. But more than that, there's a sense of self-awareness and girlish power in these outfits that feel like the core DNA of *Speak Now* itself. In the comedy *New Girl*, the main character, Jess (Zooey Deschanel), famously asserts that her power, agency, and penchant for displaying her femininity are not mutually exclusive. "I brake for birds. I rock a lot of polka dots. I have touched glitter in the last twenty-four hours. . . . And that doesn't mean I'm not smart and tough and strong." Uncoincidentally, Taylor guest starred on *New Girl*'s season two finale in 2013. In later years from her *Miss Americana* 2020 documentary, Taylor would similarly opine, "I want to love glitter and also stand up for the double standards that exist in our society. . . . I want to wear pink and tell you how I feel about politics. I don't think that those things have to cancel each other out." Get you a girl who can write all her own songs, sweep the Grammys, and play sold-out shows while wearing as many glittery heart sweaters as she desires.

Part

II

THE CONTAINED CHAOS OF COUNTRY TO POP

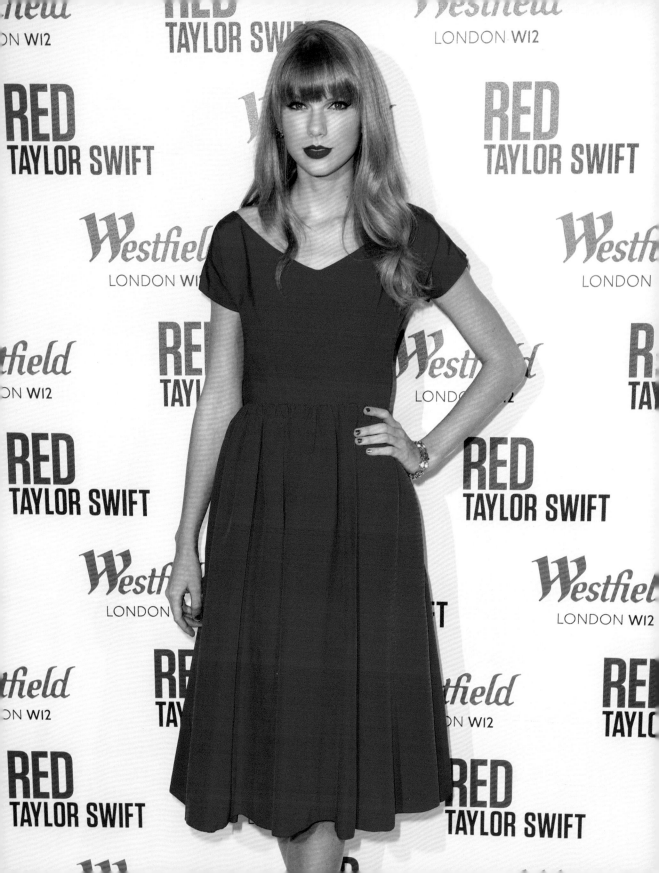

Red

MODERN GRANDMA CHIC

IF THE PRECEDING YEARS HAD BEEN SPENT NARROWING IN ON A VISUAL OF what teenage puppy love looks like, Taylor's fourth album—2012's *Red*—blots out her entire romantic worldview with the painted brushstrokes of a single hue. In an album as emotionally potent, yet sonically chaotic, as *Red*, Taylor unifies its themes and her corresponding fashion through scarlet-tinted lenses. The title track even creates a helpful color-coded legend of all the ways red has shown itself in her experiences with love.

During an acoustic performance as part of VH1's *Storyteller* series, Taylor described the synesthesia-like experience of writing the album's eponymous song. "I was writing ['Red'] and I was thinking about correlating the colors to the different feelings I went through," she explained. "You have the great part of red, like the red

emotions that are daring and bold and passion and love and affection. And then you have on the other side of the spectrum, jealousy and anger and frustration and you didn't call me back and I need space," she finished faux-huffily.

In the former category, one can include the album's opener, "State of Grace," which lures you in with a false sense of stadium-worthy rock via its pounding drums. The song also contains what I feel is the thesis statement of the entire album. Essentially: that love can be a cutting and bitter game of strategy and calculated moves—if you don't choose to play it with a pure and open heart. It's these two diametrically opposed forces that make *Red* a whiplash experience from beginning to end. The slow burn of the album's track-three ballad, "Treacherous," is followed by the dubstep-fueled "I Knew You Were Trouble." which precedes the five-and-a-half-minute, and much-beloved, epic scorcher "All Too Well," its final trailing guitar notes bleeding into the aggressively upbeat sugar rush of "22."

For some, the effect is too dizzying. But I'm of the opinion that it's by design. What better way to capture the confusion, the mess, the unpredictability of navigating your early twenties than with a tracklist that shuffles through emotions faster than a traffic light?

"Having the world treat my love life like a spectator sport in which I lose every single game was not a great way to date in my teens and twenties."

In many ways, *Red* is a bridge between girlhood and womanhood, just as it is a bridge between country and pop music. Written during that messy cusp period of Taylor's early adulthood, *Red* is a lesson in contrast and in chaotic growth. While many people her age were navigating the inherently messy lessons of one's first true heartbreak, establishing an identity away from the safety of a parent's arms, and experiencing the disillusionment of fairytale romance ideals within the relatively low-risk confines of a college campus or first forays into a grown-up job, Taylor's life played out on a world stage and under an ever-scrutinizing glare.

A very on-the-nose appearance that honors not only the color red and Taylor's vintage styling but incorporates twee, retro accessories—like her silver Mary Jane heels, by Arika Nerguiz, and a gold bow belt, by White House. For a more unified, cohesive appearance, I wish the metallics had been better matched.

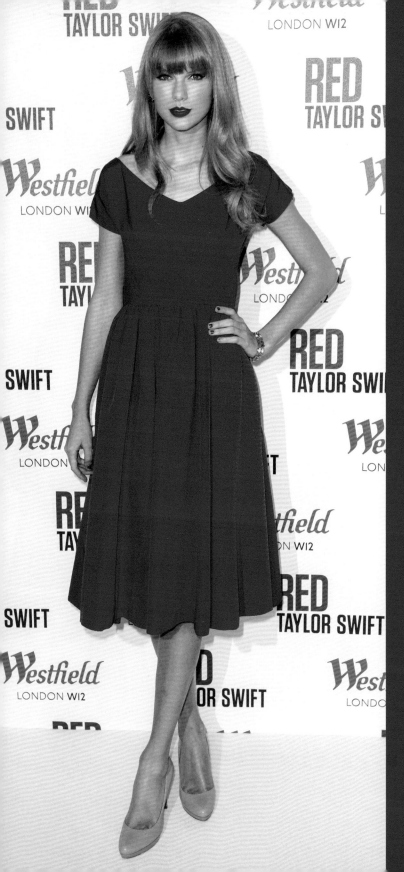

Prim and ladylike, with all the trappings of a quintessential *Red*-era look: a knee-length red dress (vintage), sensible closed-toe nude pumps (Prada), and her go-to beauty combo of bangs and red lips. This is a formula that she would repeat quite a few times throughout various promotional efforts for *Red*. To *Harper's Bazaar* in 2012, Taylor said, "There's just something so feminine about a dress. Whether it's a summertime dress that makes me feel carefree, an evening cocktail dress that makes me feel fancy, or a vintage dress that makes me feel like a '50s housewife—which I enjoy feeling like, for some reason—I just really like dresses." It's no surprise she would also cite Jackie Kennedy as a personal fashion icon (making her summer dalliance with Jackie's grand-nephew Conor Kennedy a little squirmy). To *InStyle* in 2009, Taylor said, "I'm inspired by how people dressed in the '60s, and that beautiful, feminine energy of Jackie O."

She defined this stage during a New York University commencement speech as, "Having the world treat my love life like a spectator sport in which I lose every single game was not a great way to date in my teens and twenties."

Red's lead single, "We Are Never Ever Getting Back Together," is a breakup anthem and an empowering (if cheeky and self-aware) promise to end the vicious cycle of a flaky relationship. The catchy and infectious hook encapsulates the central conflict of the album: a messy, drawn-out collapse of a toxic relationship that once held such promise. It was a fulfillment of what she had teased to *Vogue* in 2012: "There's just been this earth-shattering, not recent, but absolute crash-and-burn heartbreak and that will turn out to be what the next album is about. The only way that I can feel better about myself—pull myself out of that awful pain of losing someone—is writing songs about it to get some sort of clarity."

It also tipped the world off to Taylor Swift's next arena of domination: pop music. While her music was still technically served under the genre umbrella of "country," Taylor pushed her experimentation with typically pop sentiments further than she ever had to that point. She would later describe *Red* as "an album where I felt really compelled to experiment . . . and learn, but also as a young woman who was writing about heartbreak."

Her slew of pop singles from the album ("Never Ever," "I Knew You Were Trouble.," and "22") were coproduced with the venerable Swedish pop royalty duo Max Martin and Johan Shellback. The pair has been responsible for basically half of the *Billboard* Top 100 in any given year over the last two decades (Martin wrote Britney Spears's megahit ". . . Baby One More Time," to give you an idea of his pop chops). With the exception of the country-radio-serviced acoustic love ballad "Begin Again," the biggest singles on *Red* screamed mass-appeal pop.

Despite feeling like the twenty-two-year-old she was and writing music that other twenty-two-year-olds could relate to (and cry and dance and scream-sing along to in their cars), Taylor's fashion in the *Red* era made her look, in her own words, "like a 1950s housewife."

Tea-length dresses, midi skirts, kitten heels, and demure strands of pearls were key parts of her fashion as she promoted her most pop-forward project yet. While visually she was signaling an age many decades her senior, sonically, *Red* ping-ponged aggressively over its tracklist between the acoustic country tinges of her past and the bumping synthesizers of her as-yet-unknown future.

A Red Lip Is a Classic

In the album's title song, "Red," Taylor attaches a color to a feeling in a relationship: The vibrant passion (and perhaps unconscious warning signs) of fire engine red. The unrelenting waves of depression in blue. The unfettered joy and excitement of falling in love, like roses and ripe cherries. It's unsurprising that this album cemented one of Taylor's most signature beauty looks: the classic red lip.

Makeup artist Gucci Westman first swiped a red lip onto Taylor for her 2009 cover shoot with *Allure*—and the rest is beauty history. At the time, Taylor admitted that she was excited to give red lips a try, as she had "never done them before." The red lip is a classic beauty look that somehow blurs the line between femininity and boldness—which is an apt summary of Taylor's entire career and position in the industry. Making a red lip the focal point of any beauty look inherently draws attention to one's mouth and almost unconsciously emphasizes what one is saying (or singing). In a 2010 interview with *E!*, Taylor even said that a red lip "really helps you show emotion." As a confessional singer/songwriter, Taylor seemed destined to seal her look with a red-lipped kiss.

Taylor is rarely seen without a red lip. Even to this day, her go-to statement beauty look is often defined by a crimson pout. She told *Teen Vogue* in August 2011, "My lips are my favorite feature to highlight with makeup. Whether I'm using a dark burgundy or a bright cherry red, I pair it with lighter eyes so that the lips are the most intense feature people see." A red lip was the most logical accessory during the promotion for her 2012 fourth studio album, *Red*.

The first red lipstick Taylor ever wore is memorialized in *Allure* magazine, and the honor belongs to Elizabeth Arden's Color Intrigue Effects Lipstick in Poppy Cream.

Over the years, Taylor's favorite red lipsticks have expanded to include various formulas, like the NARS lip pencils in the shades Dragon Girl and Luxembourg: watermelon- and brick-tinged reds, respectively. During her days as a spokesmodel for CoverGirl, Taylor touted the brand's Exhibitionist Cream Lipstick in the color Hot as one of her drugstore go-tos. In later years, makeup artist Pat McGrath would step in with her own line—creating the beauty for and even appearing in the 2022 music video for "Bejeweled." Pat would describe to *Elle* (UK) taking Taylor's "signature lip to the next level" with her own LiquiLUST matte lipstick in Elson 4 and then going even further, creating what she called a "contour ombré lip" with three different shades of her PermaGel lip pencils in Deep Dive, Blood Lust, and Deep Void. And no red lipstick collection is complete without the mattest of mattes: Ruby Woo by MAC, which Taylor raved about to *People* magazine in 2015. Taylor's makeup artist Lorrie Turk revealed a few other go-to red shades she employs: Tatcha's Kyoto Red Silk Lipstick, Tom Ford's Lip Color Matte Lipstick in Flame, Armani Beauty's Rouge D'Armani Matte Lipstick in Red to Go, and Rihanna's makeup line Fenty Beauty's Stunna Lip Paint in Uncensored. Say hi to your Sephora cart for me!

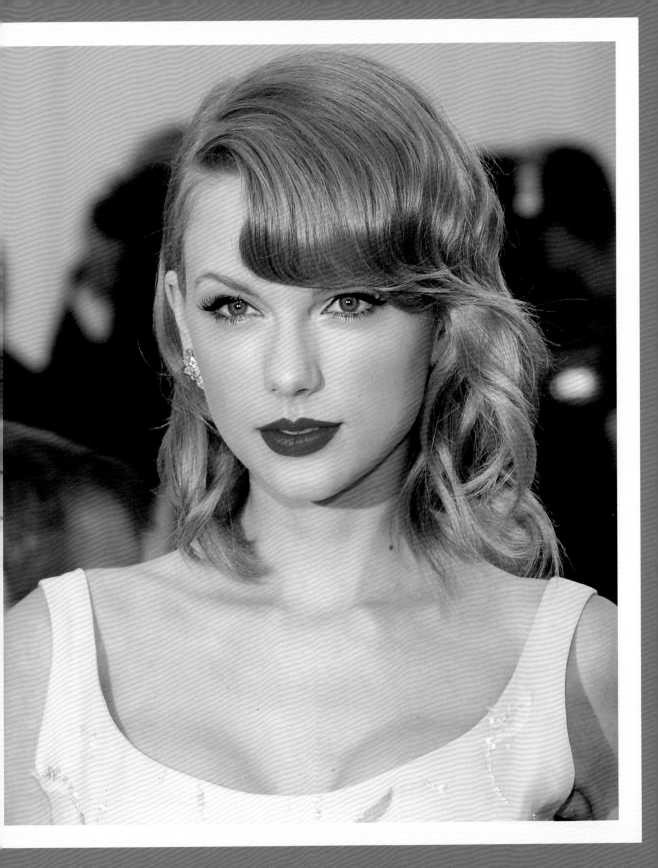

(LEFT) A cat lady in kitten heels. While promoting *Red* in London in October 2012, Taylor wore a very ladylike ensemble indicative of her vintage (see: Modern Grandma) style. She stepped out from conducting interviews wearing a vintage dress with an on-brand color-blocked red bodice and kitten heels by O Jour. Her newly uncoiled hair fell demurely over one shoulder to show off her pearl earrings. At best, modest. At worst, old-fashioned. In 2011, the *New Yorker* grossly stated, "Some have objected that Swift promotes a noxious, fifties-style ideal of virginal, submissive femininity." She was just two months shy of twenty-two years old. I wondered if the concerted efforts to appear older and more capable were an intentional overcorrection on Taylor's part. She had recently ended two high-profile relationships with significantly older men (John Mayer, thirty-two; Jake Gyllenhaal, thirty-one), each more than a decade her senior at the time of their tryst. Additionally, Taylor faced ongoing (and highly misogynistic) industry doubts about who was really in control of her songwriting. The image here paints the picture of a young woman trying determinedly to appear mature and poised when she was being accused of anything but.

(OPPOSITE) Formulaic or frumpy? Taylor relied on a blueprint (or perhaps redprint?) of fit-and-flare dresses—complete with pleated skirts—and nude heels for many of her *Red*-era appearances. Cast either in florals worthy of a set of curtains or remarkably safe shades of ballet pink and nude, the fabric shifted, but the easily duplicated silhouette streamlined styling decisions and created a cohesive era slideshow of her fashion. From left: Reem Acra dress and Christian Louboutin heels, Honor dress and O Jour heels.

Modern Grandma

During the *Red* time period, Taylor selected iconic midcentury silhouettes, like modest midi-length skirts and high-waisted bottoms. She kept her belly button hidden for years, prompting a joke among fans on social media who questioned if she even had one. As though she'd been swept off the set of *I Love Lucy*, Taylor's *Red* style further entrenched her in the sweet "All American" image she had worked so hard to cultivate. Even as she began to tentatively distance herself from the country music genre she had rooted her career in, she retained her recognizable, good girl image.

At the core of an era's wardrobe is establishing a reliable and visually distinctive silhouette that is formulaic and also fun to look at. Taylor's undying love for anything sparkly continued to see all things that glitter incorporated into her fashion. But during the *Red* era, Taylor also became obsessed with aggressively high-waisted bottoms. From a practicality point of view, they offered maximum ease of movement while she danced onstage. Aesthetically, they set her apart from her contemporaries who wore more revealing hot pants and bodysuits, while complementing the retro vibes she was going for. Her vintage-tinged footwear of choice became lace-up oxford flats, underlining her deliberate retro aesthetic by evoking the silhouette of classic jazz dance shoes. I like the fact that in both the looks pictured here (with sequin tops by Rachel Gilbert and custom shorts) the colors of the oxfords (by Miu Miu and Prada) match the corresponding tops to create a visually pleasing "sandwiched" look.

(RIGHT) Tour costumer Marina Toybina had promised that Taylor's performance wardrobe would follow a clear color palette. "Her album is called *Red* and so fans can expect a lot of white, red, and black onstage," she told *Contact Music*. True to form, black and white bases that borrowed from menswear-inspired white button-ups with unique details—like the metallic PVC trim on her 3.1 Phillip Lim shirt— were incorporated with brimmed hats and red pops of color via her Lanvin shoes. For an album that explores and plays with two opposing genres, this buttoned-up approach to fashion felt like a visual counterweight to her tea-length dresses and heels.

(CENTER AND FAR RIGHT) Alongside her "streetwear" costumes, Taylor also wore a variety of custom tour outfits for her more theatrical numbers—most of them made by costumer Marina Toybina, who told *Contact Music* that the outfits took ten days to create among a team of fifteen stylists, sewers, and dressmakers. One of Taylor's signature pieces that she would wear for multiple award show performances in addition to her tour performances was a fun circus-themed outfit complete with top hat and tails. While the costume is seemingly at odds with her fifties-themed outfits of the era (high-waisted shorts notwithstanding), a part of me wonders if this act was a humorous nod to the media circus her life had become. I like to think that she thought it brazen and funny not only to position herself at the center of that chaotic storm but also to cast herself in the role of ringleader of the whole show. Marina called the process of producing the costumes "exhausting." "We didn't get much sleep for a week and a half. But it was all worth it when we saw the end result, and the look on Taylor's face made all the effort worthwhile," she said.

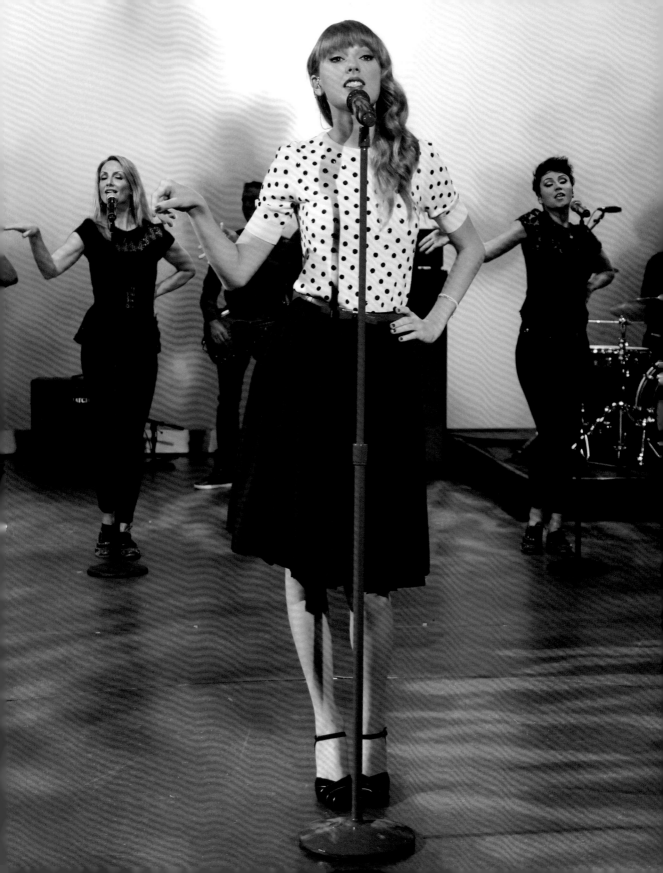

"I write about girlhood a lot. I'm very fascinated . . . with this phase of becoming a young woman, where you're at this very fragile and vulnerable age."

For this performance on *The View*, Taylor looks particularly prissy. The combination of her retro-feeling, polka dot Oscar de la Renta sweater tee with a starched, knee-length wool skirt and prim pearls makes it seem like she's about to lead a kindergarten class into a musical lesson on their ABCs. Spelling is fun!

What better way to embody the all-American girl next door than in a pair of classic Keds? In 2012, Taylor signed a three-year contract with the iconic American shoe brand. In a statement announcing the deal, Taylor said, "I've been a fan of Keds for years because they have two of my favorite elements of great style—they're classic and effortless." It was her most significant fashion collaboration project to date, having previously only appeared in a handful of ads for L.E.I. Jeans in 2008 and Abercrombie & Fitch in 2004 plus a short stint co-designing sundresses with L.E.I. in 2009. Taylor supported Keds by appearing in their promotional photo shoots and even had an additional collection made for her *Red* tour to supplement her stage costuming. The limited collection that followed included pairs embossed with the *Red* logo, but also familiar retro-inspired prints she was already wearing in real life—like polka dots, florals, and stripes.

(OPPOSITE, LEFT) This is a personal favorite *Red*-era outing for me. Gone is the obvious reference to the album's color calling card, replaced instead by simple, but striking, black. But even without the context of color you can still easily place this look in that time period. Such is the power of Taylor's distinct and recognizable visuals. Sure, you could look at the banner behind her for a clue (I suppose), but even if you stripped that away, you'd still have other key markers to deduce from. The freshly cut bangs, the red lip, and the very obvious cut and fabric of a vintage dress is paired ingeniously with a thoroughly modern pair of clear-PVC studded heels by Christian Louboutin. To me, this outfit is where the sound of *Red* meets up with Taylor's mental and emotional place at the time—aka modern pop packaged in vintage aesthetics.

(OPPOSITE, RIGHT) The fact that "kitten heels" are named after cats probably only contributed 13 percent of Taylor's interest in wearing this particular shoe style during this time period. The rest, I'm sure, was for its vintage, Audrey Hepburn feel, and how cute it looks with tights and collared dresses, like this dice-print dress by NW3.

(LEFT) This outfit feels like its own genre of fashion: Horse Girl Academia. The preppy cable-knit combined with knee-patch jodhpurs (both by Ralph Lauren), a stuffy leather messenger bag (Beara Beara), and velvet loafers (French Sole) create the flavor profile of a collegiate equestrian en route to class. I also appreciate how the blue and tan of her ensemble correlate neatly with her eyes and hair—that gets an A+ from me.

(FAR LEFT) Retro and red: two easy markers for determining if an outfit is from this period in Taylor's life. While on a press tour for *Red* in London in November 2012, she left her hotel room in a pair of burgundy cigarette pants by Theory, grounded by black accessories (her signature Ray-Ban Wayfarers firmly affixed to her face, plus repeat O Jour kitten flats) and a string of pearls. Her French Connection sweater continued the vintage feel thanks to its oversized and bouncy polka dot print. In quirky, cat-granny fashion that I'm sure was irresistible to Taylor, one of the dots was embroidered with an adorable cat face.

In 2022 Taylor was extended an honorary doctorate from New York University for her significant contributions to the world of music and art. As part of her acceptance speech, Taylor fondly referred to the fashion of her *Red* era as "cringe." She backed up her choice, though, by emphasizing that one has to lean into the cringe of existence. "No matter how hard you try to avoid being cringe, you will look back on your life and cringe retrospectively," she said, promising that hindsight would almost guarantee that the fashion you wear in the moment will be "revolting and hilarious" later on. I know there are fashion moments I feel cringe about (wedge sneakers, I'm looking at you)—but I think in hindsight, although perhaps a tad mature, most of her "granny" outfits from this period were quite cute. And truthfully, shopping vintage is not only a more sustainable and conscious choice; it also underlines Taylor's relatability factor. Not everyone can afford a Prada bag, but anyone can take a weekend to peruse the racks of their local consignment or secondhand store for upcycled vintage pieces to give new life to.

There truly is no album that epitomizes "fall" quite like *Red*. It is to Taylor's discography what pumpkin spice lattes are to coffee (I say with great affection—many PSLs were sacrificed in the making of this book). For this era, her street style was painted subtly by the *Red* brush. Charming wool toggle coats, retro prints, warm brown saddlebags, and oxford lace-up flats were pieces she wore alongside more modern garments, like skinny jeans and leather jackets, to give an outfit some vintage flair. The combination churned out candid outfits that felt entirely like Taylor's own when her contemporaries leaned into of-the-moment trends. Taylor talked about this to Yahoo! in 2013, saying, "When you . . . ignore fads and just wear what you like and what's classic and simple, I think that's the way to go for longevity as far as style." Even while she sported casual denim, small touches, like a pair of oxfords or a knit beanie, lifted the outfits just slightly out of their modern trappings, as if to indicate that their wearer went antique shopping in between Starbucks runs on weekends (which, in fairness, she absolutely did). Taylor wears: Topshop coat and Ralph Lauren bag; Fay coat and Christian Louboutin oxfords.

Having gone on many disgruntled hot-girl walks in winter to maintain my sanity, I relate to this particular candid moment on a personal level. On a gray day in January 2012, Taylor took a stroll around London, including paying a visit to the Princess Diana Memorial. Her outfit stands out in my mind as one of the best from this time period for exemplifying fall/winter fashion that could be easily replicated by anyone. Expert material and high/low mixing is on display here with a leather jacket by Rick Owens, suede Ralph Lauren saddle bag, and vintage Chanel oxfords styled alongside a cable-knit scarf from Nordstrom and (of course) a cat-print dress from ASOS.

All Too Well

On a fateful Thanksgiving weekend in November 2010, Taylor was photographed spending quality time with her then boyfriend, Jake Gyllenhaal. She looked cozy despite the autumn chill in a black peacoat, jeans, and lace-up oxfords. Taylor was later spotted with Gyllenhaal's sister, Maggie, at whose home Taylor providentially left her striped Gucci scarf. This outing became the "scarf heard around the world" via its narrative touchpoint in "All Too Well," proof that fashion can play a strong role in sense memory—and creative inspiration.

What has now become a keystone ballad in Taylor's catalog—with particular thanks to the success of its 2022 ten-minute iteration, which broke the record as the longest song to hit number one on the *Billboard* Top 100—the original five-minute version of "All Too Well" that debuted on *Red* is often cited as one of Taylor's songwriting hallmarks. The anchor of this entire grand, epic storyline is a simple scarf.

The song traces the scarf's journey from its cozy coil around Taylor's neck at the start of an autumn romance, to its abandonment in the house of her former flame's sister, to its eventual residency in the ex-boyfriend's own drawer (where he can, presumably, sniff it in his eternal regret over their failed relationship). For Taylor, it signifies something that is tangible and indisputable—a fashionable relic of a relationship where the other person went to great lengths to deny or minimize the depth of the bond. Sometimes in a breakup, you wonder if you imagined the whole thing, but Taylor's scarf makes it impossible to forget, diminish, or brush away the love she lost.

While speaking to an audience at the Tribeca Film Festival about the "All Too Well" short film, she discussed the toll that relationship took on how she approached growing up. "I write about girlhood a lot. I'm very fascinated . . . with this phase of becoming a young woman, where you're at this very fragile and vulnerable age." With this revelation in mind, poking fun at Taylor's penchant for high-waisted bottoms and severe "grandma" silhouettes feels like it comes with an unseen price tag: the cost of lost youth and innocence. From this vantage point, we see a girl at a tender age trying desperately to overcompensate for her youth, forfeiting the fun of being unburdened in a mad rush to appear older.

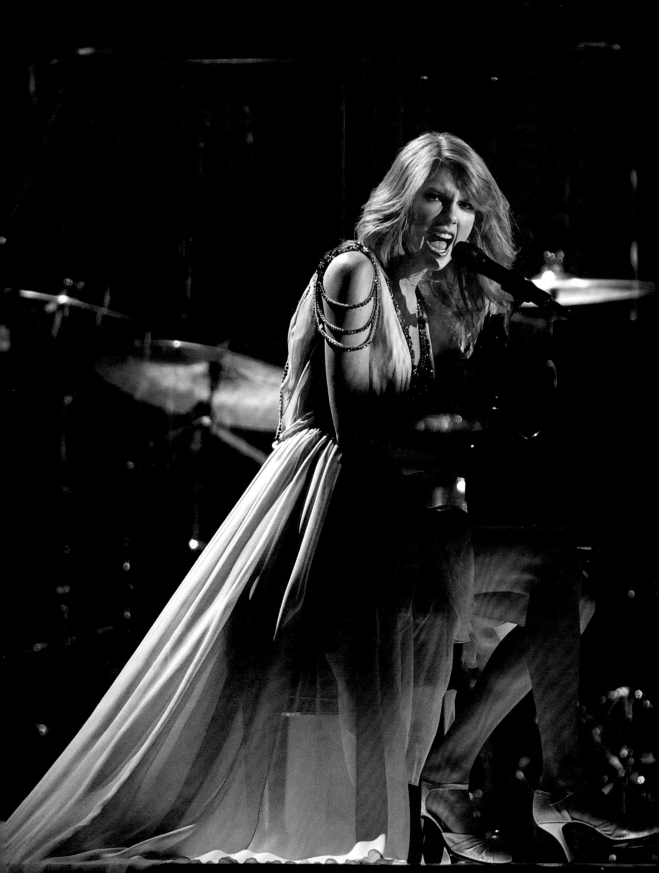

The lore of the conception of "All Too Well" is rock and roll legend. The story goes that during a soundcheck on the Speak Now Tour, Taylor walked up to her mic, and what came out was not the carefully rehearsed songs of a predetermined setlist, but a messy and rambling stream of consciousness, the freshly cut emotions and feelings pent up in her brain being siphoned in real time into song. "I was going through a really hard time then, and my band joined in playing," Taylor said to *PopDust* about the experience. The true catharsis of "All Too Well" is that it takes on a new life when screamed into the echoing caverns of a stadium during a live show. The ascent of the bridge feels so powerful that even if you've never so much as held someone's hand, you feel like you're in the midst of an all-consuming breakup. Its cult status as a fan favorite was truly cemented when Taylor chose to bring it to the most mainstream stage of all at the 2014 Grammys wearing a creamy Alberta Ferretti gown. When you're supporting an album and a song that makes color choice easy, it feels more poignant and distinctive to opt for a shade that isn't in the crimson family. Choosing to wear a white, chain-detail dress while unleashing the rage and the hurt of a song like "All Too Well" more than anything feels like a reclamation of innocence, of the girl who once was before she was painted any shade of red. A performance like this is usually relegated to an artist's single du jour, an opportunity to bump its placement on a hits chart. But this was both fan-service and self-service in its purest form—a way for all of us as a collective to funnel our pain into a group therapy session. Over the years, Taylor has talked about how the live experience of "All Too Well" and the joyous reception of fans has supplanted the sad memories that birthed the song in the first place. On the Eras Tour, she said, "*Red* was an album where I was writing about things that were really difficult for me. . . . I was writing about all these extreme feelings that I'd been having. When I would play them at first, especially one song in particular, I would feel a lot of pain when singing it. And then I would sing it with you, and you'd sing it back so passionately, that it was so incredibly transformative to see that you related to what I was singing, and that I wasn't alone in that, that all of a sudden, performing it didn't hurt me anymore. It felt like it was about us. . . . I think you've done that for every song ever since. You've redefined it and made it ours."

Two different days, two very different takes on sheer red lace. Over a black lining with nude Prada pumps and softened by sweetly curled hair, the red French Connection dress Taylor wore to the iHeartRadio Music Festival in September 2012 reads like a ladies' teatime event. But when it's an Elie Saab gown featuring a nude chantilly overlay and strategically placed straps with glossy straight hair, red lace becomes just a tad spicy and alluring, as seen at the more flashy Billboard Music Awards in May 2012.

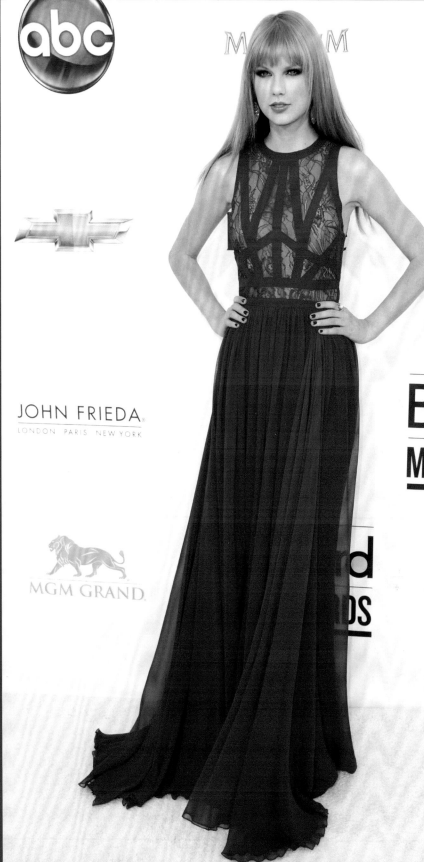

When Paper Rings Just Won't Do

While a certain scarf takes the award for the best-known accessory in Taylor's closet, a few other key pieces that she's worn carry equal emotional significance.

(LEFT) For many years, Taylor was spotted wearing this ring by Lorraine Schwartz. Its backstory is actually quite heartwarming. Typically, jewelry provided to celebrities for the red carpet is loaned—likely due to the fact that most of those precious jewels come with six-figure price tags. Taylor wore this particular ring, set in a cute floral pattern, on the night of the 2010 Grammys. Schwartz later gifted it to her as a memento of her first Album of the Year win for *Fearless*.

(RIGHT) Taylor first posted a photo of herself wearing a diamond Cathy Waterman "LOVE" ring on her Instagram in April 2012. Cathy had long been in Taylor's social circle because she also happens to be the mother of one of Taylor's closest friends, Claire Winter. The ring was originally a gift from Claire and Cathy. In true Taylor fashion, the ring unwittingly played the role of Swiftian Easter Egg, because six months later, it would be spotted in the album photoshoot for Taylor's fourth studio album, *Red*, released in October 2012. The ring is a signature of Cathy's and features intricate milgrain work and a scalloped font. "If I could, I would tattoo my love on all my people; and creating the Love Ring was the closest I could get to that idea," said Cathy. This ring was so embedded in the iconography of the *Red* aesthetic that it continued its legacy into the next decade. Taylor actually worked with Cathy in 2021 to create a custom version of the same ring's silhouette, spelling out "RED" instead of "LOVE" to wear on the cover of her re-recorded version of the album and as merchandise for fans to purchase. "The collaboration is significant to me personally and for the brand as well," said Claire of the partnership. "My mom has always said that the people she wants to be associated with most are talented, strong, hard-working women. Check. Check. Check."

This white-hot J. Mendel suit marked Taylor's first time walking the red carpet at the MTV VMAs since the mic grab seen around the world. Gone are the sweet and sparkly gowns of the past, replaced by a suffragette-worthy white suit (her first time wearing one on the red carpet) that indicated a quiet strength and a desire to wipe the slate clean. Designer Gilles Mendel told *InStyle* that Taylor was the visionary behind the look. "It was the first time she ever wore a suit on the red carpet and [she and her stylist, Joseph Cassell] challenged me to come up with something that would look sexy and glamorous, but extremely refined." To *The Hollywood Reporter* in 2012, Mendel said, "For such a young lady to have such a great sense of what she wants to wear is unusual. . . . We really collaborate with her—when she has a new idea in her mind." The designer was so inspired by Taylor's "strong point of view" that he would go on to recreate her suit in an orange print for J. Mendel's subsequent Spring/Summer 2013 collection. "Usually collections influence the red carpet, but this was the inverse," he said. Gold Tom Ford sandals added to the empowerment, imbuing the look with a subtle gladiator energy.

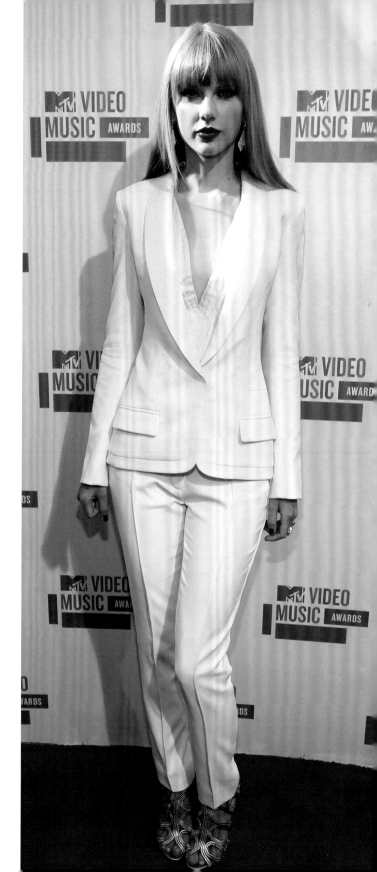

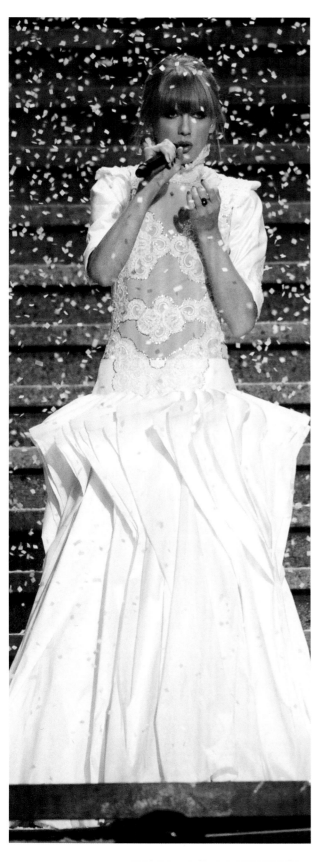
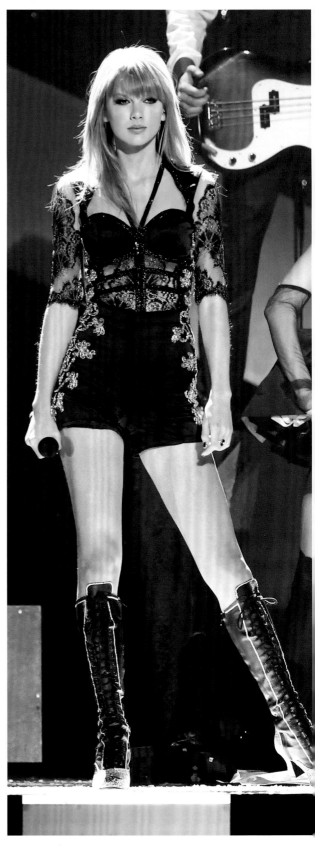

The Bangs

We can all collectively thank the hair team at *Vogue* for the fact that Taylor Swift's forehead has rarely seen the light of day since 2012. During her cover shoot, an on-set stylist suggested she cut her famous side-parted curls into a breezy straightened blowout with sleek eyebrow-length bangs. Taylor's response, after much consideration? "Oh just cut it. It's *Vogue*."

Up to that point, her hair had been a huge part of her recognizability on the world stage. An inspiration to curly-haired girls everywhere, Taylor's ringlets (often flung about dramatically onstage during head-banging performances) were an intrinsic part of her identity and what set her apart from many artists of the day. She remarked to *Vogue* during that same interview in 2012 the wonder of looking out at a sea of attendees at her concerts and seeing so many curly heads of hair. "I remember straightening my hair because I wanted to be like everybody else, and now the fact that anybody would emulate what I do? It's just funny. And wonderful."

In a behind-the-scenes capture for the photoshoot by Mario Testino, Taylor said it was "exciting to make a departure from what people see me looking like but still be recognizable. It's a great balance of the two."

Over the years, Taylor has experimented with other hairstyles—but she most often returns and seemingly "resets" to the long hair and bangs that *Vogue* established for her on that fateful day.

Costumer Marina Toybina promised that Taylor's back-to-back appearances at the 2013 Grammys (February 10) and 2013 BRITs (February 20) were designed to be intentional, fashionable bookends—creating a "yin to the yang" for the two high-profile award shows. The theatrics and costuming for both performances would later be utilized on the Red Tour, giving Taylor the chance to test out her dramatics for a televised audience. While her Grammy performance of "We Are Never Ever Getting Back Together" centered on a circus ringleader motif, her BRITs performance of "I Knew You Were Trouble." was, as Marina promised, a "much darker" production. Taylor has always loved an onstage costume change; her inner theater kid has to delight in the drama factor. But in a song like "Trouble" that explores feelings of shame and places the blame for failing to avoid the pitfalls of dating a bad boy on herself instead of on said bad boy, the very clear delineation of who she was before and who she was after this person feels eye-opening when seen through the lens of this costuming.

(LEFT) This Carolina Herrera gown, worn to the 2014 Golden Globes, was a Grace Kelly moment for Taylor that blended Old Hollywood poise and glamor with a slightly modern, color-blocked touch that also felt on-theme with the *Red* album's palette.

(CENTER) While this dress has all the hallmarks of classic *Red*-era style (the color of the embellishments and the straightened hair with bangs), it also feels significantly more relaxed and less like a costume than her attire for other events. The nude Jenny Packham gown, which she wore to the 2012 Country Music Association Awards, feels "painted" by a red brush, instead of being another in-your-face, on-the-nose scarlet gown. The hair falls between the straightened style she introduced in this era and the ringlets of her past—a nice middle ground.

(RIGHT) The 2013 BRITs were a hall-of-fame red carpet moment for me. This black-and-gold Elie Saab gown felt like a precursor to the fashion that would follow when Taylor took the stage to perform "I Knew You Were Trouble." The interplay between light and dark, sexy and elegant, and the peekaboo mesh all tie in nicely with the onstage costume theatrics that were to come later that evening. It also felt like a turning point between Taylor and this designer, whose styles Taylor loved and frequently turned to for their feminine distinction. Her previous Elie Saab gowns relied on sparkle and sequins to capture attention, but this dark-horse ensemble feels captivating in a more nuanced way. Not unlike the themes of *Red* itself as it sonically seesaws between two genres. Taylor described this gown to Yahoo! as one of her favorites.

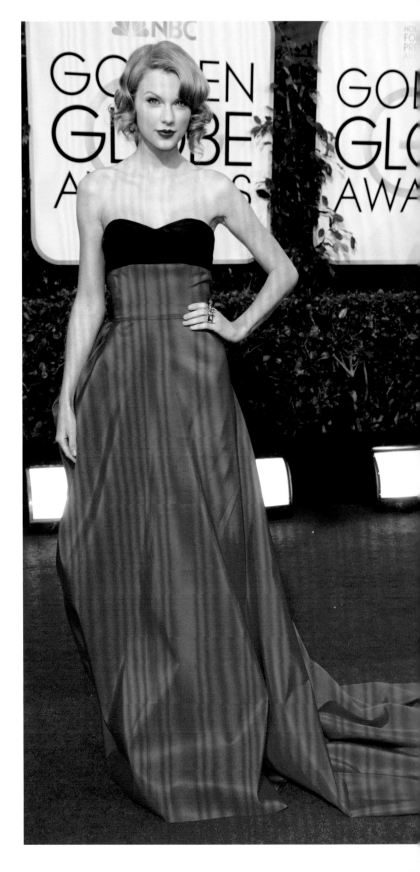

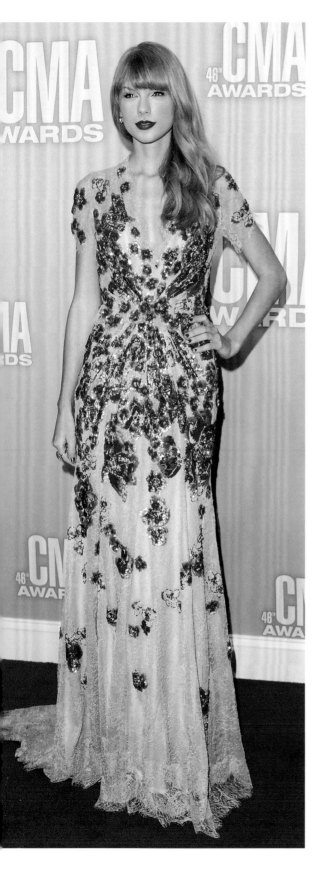
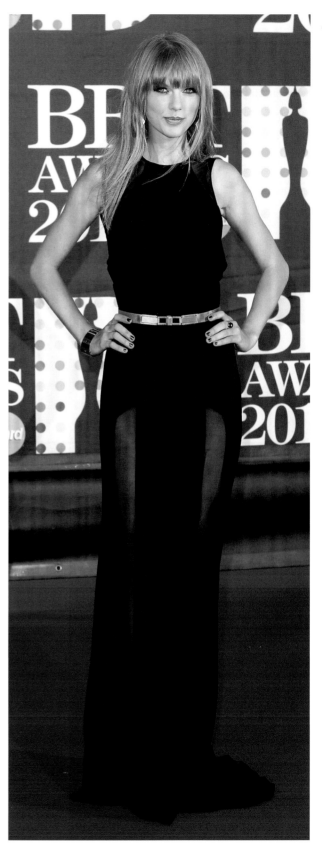

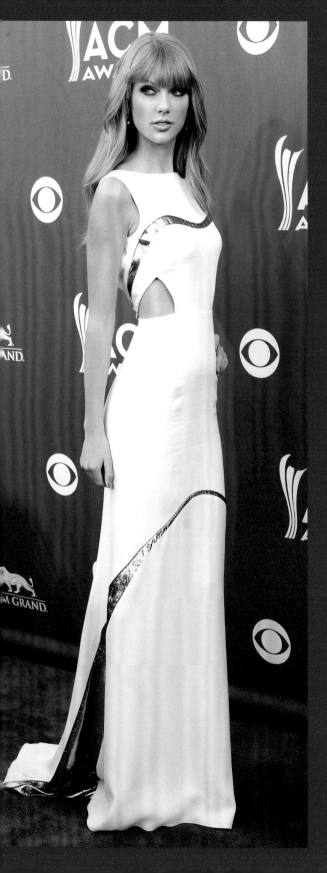

This is one of my all-time-favorite Taylor red carpet looks. The hair and makeup are a dream, featuring a more mature and restrained ashy blonde with smoked-out eyes. The white of her J. Mendel gown is so sophisticated, while the cutouts at the sides add a fun, modern element to an otherwise simple column gown (while also evoking a certain future crop-top energy). But it's the inset, curved, gold elements that really undo me. In an era full of in-your-face, stop-sign-obvious red garments everywhere, this to me is a subdued (and painfully chic) reference to *Red* and its chaotic feelings. In the album's prologue Taylor writes, "There's something to be proud of about moving on and realizing that real love shines golden like starlight, and doesn't fade or spontaneously combust. Maybe I'll write a whole album about that kind of love if I ever find it." It's a heart-clutching clue to Taylor's never-ending, hopelessly optimistic, and romantic belief in love.

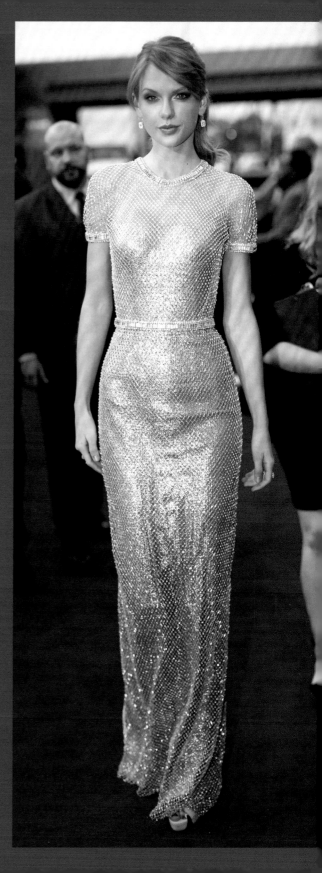

By a landslide, my favorite Taylor Grammy appearance, and an all-time-loved red carpet moment. Taylor wore this Gucci Première gown to the 2014 Grammy Awards, where she famously lost Album of the Year for *Red* to Daft Punk's *Random Access Memories*, an album as culturally relevant now as the dodo. This glittering chain-mail column gown was unexpected in every way—and seemingly a missed opportunity to go the obvious scarlet-embued route. But *Red* is an album about experimentation and curiosity, trying on a new and appealing skin to see how it fits. In the past, Taylor had turned to fairytales as her summit source of inspiration, with dreams of finding love worthy of a princess. Here, she tries on being her own knight in shining armor—to find that it fits her like a glove.

"Oh just cut it. It's Vogue."

A country music swan song. In so many ways, this red carpet outing felt like a farewell to the genre that had effectively raised Taylor. At the ripe age of twenty-three (she was just one month shy of her birthday when the event was held in November 2013), she received the Country Music Association's highest honor: the Pinnacle Award. It is given to country music artists who have reached the highest echelon possible of contributions to the genre. Barely able to rent a car, she was being told she had achieved all she could in her chosen genre. As has often been the case in her record-making career, she is the only woman to have received the honor, and the youngest winner to date. It was prophecy fulfillment, and her chosen gown projected the image of the genre's reigning princess gracefully bowing out to rule over broader kingdoms. *Slant* writer Jonathan Keefe observed in his review of *Red* that the album's "highlights are career-best work for Swift, who now sounds like the pop star she was destined to be all along." Having reached new, rarefied air, she delivered a pared-back, acoustic-tinged performance of the single "Red," accompanied by fellow legends Alison Krauss and Vince Gill. So on this night, it felt only appropriate to show up in a gown that encapsulated not just the vibrant red of her final country-billed album, but also the fairytale sweep of success she'd enjoyed. This embellished Elie Saab ball gown with a matching red lip did just that. Having effectively conquered country, Taylor's new goal was to scale another genre.

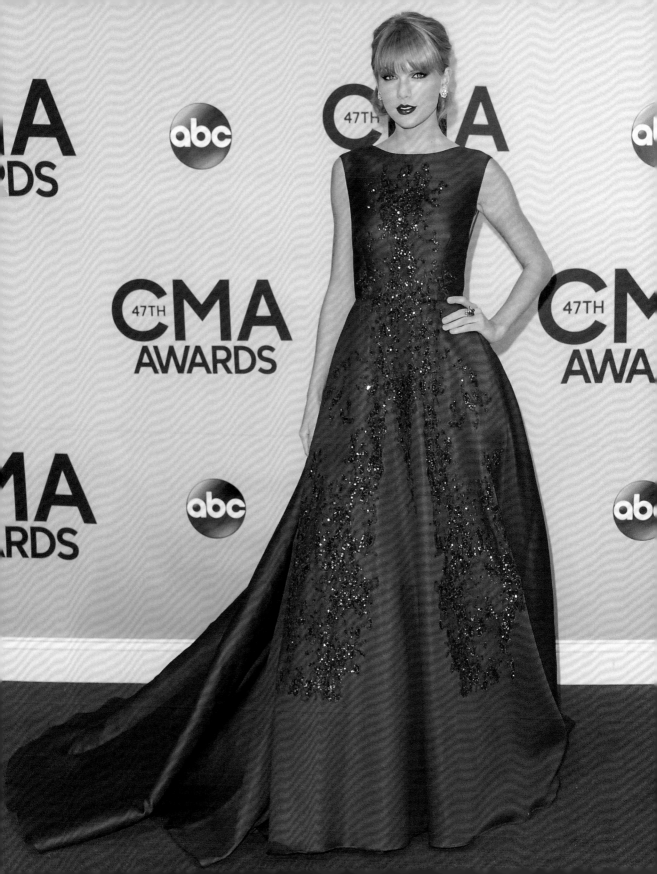

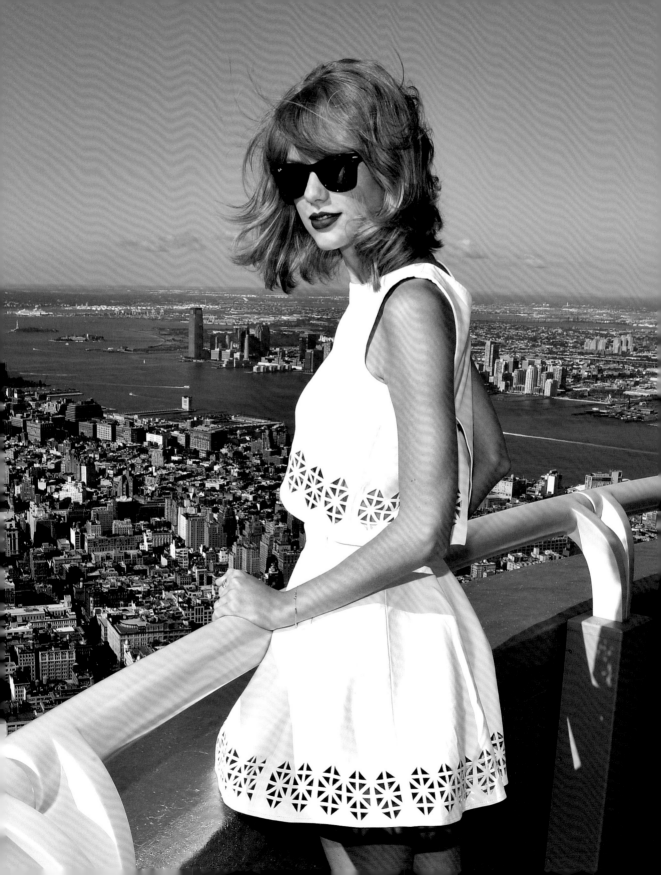

1989

WHO'S WEARING THE SHORT SKIRTS NOW?

ASK ANYONE TO NAME A TAYLOR SWIFT SONG OFF THE TOP OF THEIR HEAD, AND there's a good chance they'll list something off the record-shattering pop behemoth that was Taylor's fifth studio album, *1989*. They've probably heard "Shake It Off" at the peak of a wedding's dance-party playlist. Or maybe they laughed a little in spite of themselves at the tongue-in-cheek, satirical bop "Blank Space," which poked fun at Taylor's highly buzzed-about dating life. Or maybe they'll reference the dreamy, hazy, falsetto-filled "Wildest Dreams." None would be surprising, as all three are multiplatinum-earning singles that dominated airwaves and pop culture at the time of their release in 2014. Not to show my cards, but I'm admittedly a little biased when I call "Style" one of the best-written pop songs of all time—and certainly my favorite single from *1989*.

But underneath the impeccably polished, glittering veneer of *1989*'s pop production is a history of style and sound that was actually years in the making. To *Entertainment Weekly*, Taylor described her transition to pop not as a "crossover" but as a "spillover," beginning in 2008 with "Love Story" and its country-tinged infiltration of the *Billboard* pop charts. *1989* is the culmination of those fearless efforts into fully fledged pop and is as equally reflected in her music as it is in her change of dress.

Taylor spent years carefully placating country radio and dutifully injecting banjo into her poppier-leaning tunes (at the behest of her label head at the time, Scott Borchetta) on the genre-hopping *Red*. She lent her name to country music award shows, bringing with her the eyeballs of the coveted eighteen-to-forty-nine-year-old female demographic. But by 2014, she was ready to go all-in on pop music once and for all, and to rebrand her image by association.

Enter the matching set.

In June 2014, our first look at Taylor's fresh take on fashion could not have been clearer. On the streets of New York (her newly adopted home—she purchased a Tribeca apartment that would be home base to a clutch of buzzing paparazzi by March 2014), gone were the sweet waist-length curls of a country starlet—and the cowboy boots to, well, boot. She debuted a marled-pink matching crop top and skater skirt set by Bloomingdale's-owned brand Aqua (an affordable off-the-rack set of coordinates), paired with sky-high, leg-lengthening, six-inch Miu Miu nude heels (a steeper-priced pair of designer sandals), and finished rather sweetly with hairclips and a leather bag from Anthropologie—demonstrating that she was (and is) a queen of the fashionable high/low.

The look that launched an era. In June 2014, a decidedly single-and-not-looking Taylor stepped out in New York City wearing what would soon become the most iconic silhouette of her most commercially successful album to date: the co-ord set. Taylor had been through the ringer with a string of dramatic on/off relationships, as documented on her previous album, *Red*, so she defined this period of her life as a reset to focus on herself, her independence, and her new "relationship" with the city of New York. This outfit is the embodiment of Hot Single Girl energy; the marled-pink and flippy skater-skirt set is sweet, but the six-inch heels and the sliver of midriff express a level of self-confidence never seen before this moment in Taylor's fashion.

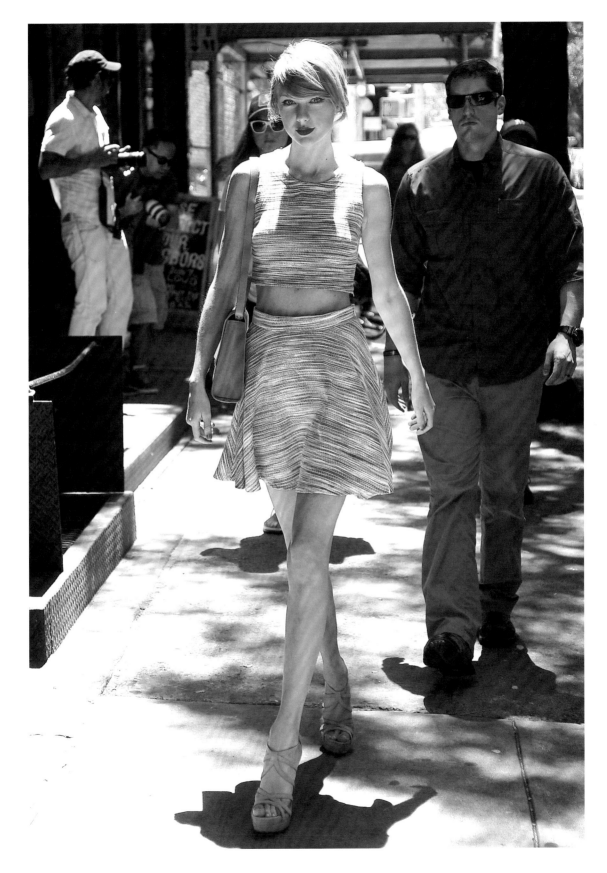

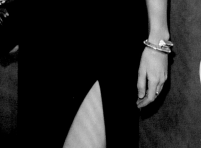

From then on, Taylor basically became a one-woman advertisement for the matching set. It was her way of very loudly telling the world how she wanted to appear: chic, put together, and powerful. For the remainder of that summer—and indeed throughout the majority of the *1989* era—she relied on relatively affordable matching sets by Ronny Kobo, Reformation, and even H&M, paired with teetering and expensive designer heels by the likes of Christian Louboutin, Jimmy Choo, and Prada, and always a shoulder bag, typically leather, usually rendered in black or nude, carefully balanced over an extended forearm.

Though Taylor sang in her 2008 hit "You Belong with Me" that her high school rivals sported short skirts while she preferred T-shirts, in the *1989* era Taylor fully embraced every miniskirt that crossed her path. Gone were demure tea-length dresses and fairytale gowns, cowboy boots and ballet flats. Taylor mostly ditched her bleacher-seat sneakers (save for a few strategic pairs of Keds—more on that later) and began fastidiously wearing high heels. As her career reached new heights in pop music, she did too—literally. The five-foot-eleven singer made it her job to strut in six-inch heels all over New York City.

Looking deeper Taylor's co-ord uniform let the world know what everyone at Camp Swift already knew: she was in charge.

One need look no further than the genesis of *1989* itself.

The album's sound was partially inspired by Taylor's move from the safe confines of country music's capital, Nashville, to New York City. It's no coincidence that *1989*'s opening track is titled "Welcome to New York." But *1989* was also a result of the perceived shortcomings of its predecessor, *Red*. When *Red* lost Album of the Year at the Grammys, critics said the loss was likely due

While the pink set in June is what really fueled the fire of her Crop Top Era, Taylor gave country fans a courtesy heads-up of what was to come in her April 2014 appearance at the Academy of Country Music Awards. Her J. Mendel ensemble was thoroughly modern and a dramatic departure from the princess gowns she had previously worn. Between the slit in the skirt, the peekaboo cutouts at the shoulders, and the slice of midriff, it was a shock to see her opt for skin over sparkle. The reliance on neutrals and an otherwise clean silhouette keeps the look sharp and modern—it was clearly the harbinger of a new era. She kept the gold-and-black theme going with well-played complementary accessories like a cute micro M2Malletier clutch, Marina B and Jennifer Fisher jewels, and strappy Casadei sandals.

to the frenetic ping-ponging between genres that detracted from the album's otherwise sound lyrics. The *New York Times* observed, "It was never a question of whether [Taylor] would become a pure pop star; the only question was what sort." Taylor's riposte was *1989*, a "sonically cohesive" album—with a visually cohesive sense of style to match.

To *Billboard* in 2014, Taylor revealed how her record company at the time tried to talk her out of releasing a fully pop album for fear that loyal country music listeners wouldn't follow her into a new genre. She described how label head Scott Borchetta begged her to put fiddle on "Shake It Off" or throw in "three country songs" to even out the tracklist and appease the audience that had built her career. Despite the doubt, Taylor followed her instincts. "Everyone, in and out of the music business, kept telling me that my opinion and my viewpoint was naive and overly optimistic—even my own label. But when we got those first-day numbers in, all of a sudden, I didn't look so naive anymore," she remarked in the aftermath of the earth-shattering first-week sales for *1989*: 1.287 million. *1989* was the first album of 2014 to exceed sales of one million units in the first week. It also made Taylor the first artist with three albums to accomplish that feat. And if that weren't enough, the 2023 re-recorded (Taylor's Version) eclipsed its original first-week numbers almost a decade later with a teetering 400,000 additional units. Talk about an album that never goes out of style. To *Rolling Stone* in 2019, Taylor would reflect that, "A lot of the best things I ever did creatively were things that I had to really fight . . . to have happen."

Despite the new musical direction of the album, her clothing's innate girlishness made her identifiable and felt true to—and consistent with—her signature feminine style. Even in one of the world's most populated urban centers, she still retained an approachable quality and an unshakeable politeness, bolstered by a sense of power befitting her new home and the new phase in her career. This is the true power of the crop top: the embodied energy of a woman fully acknowledging her sartorial and professional prowess in an unabashedly feminine way. Sure, it takes a certain level of confidence to rock a tailored take on a menswear suit, but there's something even stronger about taking a pink A-line skirt and matching top and making it your Boss Outfit.

"Everyone, in and out of the music business, kept telling me that my opinion and my viewpoint was naive and overly optimistic— even my own label. But when we got those first-day numbers in, all of a sudden, I didn't look so naive anymore."

Hot Girl Summer, indeed. Taylor relied on a consistent formula of a matching crop top and skirt set, leather handbag, and sky-high heels in the summer leading up to the October 2014 release of *1989*. She predominantly gravitated toward pastels, bold patterns, and punchier, vibrant colors. In many ways, the matching set was merely an evolution from the girlish dresses she'd favored in her early years—a display of confidence in form, but a loyalty to the "one and done" function of a dress. Taylor wears: striped floral H&M set, Prada bag, Elie Saab heels; polka dot Reformation set, Kate Spade bag, Pikolinos heels; peach Alice + Olivia set, Tods bag, Jimmy Choo heels.

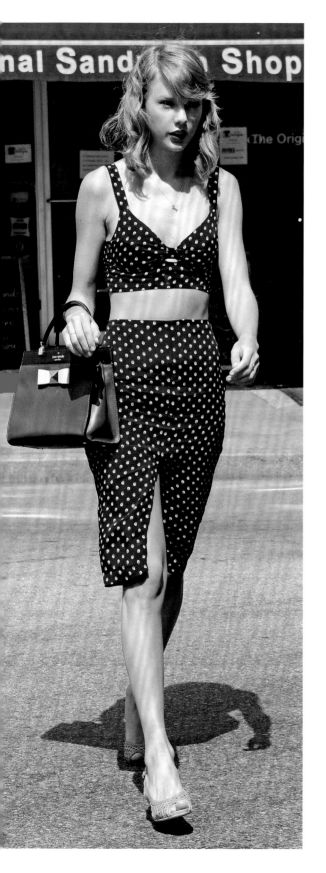
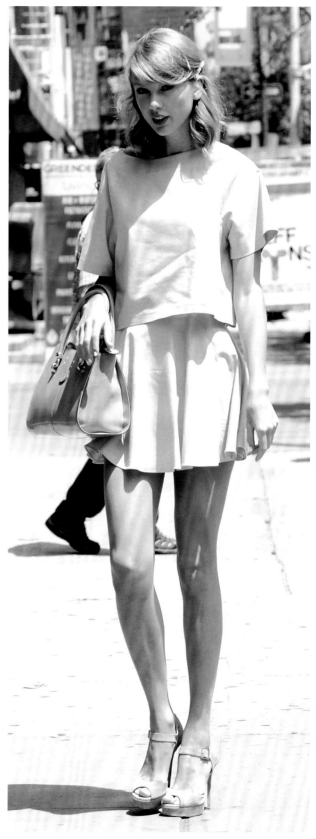

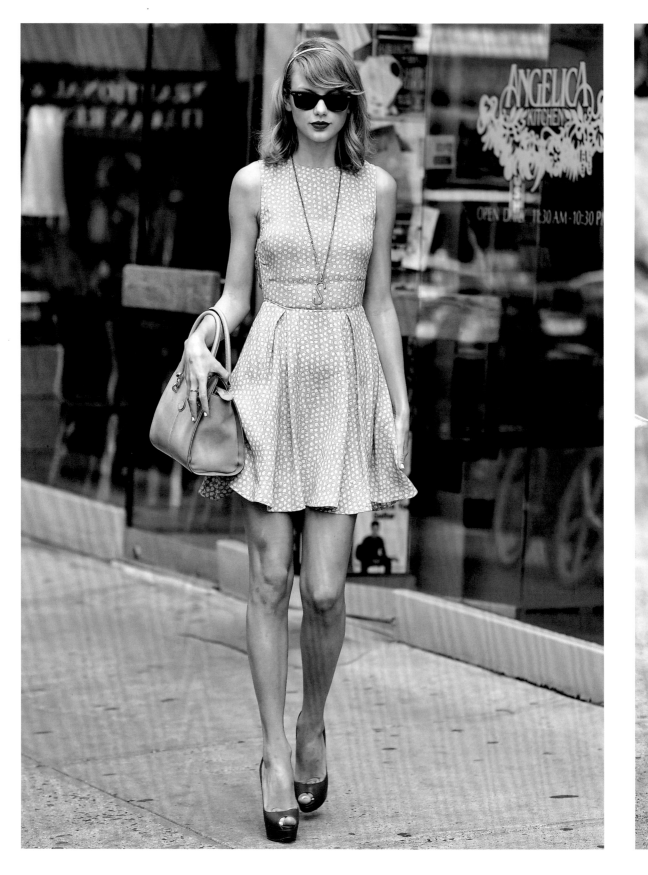

(LEFT) A casual stroll in Central Park in five-inch heels, as Taylor Swift does. The accessories here provide a fun summer-citrus pop of color against the gray marl of the set—though they do feel slightly disjointed from one another.

(FAR LEFT) This summer-ready mint-green Reformation dress was paired with designer accessories, including absolutely teetering six-inch, hot-pink heels by Christian Louboutin. The combo is a funny juxtaposition of sweet and spicy that is a callback to Taylor centering her power and boss-babe energy in the twirlability of a cute miniskirt and the knife-edge point of a stiletto. Color-wise, it's prophetic of the 2015 Grammys appearance that would come to fruition six months later. The "S" on her Lulu Frost necklace is not a self-serving reference to her last name but is in honor of her friend Selena Gomez, whose birthday it was the day Taylor stepped out in this 'fit.

(LEFT) Perfectly on-theme and also crisp and fresh, precisely the kind of outfit one needs to officially announce the release of one's first fully pop album—atop the Empire State Building, no less! Announcing the launch on the roof of one of New York City's most recognizable and iconic landmarks really hammered in her new urban aesthetic. The matching Lovers + Friends white crop top and skirt are broken up and also made more modern with those interesting laser cutouts at the hem of both the top and the skirt. The blue-and-white palette plays nicely with the colors associated with the *1989* album booklet and the sunny New York skyline. Taylor's stylist clearly checked the weather to make sure the Empire State Building and the sky would match her outfit. I am always a sucker for an ankle strap heel in a fun color pop, as served by those blue Monique Lhuillier mesh sandals. With her bold red lip, Ray-Ban Wayfarers, and chic bob in place, this outing had all the makings of a signature Taylor look for the time.

(RIGHT) There are two things one should know about Taylor Swift: she will always commit to the bit, and the girl loves Christmas. For a Jingle Ball performance on her twenty-fifth birthday, Taylor wore a custom two-piece set, as dictated by era fashion rules, by Jessica Jones in an oh-so-festive tartan print, paired with buckled boots by Jimmy Choo. When you are a present to the music industry itself, gift-wrapping is complimentary.

In a promotional interview with *Rolling Stone* conducted while walking around Central Park, she wore a marled gray two-piece by Alice + Olivia, paired with hot-pink, suede Louboutins and a contrasting yellow Dolce & Gabbana bag. Her interviewer noted the "decidedly un-park-friendly outfit" but was impressed by how well Taylor navigated the rambling trails in five-inch heels and a flippy skirt. Such was her commitment to the aesthetic of the era.

But a constant of Taylor's fashion and, indeed, a big part of her appeal and what draws her fans to her is her relatability. In every iteration of her style, there's always been a facet that keeps her approachable, that keeps her feeling familiar. It is what makes her style not only easy to recognize (so important when building a visual legacy) but also a delight for fans to replicate. Her style captured the hearts of fans and permeated the culture so deeply that it was not unusual to see attendees at the 1989 Tour wearing matching sets and sequined jackets and costumes hot-glued within an inch of their lives to mimic looks from her music videos. This was tricky to balance in a time period when her natural thinness, blondeness, and modelesque height took even more of a spotlight due to the clothes that drew those features into even sharper focus. Her propensity for designer accessories, while pretty reined in for a celebrity of her stature compared to other A-listers—even when paired with more affordable brands like Urban Outfitters or Brandy Melville—seemed more out of reach than ever for fans yearning to duplicate her style. Her perfectly polished matching outfits and sleek coiffed bob paired with teetering heels weren't the norm or a daily reflection of her fans. As a counterweight (and as an excellent business move), Taylor continued her partnership with the sneaker brand Keds to offset her heels with something more grounded—literally.

She released a limited collection with Keds that echoed the seagull motif found on the cover of *1989*. Other pairs bore the 1989 Tour logo and, of course, cats.

At the launch event for her limited collection with Keds, Taylor neatly coordinated a crisp white Rachel Zoe romper with sneakers from the collaboration, a navy pair decorated with the New York skyline and, of course, the title of *1989*'s opening track, "Welcome to New York"—color-coordinated perfectly with the signage behind her, naturally. New York was a huge part of her inspiration for *1989*, so it only made sense to include subtle references to the urban center that sparked such creativity. En route to the event earlier that day, Taylor dressed the romper up to be more in line with the chic aesthetic of the era, wearing bright-blue heels by none other than one of the most iconic fashionable New Yorkers: Sarah Jessica Parker.

The Secret Sessions

"You're the expert, you tell me. Or you can check the tag if you want!"

I'm in Taylor Swift's New York apartment, and she's gracefully pivoting around on a pair of silver mirrored Christian Louboutin heels so I can check the tag on her little black dress—confirming that it is, indeed, the Erin Fetherston brocade dress I'd posted on my blog two years prior. It feels like an intimate moment meant to be shared between close friends doing final outfit checks before heading out the door for dinner. But it's not. Because I'm a twenty-two-year-old Taylor Swift fan with a fashion blog standing in that very same Taylor Swift's apartment, and my brain is doing its best hamster-on-a-wheel impression, sprinting mindlessly on a single-lane track and screaming, "Oh my god, oh my god, oh my god, oh my god!"

Secret code names, clandestine meeting spots, multiple security sweeps, signed nondisclosure agreements. No, this isn't a highly confidential federal investigation; it's just the natural process of the Secret Sessions. The Secret Sessions were, as their name indicates, a highly hushed process of gathering some of Taylor Swift's biggest fans together to be the first to listen to her unreleased albums. They each occurred a few weeks ahead of the release of the albums *1989*, *reputation*, and *Lover*.

The format of the sessions was unique and unprecedented. They underlined the incredible sense of trust and the close bond that Taylor feels with her fans—close enough that she doesn't just have them listen to unreleased music before the rest of the world gets to; she hosts them in her own home. Taylor's music has always opened the door for fans to enter her emotional world— but this felt like going multiple steps further to ensconce fans in her physical world too. To introduce the Secret Sessions during the *1989* era, when Taylor had rocketed onto the mainstream pop scene with "Shake It Off," embodied Taylor's uncanny ability to spin viral, marketable moments out of genuine, authentic relationships.

In October 2014, when Taylor Nation (Taylor Swift's official fan club) reached out to ask me my full name and if I was available for a top secret fan event, I knew in my violently beating hamster heart what it meant. Secret Sessions for *1989* had already been hosted that week in Taylor's homes in Los Angeles and Nashville, exploding my update feeds and sending all Swifties into a collective frenzy. But it also meant that, by process of elimination, there was a 50/50 chance I would be invited to the home that Taylor had been occupying more than any other, having acquired the property earlier that year: her home in New York City. And I was. Once I had picked myself up off the floor (because apparently my legs don't know how to handle exciting news) and managed to stop hyperventilating (my lungs were co-conspirators with my legs), I booked my flight from Vancouver, Canada, to New York.

What does one wear to meet their idol? If I were to critique my own outfit all these years later, I'm happy to say there are elements that I and—dare I say—Taylor would both repeat to this day. A contrasting mini skirt set off by a "sandwich style" complementary black top and tall black leather boots is very much an outfit formula I'd wear in the present. But what I remember most fondly is that this pose was her idea—because it felt like something "fashion" we could do.

In between sharing anecdotes about her songwriting process, over cookies she had baked, I made a joke about my blog, *Taylor Swift Style*. Taylor laughed. She happened to have written a song called "Style," wouldn't you know. New core memory: unlocked.

If you've never had the opportunity to meet Taylor Swift, I highly recommend it. 13/10. She's warm and gracious, engaged and focused. She makes you feel like you are the only person in the room, even if you're just talking about your flight from Canada, or what coffee shops in SoHo you've managed to hit up, or, say, how much her music has changed the trajectory and meaning of your entire life. Light, casual conversational fare. She also gives excellent hugs, and her laughter sounds like angels singing.

Taylor gifted me with many things that night. First, the incredible opportunity to meet her in such an intimate, once-in-a-lifetime setting—her home filled with adorable cats who will happily lie across your forearm like fuzzy gloves, Grammy trophies in gilded cages, antique books with faded spines, and a supermodel named Karlie Kloss popping by for a quick hello. Secondly, Taylor also made it so that the first song I listened to on my maiden visit to New York was "Welcome to New York," the incredibly appropriate opening track of her album *1989*. I listened while seated cross-legged on her worn wooden floors, which were adorned with richly embroidered vintage rugs, the soft light of about ten thousand lamps (primarily table) and candles (exclusively Le Labo) illuminating the space, and the warm scent of homemade chai cookies permeating the air.

If I wasn't already well aware of this fact, Taylor Swift is the queen of crafting an impeccable moment.

(OPPOSITE) While I was meeting my best friend at the top of the Empire State Building at midnight (it felt like a sweeping New York–worthy thing to do), Taylor Swift was exiting her SoHo apartment after an evening spent sharing her unreleased album *1989* with eighty-nine handpicked fans, myself among them. I recognized her Erin Fetherston LBD thanks to her having worn it a few years prior while on a date with Harry Styles. A dress like this is recognizable to the discerning eye thanks to its decorative brocade, but it's a timeless piece that works for any fancy (or fan-filled) occasion. Taylor's signature high/low factor is also at play here as she paired a $50 purse from Aldo with $1,345 heels by Christian Louboutin.

Squad Foils

Taylor's popularity during the *1989* era soared to a higher echelon of legacy-making icon status than ever before—not only with the general public, but also with other famous individuals. It was during this time period that "squad goals" became a term highly intertwined with Taylor's image and appeal. Friendships were quickly forged with other blonde, leggy models or It Girls of the moment and then cemented in the star-packed music video for her single "Bad Blood." A remixed version with rapper Kendrick Lamar was a big-budget ode to superhero action films, with a healthy dose of James Bond thrown in. The troupe of guest stars included the likes of Selena Gomez, Gigi Hadid, Zendaya, Martha Hunt, Lily Aldridge, Karlie Kloss, and Cara Delevingne, along with almost a dozen other models and actresses.

In later years, when reflecting on this time period and on the image she projected to the world and to fans, Taylor acknowledged the deeper scars beneath the surface. To *Elle* in 2019 she opened up about her lonely childhood and the empty lunch tables that haunted her past. As a result, she said, "In my twenties I found myself surrounded by girls who wanted to be my friend. So I shouted it from the rooftops, posted pictures, and celebrated my newfound acceptance into a sisterhood, without realizing that other people might still feel the way I did when I felt so alone. It's important to address our long-standing issues before we turn into the living embodiment of them."

Embodying the goal of the squad. At the Billboard Music Awards in 2015, Taylor's "date" for the night was a group of female friends who were guest stars in her music video "Bad Blood"—which she happened to premiere exclusively at the opening of the awards show. She nodded to the premiere appropriately via her accessories, thanks to a custom Edie Parker clutch. Her chic jumpsuit by Balmain provided a clean base for the clutch to really pop. Simultaneously, the dramatic cutouts and plunge gave off the essence of the *1989* fashion signature of the matching set, appearing at a quick glance to be a crop top and pants.

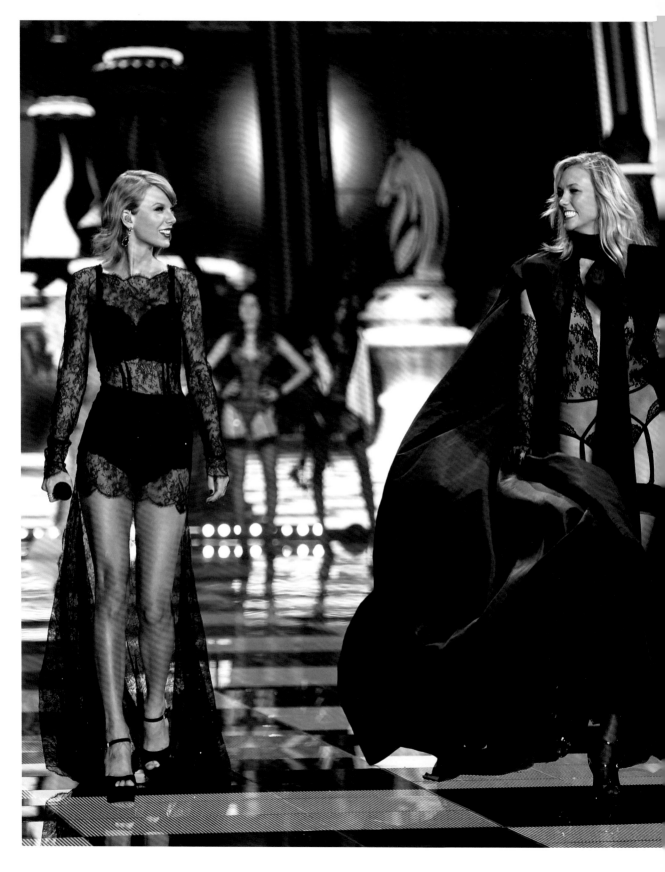

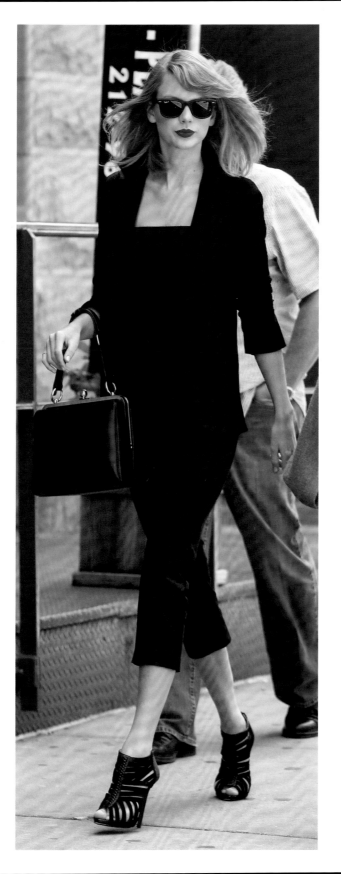

(LEFT) Off-duty-model energy. Perhaps inspired by her bevy of fashion-forward friends, this outfit just screams model power-walk to me. *1989*'s fashion had largely centered on matching sets, but a jumpsuit—like this strapless one by Reformation—feels like a streamlined riff on the convenience of a coordinated top and bottom. Designer accessories like a Dolce & Gabbana bag and Christian Louboutin booties (these were previously worn on a red carpet to the 2013 MuchMusic Video Awards) add to the chic factor. In my opinion, an all-black outfit combined with a red lip will never go out of style.

(FAR LEFT) In Taylor's squad was a veritable Rolodex of supermodels, including Karlie Kloss, whom Taylor got acquainted with after performing at the Victoria's Secret Fashion Show in 2013 and returning for a back-to-back performance in 2014. The two presumably bonded initially over being naturally leggy, blonde, and able to make a dozen cookies at a moment's notice.

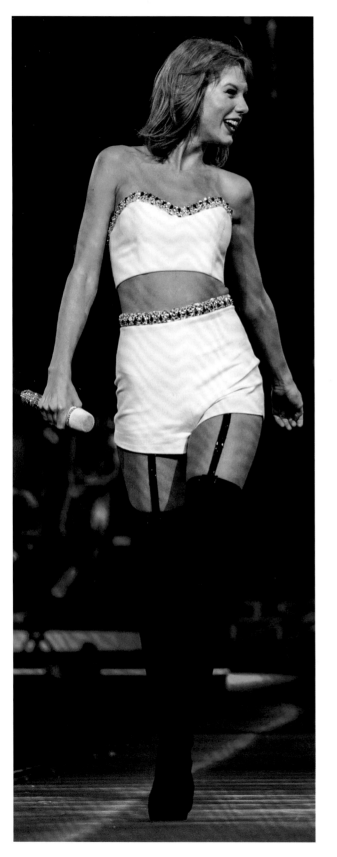
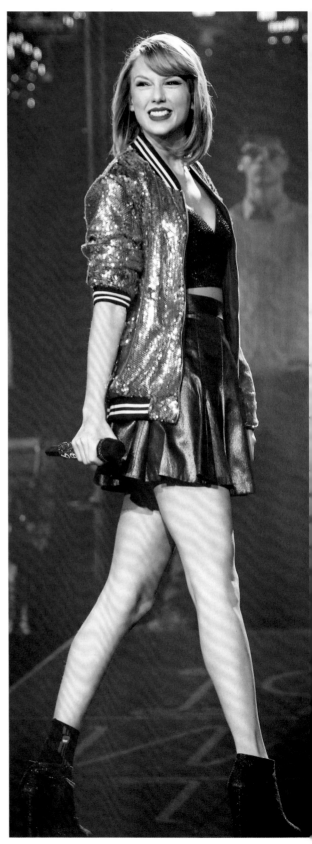

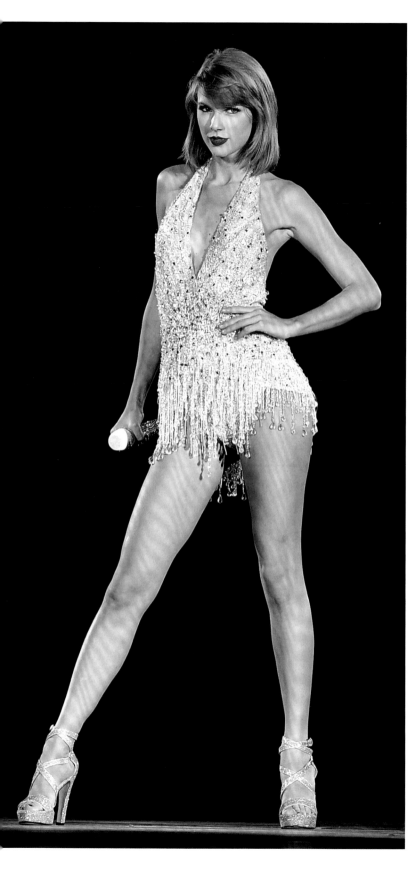

One thing you can always rely on a Taylor Swift show to be is sparkly. But creating a tour wardrobe that captured the dramatic and powerful shift in her style during a new phase in her life, while still staying true to her girlish image, particularly when projected onto gigantic stadium screens to be viewed by tens of thousands of people was . . . tricky, to say the least. The biggest pivot to mark this era continued into her stage costuming. Here, sequins for the tour were often slashed at the midriff (in true crop-top-supremacy fashion) or sewn into svelte leotards, like the rare off-the-runway Zuhair Murad couture version (left) she wore to perform the cream of her pop crop, "Style" (in my completely unbiased, third-party opinion). Heels also played a key role across all her outfits. For previous tours, Taylor had gravitated toward more walkable styles, like cowboy boots, flat knee-high leather boots, or lace-up oxfords. But there truly was no strut more powerful than those provided by the Stuart Weitzman high heels or heeled booties or thigh highs with attached garters (spicy!) that she wore on the 1989 Tour. Especially when paired with coordinating sets or crop tops and skirts by Jessica Jones or a sequin bomber jacket by Libertine.

The Bob

Taylor Swift is not the first woman to make dramatic hair-length decisions postbreakup. And while other celebrities have certainly undergone far more dramatic changes in hair, some cite the "start" of the *1989* era as the moment backstage during the final night of the Red Tour's European leg when, clad in a casual plaid Rails shirt and surrounded by friends, Taylor chopped her signature curls into a super-stylish bob. About a week later—according to a Polaroid in the *1989* lyric booklet—she penned the song "Style," a very pointed (and fashion-forward) nod to the song's purported subject, British boy-bander Harry Styles.

At the height of *1989*'s popularity, the highly polished slew of pop radio hits—"Shake It Off," "Blank Space," "Bad Blood," and "Out of the Woods"— were the sonic complement to the New York fashion takeover. Taylor was photographed near daily—often twice a day—in varying combinations of midriff-baring outfits and heels, most often leaving trendy Tribeca and SoHo gyms, always with that coiffed and bouncy bob and her signature matte red lip. The distilled memory of this iconic, transformative cut even marked the opening passage of the *1989 (Taylor's Version)* album booklet. "For me, it was more than a change of hairstyle," Taylor wrote. It was reinvention.

(LEFT) This outfit has to be the source inspiration for Taylor feeling like a sexy baby. Truly, only Taylor could make low-rise overalls, by Tinseltown, look this cool. I suspect that the simple styling, with a white Topshop tee and Topshop boots that blend into the cuffs of the overalls, coordinated with her red Westward Leaning sunnies and her red Gucci bag, had something to do with it. Having model-worthy height also gives her an edge.

(FAR LEFT) On February 12, 2014, the world got its first official look at Taylor's newly shorn hair. Fresh off a plane from London, Taylor debuted her chic bob while exiting the international terminal at LAX. The chop was modeled after the style worn by Karlie Kloss, who told *The Cut* that after the two had met at the 2013 Victoria's Secret Fashion Show, Taylor had foretold that the cut was imminent, saying, "Karlie, if you see me in a few months with that haircut, know it's because of you." Despite it being her most dramatic hair change to date, I appreciate all the subtle details in this outfit that keep her recognizable even if her most traditionally identifiable trait was suddenly missing. The red lip (sandwiched nicely by a pair of burgundy Rag & Bone boots that I wouldn't mind stealing), the gold Laura Gravestock "13" necklace as an ode to her favorite number, and the Taylor Guitars soft case in hand. These tiny details also have more space to pop due to the incongruous black base of the rest of the ensemble.

Behold actual photos following
Taylor "Angels Do Not Sweat"
Swift theoretically completing
an arduous workout at her go-to
gyms in New York while looking
like she's just stepped out of a
combined Pantene and MAC ad.
She was truly projecting peak
"I Am Single and Going to Work
on Myself" energy as she often
hit up various Barre and Pilates
classes. And I was very much here
for it. Taylor wears: Reformation
dress, Tods bag, Prada platform
sandals; Novis NYC dress, Bulgari
bag, Christian Louboutin peep-
toe heels; black-and-white
Suno romper, Derek Cardigan
sunglasses, Anthropologie bag,
Gucci heels.

In retrospect, it's clear how Taylor's perceived happiness and commercial success at the time were at odds with what was really going on beneath the surface. In her 2020 documentary, *Miss Americana*, Taylor acknowledged having battled an eating disorder and body dysmorphia during the *1989* era. "I tend to get triggered . . . whether it's a picture where I feel like my tummy looked too big . . . and that will trigger me to just starve a little bit, just stop eating," she admitted.

She spoke candidly to *Variety* in 2020 about spending hours on the treadmill, opting for salads during cover stories with journalists, and feeling like she was going to "pass out at the end of a show" because of how little food she was eating on tour. It has become evident in later years how she used her crop tops and heels as an armor to disguise the disordered body-image issues she was trying to keep at bay.

While Taylor is no stranger to injecting vulnerable personal details into songs, this was a rare moment of directness from her in a nonmusical setting. In recent years, Taylor has been part of a wave of young female celebrities engaging in more open conversations about the pressures of the limelight and its ramifications on their mental health. As someone whose image and style are emulated by millions of impressionable young women, Taylor's frank admission was powerful. She continued in *Miss Americana*, "I'm a lot happier with who I am [and] I don't care as much if somebody points out that I have gained weight. The fact that I'm a size six instead of a size double zero—that wasn't how my body was supposed to be. I just didn't really understand that at the time."

Taylor opened the 2016 Grammys with a rendition of *1989*'s penultimate single, "Out of the Woods." Her glittering catsuit, custom-made by Jessica Jones, was a reference to a similar silvery one she wore by that same designer on tour. The black here ultimately fared better with the shadowy tree imagery that supported the song's themes. Joined onstage by album collaborator Jack Antonoff partway through her performance, Taylor auspiciously announced, "Hello and welcome to the 2016 Grammy Awards. But right now, it's *1989*." Though she didn't know it then, her kickoff to that night's festivities would turn out to be an accurate descriptor with *1989* being the talk of the awards when it secured her second Album of the Year win.

Ultimately, it is her pair of complementary, sister Grammy looks in back-to-back years that I not only associate with the era but indeed consider some of the most memorable and iconic fashion choices of her entire career. The looks are unified by a short hairdo, vibrant colors, and a high/low hemline.

Cinematic couture. Taylor's major performance of her juggernaut hit "Blank Space" at the 2014 American Music Awards proved to be just as theatrical as its supporting music video. An onstage costume change, handheld pyro magic, pulley cables, and of course an exploding rose garden all played out over the course of four minutes—some in direct reenactment of the music video, which to this day is still one of her most epic, style-forward video productions. A custom dress by Yousef Aljasmi serves as a sparkly stage-worthy continuation of the couture and chaos the music video establishes. It's with this song—and the video's premise—that Taylor first starts to play with her perceived identity, narrating a metasatire on the media's fictionalized idea of her man-eater image. The "Blank Space" video opens on Taylor in black-widow lace, twitching the strands of her web in La Perla lingerie; next, she's in an Elie Saab gown as she welcomes her next victim—er, boyfriend. The pair dine at a twenty-seater table for two, laden with gold candlesticks that set the mood lighting for her Jenny Packham gown. They march their matching Dobermans across the lawn in Elie Saab. They ride horses in Ralph Lauren. She paints his portrait while wearing Prada, then hangs it in a hallway curiously lined with other eerily similar portraits while wearing Oscar de la Renta. All is well. Until it goes up in the fiery flames of screams and cries and perfect storms. Suddenly, she has made all the tables turn. She's dropping his phone into a fountain while wearing a *1989*-worthy two piece by Naeem Khan. She's dressed in her *Real Housewives of New Jersey* best with head-to-toe Dolce & Gabbana leopard, accessorized by rivers of mascara running down her face mid–mental breakdown. His shirts are in ribbons because she cut them with scissors while wearing Oscar de la Renta. His clothes are in a fiery pit of ash on the expansive lawn because she threw them from the balcony while bedecked in Georges Chakra. His once-perfect portrait has a kitchen cleaver in it after she donned a J. Mendel gown and stabbed his painted face. She's worn her best mesh Milly skirt and Bionda Castana stilettos to go full-on Lumberjacks Gone Wild and axe the tree down that they had once carved their initials into. But it's not really over until Taylor takes a golf club to his car, looking hysterical—but adorable—in a matching pale-pink Katie Ermilio crop top and skirt. And then the cycle repeats. It's a feature film condensed into four minutes and set to an infectious earworm beat. With an unparalleled couture wardrobe.

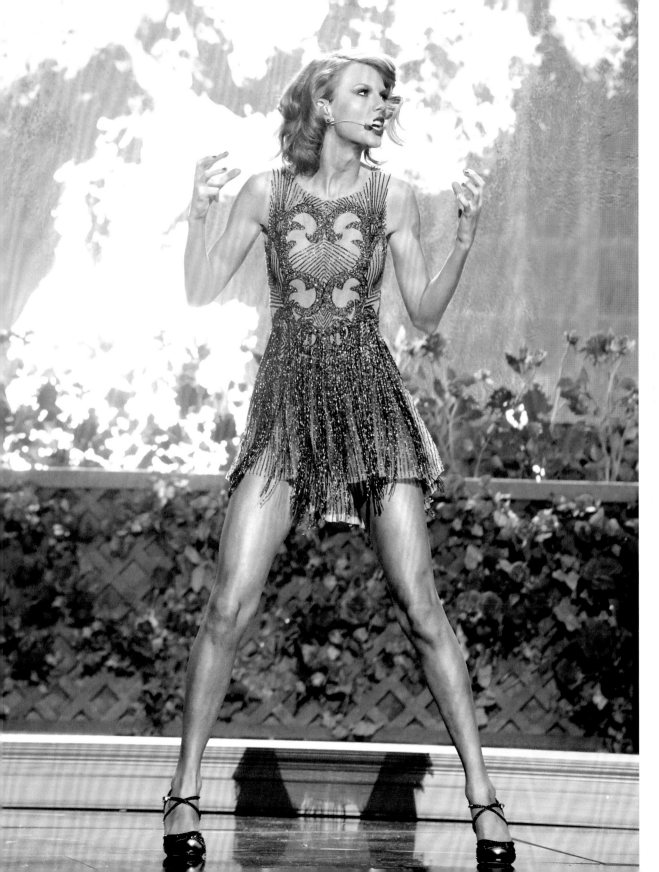

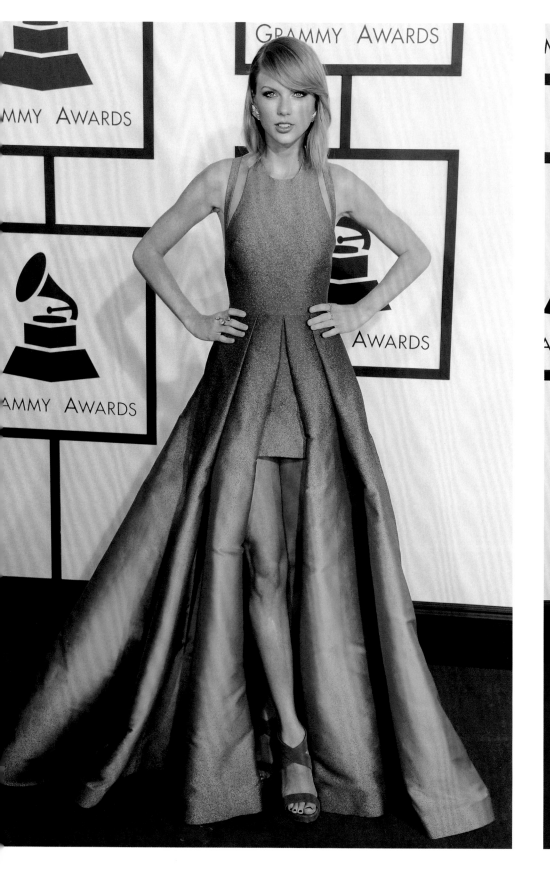

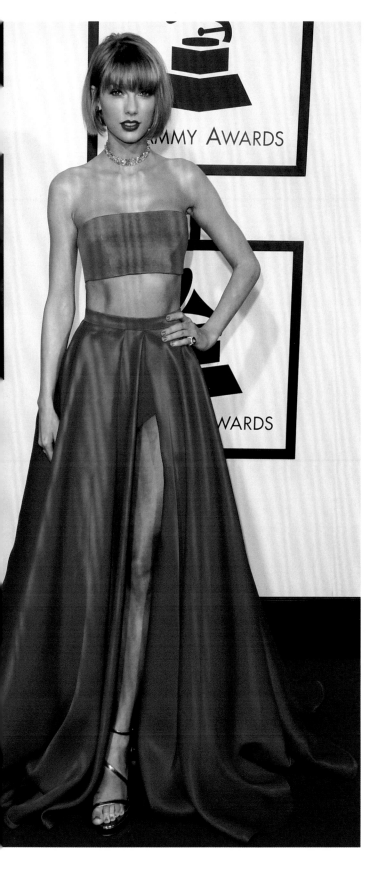

Taylor's double-header appearances at the Grammys in support of *1989* in 2015 and 2016 aesthetically place her squarely in the era. The use of vibrant color, the straightened hair worn in a bob, and specifically the bandeau worn in her 2016 iteration (an ensemble by Atelier Versace) feel like the apex of her crop-top era. The 2015 ombre mullet mermaid gown by Elie Saab was made dramatically more modern when paired with fuchsia heelless strappy shoes by Giuseppe Zanotti. Though I applaud the unique straps, the memorable styling, and the statement jewelry—including some iridescent Lorraine Schwartz studs that really underline the Ariel Goes to the Grammys energy—this admittedly beloved, fan-favorite look falls to my bottom three Grammy moments for Taylor. The 2016 look, which I playfully refer to as Anna Wintour Malibu Barbie, was indeed actually inspired by the great *Vogue* editor in chief. In September 2016, in a video segment for *Vogue* titled "Go Ask Anna," Taylor asked Anna what she thought of her copying her iconic cut, to which Wintour replied with signature brevity that she was "honored." Anna's glib response is about all I'm able to muster about the look as well. While each were iconic in their own right, neither of her *1989* Grammy looks are winners for me.

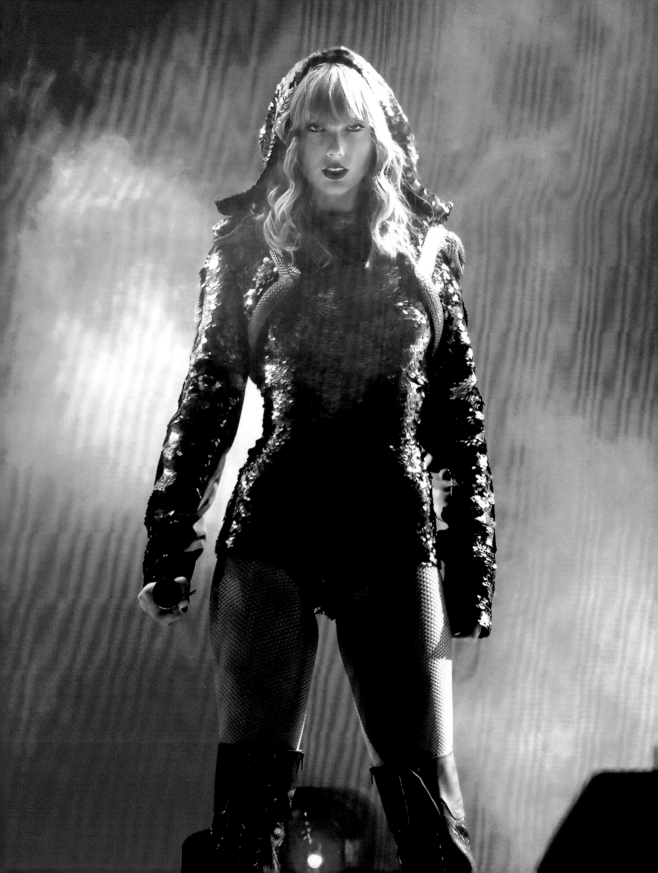

6

reputation

BREAKUPS, BREAKDOWNS, AND THE ULTIMATE COMEBACK

I'VE ALWAYS SAID THAT IF YOUR FAVORITE ALBUM IS *REPUTATION*, YOU REALLY "get" Taylor. *reputation* and its corresponding rollout (an impeccable work of marketing strategy) form a case study in perceived image and lived reality, in smoke and stylish mirrors. Even if you were living under a cultural rock in 2016, you likely heard of the now infamous phone call between Taylor and Kanye West that his then wife Kim Kardashian uploaded in strategically spliced parts to Snapchat. Response to the video resulted in the #TaylorSwiftIsOverParty hashtag on Twitter that called for the "end" of Taylor Swift, in a violent and viral outpouring of cyberbullying. With her identity in free fall, 2016 was a supercut of chaotic decision-making. A breakup with her long-term boyfriend record scratched into a rebound summer fling that flung itself across Europe

And somewhere along the way she had undergone a complete and dramatic aesthetic transformation—wearing chokers, all-black clothes, and sporting short, bleached hair. To the general public, it was easy to point from A (the Kanye West drama) to B (Taylor's makeover) and surmise, "Well, that explains that."

But if you paid close attention, as Taylor's devoted fan base always does, you saw a master in public image at work.

Interspersed between the baggy sweatshirts and the black-cherry lipstick, the white-blonde distressed hair and camo prints, were cracks of light that quietly indicated what was *really* happening when the rest of the world thought she was falling apart.

(PRECEDING PAGE) The origin stories of *reputation* were reflected in the costuming of its eponymous stadium tour, and it's these visuals that Taylor said snapped the entire record into focus for many. "I'd never before had an album that wasn't fully understood until it was seen live. When it first came out everyone thought it was just going to be angry; upon listening to the whole thing they realized it's actually about love and friendship and figuring out what your priorities are," she said to *Entertainment Weekly* in 2019. Comprised entirely of custom pieces by longtime costume designer Jessica Jones, the show's opening scenes of smoke, hissing snakes, and a sultry query asking the audience if they were ready melted into sparkles, rainbow sequins, glitter, and ballads played on acoustic guitar and piano. The sharp contrast of the album's two opposing forces crystallized with the final visual puzzle piece of the tour. "That is the album that took the most amount of explanation, and yet it's the one I didn't talk about," Taylor said to *Rolling Stone*. "I'd never played with characters before. For a lot of pop stars, that's a really fun trick, where they're like, 'This is my alter ego.' I had never played with that before. It's really fun. And it was just so fun to play with on tour—the darkness and the bombast and the bitterness and the love and the ups and the downs of an emotional-turmoil record."

What We Thought Was Happening

Fresh from the meteoric success of the *1989* era, Taylor revealed that after releasing five albums in two-year intervals (since her eponymous debut in October 2006, it had become something of an industry joke that one could consistently expect a fresh Taylor Swift LP to drop in the fourth quarter of every even year like clockwork), it was time for a break. In October 2015, she told *NME* that after the last leg of the 1989 Tour, she "should take some time off." She continued, "I think people need a break from me."

But what had been a planned, intentional, and frankly well-deserved break from almost a decade of shuttling from recording studios to promotional appearances to sold-out arenas and stadiums was very quickly derailed. That summer is what Taylor described in diary entries as "the apocalypse."

In February 2016, Kanye West released his song "Famous," in which he assigned himself kingmaker of Taylor's success. Somehow even more insulting, he also indicated that they would hook up—while simultaneously calling her a bitch. The line is a reference to Kanye's first public altercation with Taylor and, by extension, an insulting presumption about who deserves the real credit for Taylor's success. The accompanying music video disturbingly depicted a wax figure of Taylor naked in a bed with Kanye and other wax replicas of famous people, including Donald Trump, Amber Rose, and Anna Wintour. In a Tumblr post, Taylor described the project as "revenge porn." It was a moment cemented in celebrity feud culture that had occurred almost seven years prior when Kanye ran onstage during the 2009 MTV Video Music Awards to rip a microphone from the teenage Taylor's hands as she accepted her award.

Upon the release of "Famous," Taylor took to social media to condemn both the lyrics and the video. In response, Kim Kardashian released heavily edited clips to the short-form video-sharing app Snapchat depicting Kanye on the phone with Taylor as she appeared to approve the sex lyric (though notably the "bitch" portion was not included). Taylor pleaded a technicality, asking, "Where is the video of Kanye telling me he was going to call me 'that bitch' in his song? It doesn't exist because it never happened." But the damage was done. When Kim took to Twitter to describe Taylor as a snake to her millions of followers ("It's . . . National Snake Day? They have holidays for everybody, I

mean everything these days!"), the moniker stuck, "proof" of Taylor's slithering insincerity. Her social media feeds became a digital snake pit, filled with thousands of comments depicting the snake emoji in giant, unavoidable blocks. In the wake of her highly public cancellation, her only remaining weapon was to follow her original plan: to disappear.

To *The Guardian*, she described why silence was her chosen method of defense: "When people are in a hate frenzy and they find something to mutually hate together, it bonds them. And anything you say is in an echo chamber of mockery." The result was worse than a raking over the coals; it was a vengeful celebration of a public autopsy. "When you say someone is canceled, it's not a TV show. It's a human being," she said to *Vogue*.

Her strategy turned to survival amid a tidal wave of public opinion and vitriol. "You can either stand there and let the wave crash into you, and you can try as hard as you can to fight something that's more powerful and bigger than you. Or you can dive under the water, hold your breath, wait for it to pass and while you're down there, try to learn something."

When Taylor resurfaced in 2017 with *reputation*, she had skillfully created a cohesive project that reclaimed her story sonically and visually. From her first announcement of the album, Taylor declared, "There will be no further explanation, there will just be *reputation*." Forgoing her traditional media interviews, which usually provided journalists with early access to her thoughts and her personal journey to creating an album, she cut off all media contact. This shifted the focus of both the public and the media to the two communication methods over which she had total control: her music and her fashion. And both delivered to bombastically convey the two-part story of her perceived reputation and her lived reality post-"Famous."

"There will be no further explanation, there will just be reputation."

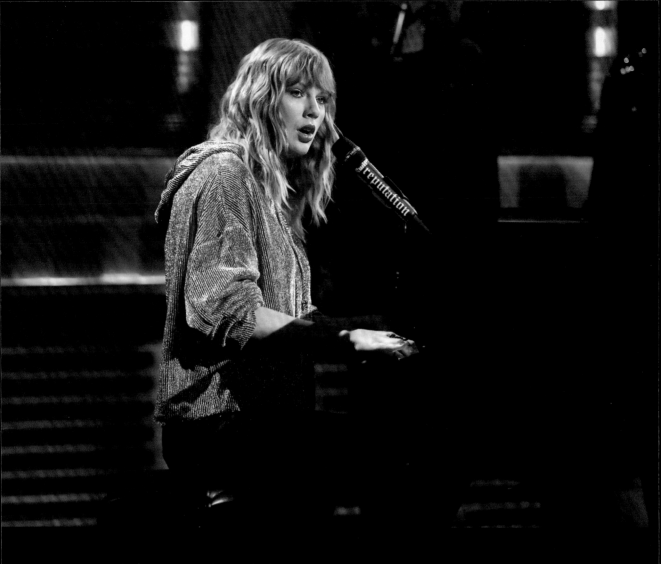

reputation's grungy aesthetic relied on a predominantly darker color palette accented by plaid prints, studs, and distressing. Typically, sartorial risks tend to be risqué. But what Taylor does best with her music and her fashion is to forge her own path. Here, it's ironic that what is seen as an era of her greatest fashion gamble is actually an inversion of the salacious norm. While previously she may have worn a crop top to make a statement, in the *reputation* era she instead blanketed herself in oversized pieces like this RIA hoodie, which shrouded her body—aiding in the mystique of *reputation* while also cocooning her in a cozy armor. The slightly shimmery quality of the fabric gives it a subtle chain-mail feel while still adding a sense of softness, an appropriate balance as she took to the piano for a performance of *reputation*'s gentlest song— the closing ballad "New Year's Day"—on *The Tonight Show with Jimmy Fallon*. Jimmy revealed that Taylor had chosen to surprise him by debuting the live version of the song on his show as a tribute to his mother, Gloria, who had recently passed away. He identified with a line in the song's second verse, sharing, "When we were little, my mom would walk us to the store and we would hold hands and she would squeeze my hands three times and say, 'I love you.' And I would squeeze back, 'I love you too.'" Even in what was seemingly her darkest time, the Taylor who connected to people emotionally through the power of her music showed up. The two shared a tearful hug at the end of the performance.

What Was Really Happening

It isn't surprising to me that the longest-lasting of the *reputation* era's songs is not the bombastic, smack-you-in-the-face, unapologetic lead single, "Look What You Made Me Do." It was instead the quiet, unexpected sleeper hit "Delicate" that made the most waves on radio, staying on the *Billboard* Hot 100 for thirty-five weeks, the longest-charting single of any from *reputation*. This success is an almost perfect reflection of *reputation* itself, an album that at its core is about a love story that blossomed in the dust left behind from her crumbled pedestal. To *Rolling Stone*, Taylor would say, "The one-two punch, bait-and-switch of *reputation* is that it was actually a love story. It was a love story in amongst chaos." *reputation* speaks to the perception of dressing for a prewritten role against the soft, unembellished reality of finding comfort in the people who accepted her when the costumes were stripped away.

Behind the smoke and mirrors and, yes, all the snakes, Taylor was falling in love. For every "I Did Something Bad," self-casting as a witch at the stake, there is a "New Year's Day" quietly picking up bottles with a loved one at 12:01 a.m. on January 1. For every "Getaway Car" crime-scene, high-speed-heist exit from a poorly handled rebound, there is a "King of My Heart," a cautiously optimistic declaration that perhaps the end of relationships ending has finally come. She took moments throughout the promotion of *reputation* to inject more familiar and classically Swiftian styles into her wardrobe, like sequined minidresses, ringlets, and sparkles—all of which got a slight facelift for the album's thematic fashion. Her curls were more relaxed and unkempt, as though Taylor felt so comfortable in her own skin that there was no need to break out the curling iron. Her favored glitter dresses moved away from singular hues of gold and silver metallics and into glistening, unabashedly happy, chromatic rainbows. She was finding solace. She was creating a safe space to be seen as Taylor Swift, the human. And it showed in the careful and considered way she let her fashion reveal the happy emotions she was experiencing in private. "It's so strange trying to be self-aware when you've been cast as this always smiling, always happy 'America's sweetheart' thing, and then having that taken away and realizing that it's actually a great thing that it was taken away, because that's extremely limiting," she noted to *Vogue*.

Reclaiming the Snake

In response to her perceived reputation, Taylor doubled down on the insults people projected on her. She interspersed well-placed snake motifs throughout her wardrobe and reclaimed the reptile as the symbol of her comeback. The announcement of *reputation* was ushered in by a complete wipe of her social media feeds, replaced by a three part gif of a coiled snake—primed to attack. In later years, she would expand even further on her affinity for the creature. To *Elle*, ahead of her thirtieth birthday in 2019 (is anyone surprised that, according to Chinese zodiac, 1989 is the year of the snake?), she advised being "like a snake—only bite if someone steps on you." In this way, she reframed what was first used as an attempted takedown of her career—a symbol of her alleged duplicity and lies—to reinforce her side of the story, responding as a last resort. It also gave her a litmus test of who in her life she could really trust to stick around, and who was simply fair weather.

One of her best, and most nuanced, sartorial snakes was captured in her *reputation* release-week appearance on *Saturday Night Live*. Taylor combined her dichotomous reputation into a single moment. For her performance, she sang "Call It What You Want," a vulnerable and soft ballad that describes the loving relationship she had built out of sight from the prying eyes of the public. One of the handful of songs on *reputation* she would describe as one of the "moments of [her] true story" captured from her "newly quiet, cozy world that was happening on [her] own terms for the first time." But she did so while wearing an oversized black sweatshirt by Gucci, immediately recognizable by the crisp red, black, and white stripes of a scarlet kingsnake—one of the brand's signature animal tokens. It was a smart and succinct way to visually place her in the *reputation* era (the dominating black color palette, baggy silhouette, and tough lace-up combat boots, so different from the heels and cowboy boots of her past) while still reminding people of who she has always been: a girl with a guitar, singing about her feelings. It's also worth noting that the kingsnake is held in regard as a symbol of power and wisdom—a perfect animal symbol to adopt when you're seeking to reclaim the narrative of your career, armed with the experience and wisdom that comes from rebuilding your life after a devastating blow.

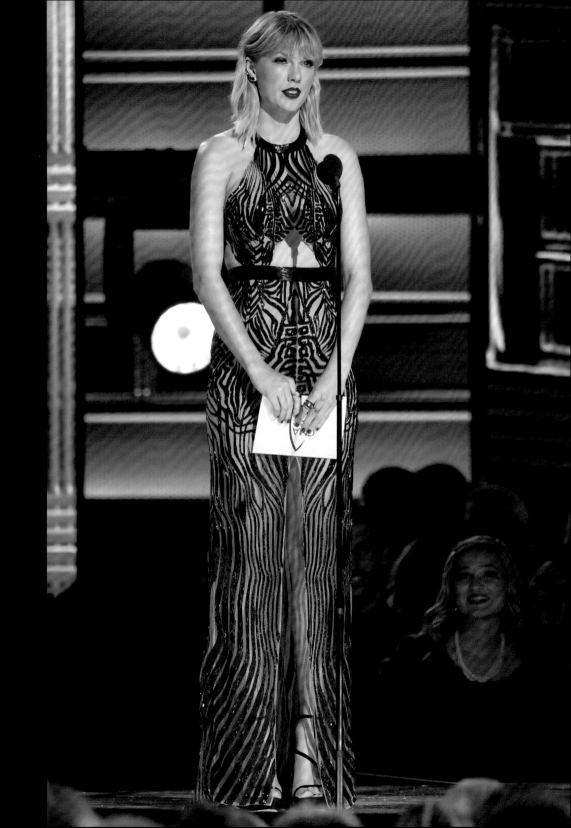

"The one-two punch, bait-and-switch of reputation *is* that it was actually a love story."

—Taylor Swift, *Rolling Stone*, 2019

(OPPOSITE) One of Taylor's rare public appearances between the end of the *1989* era and the official kickoff of *reputation* was in November 2016 at the 50th Annual Country Music Association Awards. She turned up to present the show's highest award, Entertainer of the Year, an accolade she herself had received twice. She took to the stage in a very spicy, black, strategically sheer-paneled halter gown by Julien Macdonald. It feels noteworthy to me that this look both bridges some iconic fashion silhouettes from the previous era (cutouts and a slightly peekaboo midriff, à la *1989*) and offers a potential nod to what would come next (the dark-palette, edgy, and slightly disheveled styles of *reputation*—the way the straps of her Stuart Weitzman heels wrap around her ankles feels almost snakelike, no?). It had been three years since she had appeared at this awards show to seemingly say her gracious farewell to the genre. And during such a turbulent time for her image, I'm sure it felt really good to be back in the arms of a very welcoming crowd, who were just happy to see one of the genre's biggest (former) stars in their midst once again.

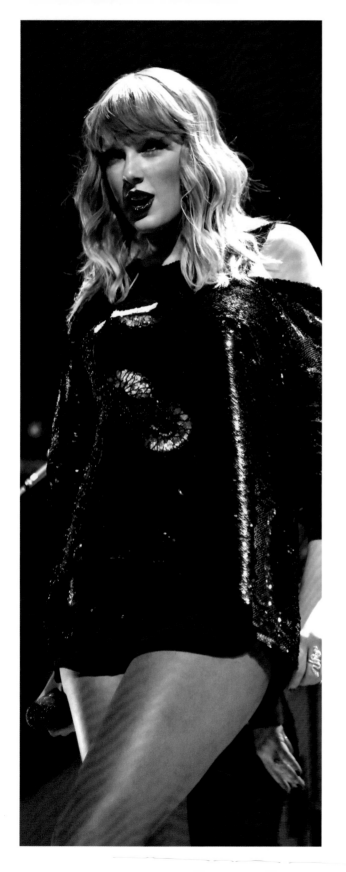

(LEFT) While performing at the 2017 Z100 Jingle Ball in New York, Taylor combined her lifelong love of Christmas with her latest animal familiar—the snake—by wearing a custom sparkly, oversized black top featuring the reptile sporting a jaunty and festive Santa hat. This was such a fun tongue-in-cheek fashion moment. Throughout the *reputation* era she would continue to evoke imagery of a snake, highlighting the best parts of the misunderstood creature after it had been used to negatively paint her image just a few years prior. Her ability here to make it cute and even funny demonstrated that the online taunts no longer had the ability to harm her. And evoking it alongside one of her core personality traits as a hardcore holiday enthusiast provided the visual of self-acceptance—as though she had absorbed the motif as a true part of her identity.

(RIGHT) Snakes played a powerful role during the *reputation* era, symbolizing the reclamation of Taylor's narrative. This gigantic cobra, part of the reputation Tour theatrics, was named Karyn by Taylor. Specifically with a *y*. In a personal essay to *Elle* in 2019, Taylor wrote, "A few years ago, someone started an online hate campaign by calling me a snake on the internet. The fact that so many people jumped on board with it led me to feeling lower than I've ever felt in my life, but I can't tell you how hard I had to keep from laughing every time my 63-foot inflatable cobra named Karyn appeared onstage in front of 60,000 screaming fans. It's the stadium tour equivalent of responding to a troll's hateful Instagram comment with 'lol.' It would be nice if we could get an apology from people who bully us, but maybe all I'll ever get is the satisfaction of knowing I could survive it, and thrive in spite of it." As a bonus, during the show Taylor was transported from stage to stage positioned in a ten-foot-tall replica of a snake's skeleton (sadly nameless).

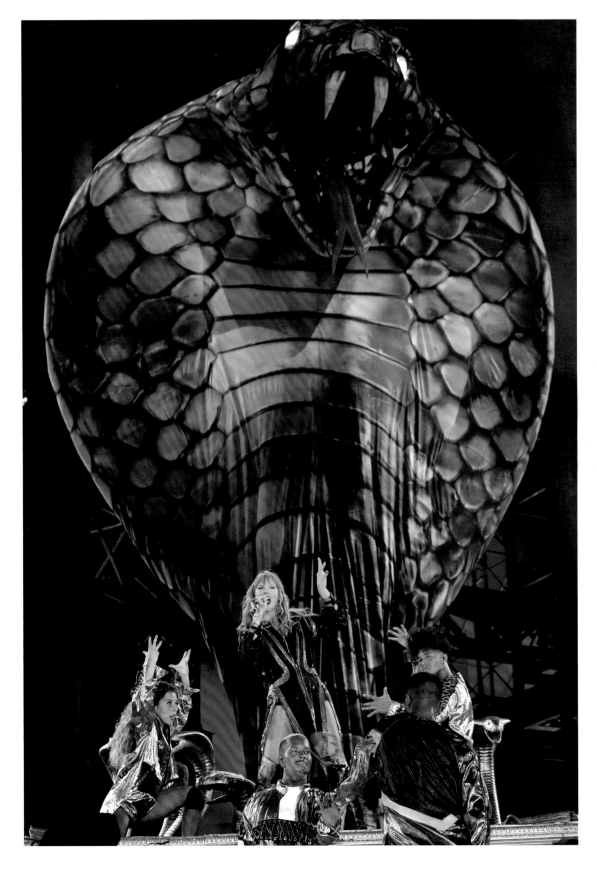

(LEFT) Ahead of reputation Tour dates in nearby East Rutherford, New Jersey, Taylor walked out of her Tribeca apartment in a look that was about a hair's breadth away from being a *little* too brazen. It was, however, saved by fun accessories (like the octagonal Fendi sunglasses and studded Saint Laurent sandals) and low-key hair styling that push it toward cool rocker girl and away from sad coyote ugly. I'm particularly a fan of the expert layering of animal print here via her R13 leopard skirt and Stella McCartney leopard chain backpack.

(RIGHT) In addition to plenty of black and camouflage, Taylor turned to animal print as part of establishing the reputation of *reputation*. It brings to mind the image of the caricature she painted in the "Blank Space" music video from 2014 of a desperate pseudohousewife crying on the floor in head-to-toe animal print with rivers of mascara running down her face. If "Blank Space" was a song that poked fun at appearances versus reality, *reputation* was the embodiment of that dynamic in album form: the coy dance between how she was perceived and how she actually felt. Her voluminous A.L.C. leopard coat and sky-high Prada heels—with a lot of leg in between—feels like a cheeky and knowing flirtation with caricatures of her image

Bleachella

reputation was full of dramatic style changes, including makeovers within the era itself. But none were as polarizing as the freshly shorn, jagged, platinum bob she debuted at the music festival Coachella in April 2016. It earned this mini era the nickname "Bleachella" (don't worry, folks, she came to her senses and returned to her natural ashy blonde within a few months). Eschewing typical festival fashion, Taylor traipsed those festival grounds in an oversized T-shirt by The Great and black shorts paired with a $575 Versace choker and $565 Golden Goose sneakers. Her most talked-about accessory, though, of course, was that hair.

In April 2016, *Vogue* headlined the feature "Taylor Swift as You've Never Seen Her Before." Provocative and click-baity, sure, but nevertheless completely accurate. It featured a bleach-blonde Taylor in platform leather boots by Vetements that leaned more Gaga than Swift. The spread was jarring, editorial, and unified by her new hair and those boots, which she would subsequently steal from the set and proceed to wear while clomping around New York City. It also marked the second time a *Vogue* spread prompted a dramatic change in hairstyle for Taylor, the first, of course, being her *Red*-era bangs. Now that the peroxide fumes have cleared and the initial shock factor has waned, I feel we should applaud the team at *Vogue* for having the visionary confidence to see Taylor as someone who could live up to the editorial edge the bleached look gave her. I like to think of it as permission from the highest "powers that be" in fashion to be a little messy and uninhibited. Things Taylor likely hadn't given herself full permission to embody in her career thus far.

During this short time period, her most notorious Bleachella-related appearance was at the 2016 Met Gala. Organized by *Vogue*, the gala—sometimes known as the Costume Institute Gala or even the Met Ball—is a fundraiser for the Metropolitan Museum of Art's Costume Institute in New York City. Throngs of celebrities descend upon the Met every first Monday of May. Fashion coverage is so extensive that the evening is often cited as one of the most significant fashion events of the year. Because Taylor was one of the co-chairs that year, her red carpet look was highly anticipated. Expectations for co-chairs and their adherence to the Met Gala's annual "theme" are high, and

Taylor delivered her take on the theme Manus x Machina: Fashion in an Age of Technology in a silver metallic cutout ensemble by Louis Vuitton.

Thanks to the styling—with dark lipstick, bleached and shredded short hair, and sharp onyx accessories—the look was one of her most dramatic and starkly different fashionable outings. In her quest to meet the theme (which many guests interpreted as "sci-fi" adjacent), Taylor appeared nearly unrecognizable in this futuristic goth-girl ensemble. But that is the fun of fashion, especially when you introduce new styles at key periods of your life, as Taylor is so apt to do. It forges memories and places a certain person at a certain time, crystallizing exactly the circumstances of that moment. Taylor even said herself in an essay to *Elle* upon her thirtieth birthday, "If you don't look back at pictures of some of your old looks and cringe, you're doing it wrong. See: Bleachella."

"It would be nice if we could get an apology from people who bully us, but maybe all I'll ever get is the satisfaction of knowing I could survive it."

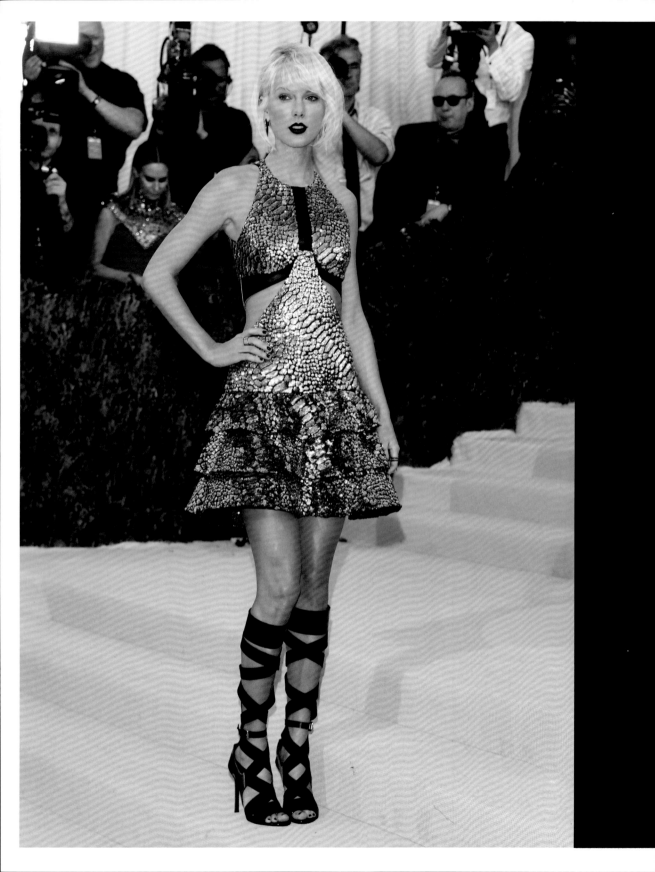

Because when you're fresh off a breakup, there's nothing better than attending the Met Gala in a sparkly mini and some saucy knee-high wrap stiletto boots. This night went down in history as one of the most chaotic for Taylor fans: the bleached hair, black-cherry lipstick, general IDGAF energy—and of course the photos that emerged from the event of Taylor dancing the night away with actor Tom Hiddleston. Taylor would go on to have a whirlwind summer romance (aka steamy rebound) with Hiddleston; months later they were photographed traipsing around Italy and England and engaged in heavy PDA. The moment images of the two emerged in a full headlock embrace on a rocky seaside formation is forever burned into the memories of many. The theme for 2016's gala was Manus x Machina: Fashion in an Age of Technology—a convoluted way of dictating that attendees wanting to adhere to dress code should incorporate fashion that involved fancy tech in the production process. Most celebrities, Taylor included, took this as a reductionist opportunity to go "sexy sci-fi robot." Since she was co-chair of the event, nominated by *Vogue* editor Anna Wintour, all eyes were on her (and her fellow hosts) to set the tone (and the bar) for one of fashion's biggest nights. In the microcosm of Taylor's world, this look represented a sartorial shift dramatic enough to flip the lid—and matching skirt set—of any Swiftie who knew her best for her ultrafeminine, approachable style. On the world stage of fashion, where the Met Gala is the benchmark event of the social calendar—this look gives clubbing, not couture. In short, it fell short of expectations.

(RIGHT) The night before the 2016 Met Gala, Taylor attended a dinner at *Vogue* editor Anna Wintour's home, giving a taste of the edge to expect the following evening with a head-to-toe patent and plaid look by Louis Vuitton. There's a certain Vivienne Westwood, London punkitude tilt to the outfit that works in favor of her edgy new bleached look.

(FAR RIGHT) A leopard may not be able to change its spots, but Taylor would have, could have, should have changed out of this velvet leopard dress by Monique Lhuillier. From the neck up, this is a fun punk Bleachella moment with hair as white as angel wings and as fine as angel hair pasta. The dress itself, though, particularly in conjunction with a choker, gives this millennial crushed-velvet flashbacks.

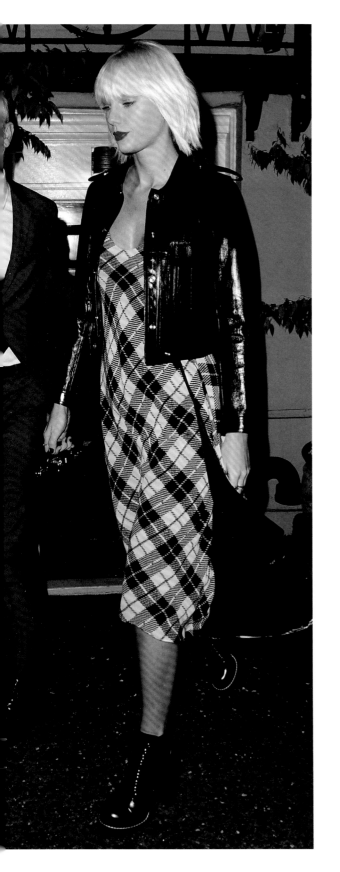
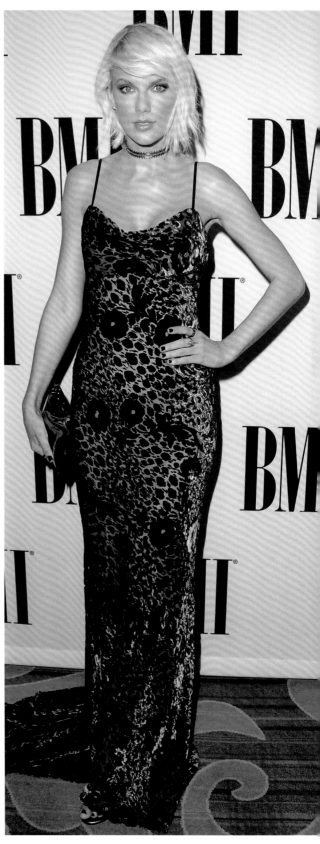

If she wasn't reaching for chunky platform boots to add height and edge, Taylor was opting for designer sneakers that retailed in the hundreds of dollars by brands like Golden Goose, Saint Laurent, and Gucci to provide a casual look that complemented the distressed and plaid pieces she was now turning to. But a mainstay of Taylor's style has always been combining high and low garments—like a $62 denim crop top by Madewell (right), or a $77 pocket-front romper by Bishop + Young (far right).

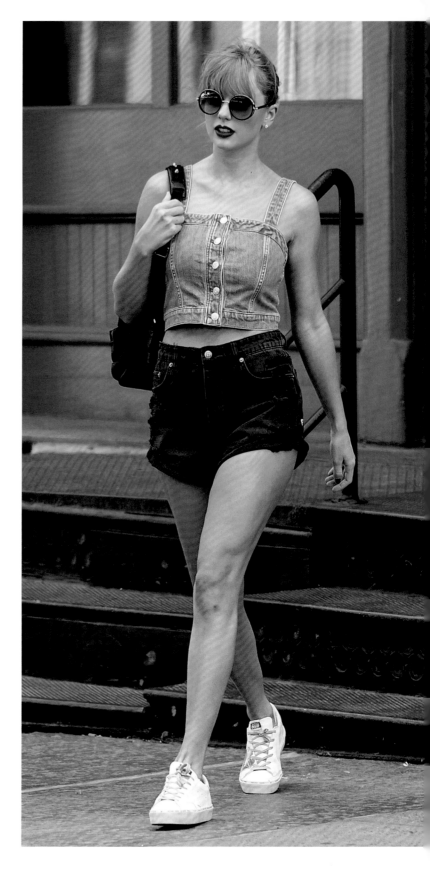

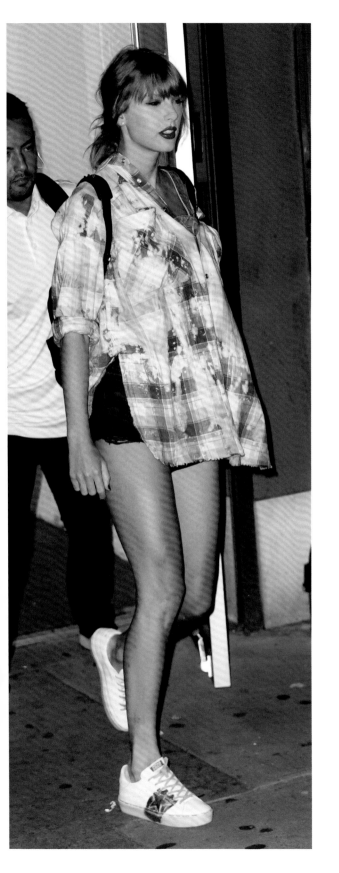
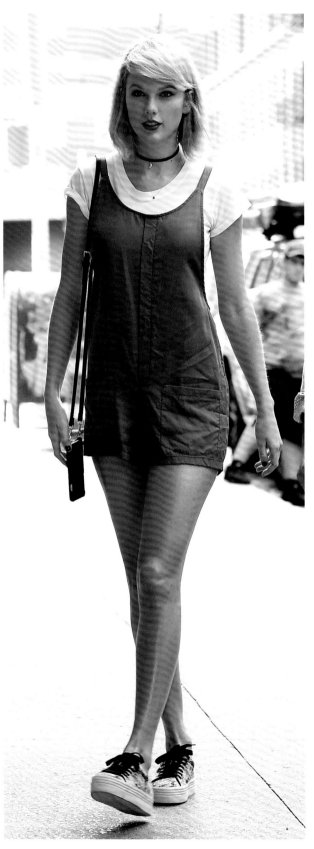

(FAR LEFT) Even *reputation*'s take on the city that had been iconified in the poppier *1989* album leans a little more grungy and dirty. An oversized bubblegum-pink Balenciaga hoodie is paired with frayed, Alexander Wang denim and zippered leopard Giuseppe Zanotti boots. The straps on her Christian Louboutin backpack give the entire look a spunky school-goer look, on a designer budget.

(LEFT) Almost to soften the blow of her edgy accessories and all-black Isabel Marant ensemble, Taylor retained a semblance of her recognizable style in February 2016 thanks to her short bob and red lipstick. The Vetements boots, on the other hand, foreshadow the darker and edgier fashion to come and were an Easter Egg from the attention-grabbing *Vogue* photoshoot (where she acquired them through an act of sneaky stealing) that kickstarted her most dramatic aesthetic shift to date.

(RIGHT) Forget snakes, this Alexandre Vauthier couture gown gives black widow. Worn to the 2016 Vanity Fair Oscar after-party, everything from the gold styling to the artful balance of the plunge and the high slit (I'd normally recommend one or the other to avoid being too much, but too much here is just enough) is the Midas touch. Easily a top-ten fashion moment.

TSS Green

We all have our favorite color combos. Mine involves green—or, more specifically, Taylor Swift in green. Emerald, hunter, kelly, shamrock, evergreen—I don't discriminate. There's just something about seeing this particular hue in fashion that enchants and excites me. Possibly because it can veer anywhere from a bold and saturated red carpet moment, to a colorful fashion pop in a candid outfit, all the way to what I call a "colorful neutral" that isn't one of your standard shades of black, white, or gray but plays well with all those neutral tones and can successfully blend into the role of a secondary fashion character when needed.

Lucky for me, Taylor has worn many beautiful green things over the years.

(LEFT) This Michael Kors gown, worn to the 2014 American Music Awards, is still one of my favorite green items Taylor has ever worn. That shade is so zingy and fresh against her tanned skin. It's impeccably tailored (pun intended) to just kiss the floor, and the illusion neckline is as close to perfect as one can be. Note how seamlessly it blends into her skin tone to be invisible and give the appearance of a sweetheart crop top. And on that note, it's a fresh and unexpected way to present the most iconic fashion item of the era in a dramatic way for the red carpet.

(CENTER) A sweet and sassy emerald mini by Miu Miu. Taylor wore this satin emerald dress to the LA premiere of her good friend Emma Stone's film *Easy A* in 2010. This saturated color just pops on the red carpet, and I love the choice to consistently accessorize with gold. Even her locket—by Neil Lane—had a small emerald set into it to perfectly coordinate.

(RIGHT) This Novis NYC two-piece was a refreshing, minty choice that was light and breezy—perfect for the youthful and fun 2014 Teen Choice Awards. The graphic panels and hem detail of the skirt add some interesting fashion elements, and I loved the choice to go sunny and yellow with her Charlotte Olympia knotted sandals.

(LEFT) Business in the front, emerald-green party in the back. This paneled Antonio Berardi dress Taylor wore ahead of her appearance on *The Late Show with David Letterman* in October 2014 was the perfect choice for a late-night talk show interview—an excellent example of dressing for the occasion. The black is classic and chic, with a requisite Swiftian sparkle going for it in the embellishments. The front is great for an evening moment and is the most prominent thing the camera will see during the main, seated-interview portion of her appearance. But the contrasting satin side and back panel is a fun pop onscreen that's visible during her walk-on to add a fashion element to her big introduction to the show.

(CENTER) Designer Katherine Hooker says that timeless quality is the bedrock of her brand. With the Princess of Wales as a repeat customer, that makes all the sense in the world. Katherine noted to me that Taylor first began to wear her designs when her style started taking a turn toward vintage. "There's a natural elegance to my clothes. I thought it was very interesting when Taylor started buying my stuff. It felt like my clothes were being bridged between my take on classic and hers. She's very classic in a completely different way." Katherine said this silhouette was born from a desire to do her take on a cape that still allowed enough range of motion to easily carry a handbag. This was made possible by the coat's unique ultra-high back pleat, which provides room for the coat's swinging shape. "It's all about the line of the silhouette, and the cut of a coat can not just change the way that you feel but the way that you move," she said. Her concept of creating heirloom pieces worthy of passing down through the generations really resonates here with Taylor's mix of modern (those burgundy Rag & Bone boots) and vintage-tinged (that cornflower drop-hem Paul & Joe dress). "My aim is that your piece is the best item of clothing that your granddaughter and great granddaughter will find in your attic," says Katherine. Oh to be in the steamer trunk pressed and saved with this coat for decades.

(RIGHT) Expertly displaying what I like to call "sandwich styling." Like two pieces of artisanal sourdough, Taylor's coordinating green Elie Saab bag and Prada heels create a neat, symmetrical visual with chic neutral fillings in between—in this case a blazer and shorts set by Missguided. If there is one item I'd like to call "dibs" on from Taylor's entire closet, it's that beautiful green bag.

(ABOVE) Sure, you've seen Taylor Swift in a shimmering sequined gold gown before. But have you seen Taylor Swift in a shimmering sequined gold gown with emerald drop earrings? Just this once. And that's truly the power of styling: when a relatively small part of an outfit can make such a big, distinctive impact. At the 2011 American Music Awards, her sparkling Reem Acra gown was upstaged by this pair of oval green earrings by Lorraine Schwartz. They frame her face and provide a much-needed color pop against what is ultimately a lot of (lovely) gold. Her sleek side pony also represents an excellent bridge between the charming side braids of the *Speak Now* era and the straightened strands of the *Red* era.

(ABOVE) Taylor had quite a few of these fringed sets by Jessica Jones to wear for her finale number on the 1989 Tour. They came in a myriad of colors, including pink, blue, and—of course—green. I know I don't have to tell you which one is my favorite. And whether she knew it or not, I don't think there was anyone seated anywhere in Rogers Arena more happy than me to see her wear the green set when she performed in Vancouver.

(RIGHT) Taylor's duality means that sometimes she is a daisy—but I personally prefer a poison ivy touch. On her Eras Tour, to bring the wood-nymph-goddess energy of *folklore* to the stage, Taylor leafed through a series of beautiful gowns by Alberta Ferretti—unified by flowing chiffon elements and swishy cape or split-sleeve details—that appeared to be lifted from Florence Welch's closet. My favorite of them all is this chartreuse-green frock with intricate, trailing leaf embroidery, trumpet sleeves, and illusion detailing.

The signature sequined minidresses of previous tours got a Technicolor makeover in support of *reputation*. And it isn't even slightly surprising that this costume, a custom rainbow sequin number by Jessica Jones, was chosen to be worn during the performance of "Delicate," a song about that first taste of vulnerability with someone new, of testing the waters and tiptoeing around big feelings and romantic admissions. It's the clearest nod to what lies at the heart of *reputation*. Visuals like this, seen by tens of thousands every night, helped to bring into focus the sincerity and the satire that split *reputation*'s narrative. In its review of the tour, *Variety* noted that, "at the beating heart of it all, we're still left not so much with dragons or defensiveness but in the endearingly earnest presence of pop's most approachable superstar." It's no wonder that Taylor would describe the reputation Tour as "the most transformative emotional experience" of her career that put her in the "healthiest, most balanced place" she'd ever been and helped her "disengage from some part of public perception [she] used to hang [her] entire identity on." To *Entertainment Weekly* Taylor described moments from the reputation Tour when she "would look out into the audience and I'd see these amazing, thoughtful, caring, wonderful, empathetic people . . . [who] actually see me as a flesh-and-blood human being. That—as contrived as it may sound—changed [me] completely, assigning humanity to my life." Forget candy-coated, *reputation* is cobra-coated to disguise the sweet and authentic romantic heart of an album that does a fantastic job of putting on a tough front.

In May 2018, Taylor was scheduled to appear at the 2018 Billboard Music Awards, her first major awards show since the release of *reputation* six months prior and, really, since her historic 2016 Grammy wins for *1989*. The assumption for her fashion, naturally, was something brash and edgy to reflect the externalized imagery of her album. Instead, she subverted all expectations in a pastel custom Versace gown. Even her hair and makeup exuded softness and sweetness. Rather than opting to play the costumed role people wanted, she allowed the public—for a brief moment—to peek behind the curtain so they could be in on what fans had already been translating from her music and less publicized outfit choices.

In accepting the award for Top Selling Album for *reputation*—which had become her fourth consecutive album to sell a million units in a single week— Taylor spoke directly to her feelings of humanity and their role in her music. "When I started writing songs when I was twelve, I started because it made me feel more understood," she said. "When I was making *reputation* I felt really misunderstood by a lot of people. So to the fans I want to say thank you for continuing to show up. . . . Thank you for making me feel understood again."

"When I was making reputation I felt really misunderstood by a lot of people. So to the fans I want to say thank you for continuing to show up. . . . Thank you for making me feel understood again."

Designer Donatella Versace confirmed via social media that Taylor's gown for the Billboard Music Awards took over eight hundred hours to make. On her own Instagram, Taylor aptly described the dress as "delicate"—a direct nod to the song that captures the first tentative feelings of revealing your most vulnerable self to someone. What I love about this dress is how its inherent softness contrasts with its strength and its feeling of incompleteness. The asymmetrical straps and thigh-high slit create negative space that is at odds with its embellished, single-shoulder cape detail. To me, the effect reads as competing notions of leaving oneself bare and unguarded while also embracing one's own power and might. The soft pink hue and feathery, winglike details also quietly foreshadow the sweetness of her next project.

As part of her promise to let the album *reputation* do most of the talking for her, she dramatically limited her public engagements and touchpoints with the media. In the year following *reputation*'s release, Taylor made only two awards show appearances: at the Billboard Music Awards in May, and at the American Music Awards in October. In different ways, the fashion she selected for the appearances tackled the hidden themes of the album she was supporting. While her choice for the BBMAs embodied her inner softness and strength, her selection for the AMAs sought to quite literally reflect and bounce back the harsh external spotlight placed on her: she wore a mirrored Balmain mini and matching thigh-high boots.

In her acceptance speech when *reputation* won Best Pop/Rock Album at the AMAs, Taylor alluded to what I feel is the deeper meaning behind her dress choice: "This was actually the first time I ever wrote an album based on a title first. . . . So the whole time . . . I was writing an album based on all the facets of a reputation and how it affects you, what it actually means to you, I was surrounded by friends and family and loved ones who never loved me less based on the fluctuations of public opinion." She finished, "I always look at albums as chapters in my life, and to the fans I'm so happy you like this one."

Her word choice of "facet" brought everything about the night into sharp focus. She wore a clever garment that not only looked beautiful under stage lights and bedazzled on camera, but also served a two-pronged purpose: to highlight the criticism she had endured and survived, which she could now shine back on the guilty party once the dust had settled and she had wearily— but triumphantly—risen from the ashes.

In an age when there is a cultural expectation for people to overshare all the most intimate details of their lives for digital consumption, this subtle projection of the duality of Taylor's life is almost charming—and indeed is very much in line with why Taylor fans feel such attachment to her in the first place. Even at her most famous (the regular way, not the gross "Famous" way), she found paths to speak directly to fans and to let us in on her world. Through her music, yes, but also through her clothes and the story they tell about her state of mind. As she balanced her newfound (and much-earned) privacy within her love life, she still forged fashionable ways to communicate her feelings to the

A disco ball—nay "mirrorball"—dream come true. For someone who loves things that shine and sparkle as much as Taylor does, I have to imagine that this look was pure, happy eye candy. Part fembot, part '70s disco. I appreciate the play on proportions and silhouette and even texture on display here, a feat from a look comprised of basically one single, shiny material. The mock neck and long sleeves nicely balance the short hemline, while the slouchy shape of the boots offers a relaxed foil to the bodycon fit of the dress. To me, these differences create balance and interest. As someone who typically champions a minimalist ankle-strap sandal, I can see how one could easily be slotted in here for a sleek, if safe, finisher. But there is a time for playing it safe, and as we know, sometimes that route is not worth the drive. So we go forth and go bold in the scrunched boot silhouette that says nonchalant, relaxed, fashionable sophistication and would be the envy of any *The Devil Wears Prada* fan.

people who supported her, and it seemed important that she continue to foster (even in this seemingly "bad girl" era) her approachability to fans.

Her relationship with British actor Joe Alwyn, which started in the *reputation* era, was defined by a more private approach than fans were used to. Their preference was to shift media focus to their respective careers and not their coupling—they rarely commented on the nature of their relationship beyond affirmations of the state of their commitment and overall happiness.

So much of *reputation* and all its layers were best seen and observed in a fashionable way long after the project and its tour were through, likely because so much detail and context were lost while Taylor committed to her media blackout and allowed the album to speak for itself. One of my absolute favorite style outings—undeniably *reputation*-inspired—was the 2019 American Music Awards. Despite having by then released an album with a markedly different fashion palette than *reputation* (see the next chapter), Taylor's bottle-green gown by Julien Macdonald with black Casadei boots was undeniably in line with the snakelike aesthetic of *reputation*.

> *"I was writing an album . . . surrounded by friends and family . . . who never loved me less based on the fluctuations of public opinion."*

As a lover of seeing Taylor wear green, I had my breath taken away by this particular outing. The sequins make it a recognizably Swiftian outfit, but the thigh-high boots and snakelike emerald-green color place it securely within the carved-out aesthetic of *reputation*.

When using visuals as a messaging system, sometimes the translation is immediate—like a bomb. Other times, it's like a long-range missile, its trajectory slowly piercing across the sky as you brace for impact. Every night on the reputation Tour, Taylor dedicated a portion of her set to the openly gay modern-dance pioneer Loie Fuller. The screens in the stadiums touted Loie as someone "who fought for artists to own their work." Loie's most famous (and copied) act was called the Serpentine dance, which used billowing robes tented by poles to create a sweeping, mesmerizing effect, enveloping Loie in "a hurricane of drapery," according to *Vogue*. Loie's application to copyright her dance was denied in 1892. Over a hundred years later, when Taylor was caught in a serpentine maelstrom of her own, she was quietly battling for a new record contract with her label that would allow her to gain the rights to the masters of her first six albums. Like Loie, she would also be denied that right.

Part
III

THE POWERHOUSE
SHE BUILT

7

Lover

A TECHNICOLOR METAMORPHOSIS

LOVER WAS THE FIRST ALBUM TAYLOR RELEASED UNDER A NEW CONTRACT AND label, Republic Records, that granted her ownership of her masters. Her previous contract with Big Machine Records had reached its conclusion and was not renewed, specifically based on contention over the ownership of her back-catalog rights. Emerging from the depths of *reputation*'s snake pit and embarking on a more empowered journey as an artist, Taylor embraced fashion during this time period that represented a hard pivot (though some may characterize it as a dramatic overcorrection) from the darker color palette that dominated its predecessor. Taylor said to *Rolling Stone* that she was originally going to title the project *Daylight* but felt that was a little too "sentimental . . . [and] on the nose." On its surface, *Lover* was sugar sweet, filled with pastels, and presented a symbolic new animal motif to succeed the snake: a butterfly.

Promotion for the album opened on the saccharine, uplifting message of its lead single, "ME!" The song's accompanying music video set the tone for a fantastical, whimsical—dare I say campy—aesthetic, dominated by a pulsating, vibrant, relentlessly cheerful world of Taylor's own creation. Imagine that the hottest night club just opened in Disneyland and acid tablets came free with admission. Its opening sequence literally shows a snake exploding into a confetti spray of pastel butterflies, and its grand finale culminates in flash mobs prancing on iridescent cobblestone streets as powder-blue rain falls from the sky. A Taylor with equally powdery-blue streaks in her hair is shielded from the downpour by an umbrella and accompanied by her duet partner, Brendon Urie of Panic! At the Disco, who floats down effortlessly from a cotton candy sky. The video for the album's second single, "You Need to Calm Down," doubled down on this aggressively cheery aesthetic. *Vogue* aptly described it as a "Big Gay Candy Mountain trailer park." One of the video's opening scenes features a bouffant-topped Taylor shrugging off an oversized pink (faux) fur jacket to reveal a baby-pink, strapless, crystal-embellished bikini. Oh, and a gigantic (also faux) back tattoo of the aforementioned butterfly-snake explosion. The album's fourth music video, for "The Man," saw Taylor cross-dress as a Leonardo DiCaprio–type womanizer flaunting wealth and physical magnetism on a yacht surrounded by models, aggressively man-spreading on the subway, and generally flexing all the questionable public behavior that men seem to get away with. Subtle the *Lover* era was not.

If anything, *Lover* was about creating a distinctly light-filled aesthetic as a way to visually signal letting go of past hurt and finding a new, happier place of healing. About this visual transition, Taylor said to *Vogue*, "With every reinvention, I never wanted to tear down my house. . . . This house being, metaphorically,

> *"With every reinvention, I never wanted to tear down my house. . . . I just wanted to redecorate."*
>
> —Taylor Swift, *Vogue*, 2019

my body of work, my songwriting, my music, my catalog, my library. I just wanted to redecorate. I think a lot of people, with *reputation*, would have perceived that I had torn down the house. Actually, I just built a bunker around it." *Lover* eased the vault door open to let people back in, and while she was at it, she installed a pastel mailbox to increase curb appeal. Taylor reinforced this visual in the music video for title track "Lover" which featured color-coded rooms that seemingly aligned with each of the aesthetics of her previous albums.

Anything ruffled, pastel, or both made an appearance in her wardrobe. Temporarily dip-dyed hair tips were a playful way she immersed herself in the vibrancy of the era's style. But truthfully, it felt like throwing neon paint on *reputation*'s gothic window dressing, inverting that album's harsh exterior and soft center. Where in the past she had chosen to cover up her vulnerabilities with outfits comprised of leather and camo, her new de facto armor became glitter and pastels. Because beneath its sugary singles, *Lover* explores significantly more vulnerable themes than its candy coating would have you believe. Its songs expose deep-seated insecurities ("The Archer"), lament the debilitating illness of a family member ("Soon You'll Get Better"), lash out at loved ones as a learned defense mechanism ("Afterglow"), examine the slow demise of a love built on apathy ("Death by a Thousand Cuts"), and face vulnerable fears of losing the love she's finally found ("Cornelia Street"). Taylor spoke about this contrast to *Rolling Stone*: "I don't think I've ever leaned into the old version of myself more creatively than I have on this album, where it's very, very autobiographical. But also moments of extreme catchiness and moments of extreme personal confession."

Ultimately, the COVID-19 pandemic cut the promotional cycle of this album short, including the supporting tour Lover Fest. Had *Lover* been given the full runway it deserved, I suspect that this album was designed to bring Taylor visually back into the throng of commercial, mainstream success. Her fluffy, twee clothes were ebullient and expressive; she hadn't appeared, on the surface, to be so carefree in such a long time. She even expressed timidly (and incorrectly) in the documentary *Miss Americana* that the album was "probably one of my last opportunities as an artist to grasp onto that kind of success. . . . I'm reaching thirty. . . . I want to work really hard while society is still tolerating me being successful."

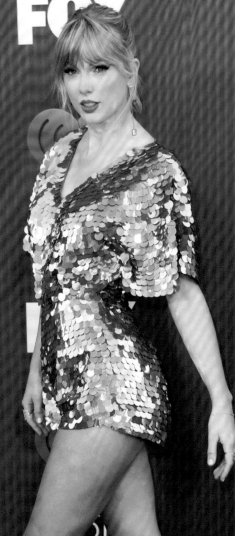

Taylor's penchant for glitter had never truly died, but her newly cupcake-ified wardrobe was like the first grateful exhale after one has held their breath while driving through a dark tunnel. To *Vogue* she described *Lover* as feeling "like a new beginning. This album is really a love letter to love, in all of its maddening, passionate, exciting, enchanting, horrific, tragic, wonderful glory." *Entertainment Weekly* described "*Lover*'s social media rollout [as] a breath of fresh summer air compared with the icy prologue to her 2017 album, *reputation*."

A Butterfly Gets Its Wings

It's early April 2019, and street artist Kelsey Montague takes her brush to a giant blank wall in the Gulch neighborhood of Nashville, Tennessee. Her winged creations have been painted on large urban canvases in exquisite detail all across the globe. By design, her butterfly murals invite and encourage interaction; people who pass them are drawn to stand in the presence of her art and become one with it. As far as she knows, she's been commissioned by ABC to paint a mural in support of the NFL draft, which is being hosted in Nashville. The mural takes three days to paint and is completed within four weeks of conception.

The iHeartRadio Music Awards in March 2019 was the first major appearance to reveal the sweet, iridescent, and feminine fashion of the *Lover* era. This playsuit—by the small high street UK brand Rosa Bloom—was paired with butterfly heels by Sophia Webster, a very obvious nod to metamorphosing into the next phase of her career, one in which she not only creates and writes her music, but owns it too. Her makeup here was perfectly sweetened, and as a supporter of the ankle-strap heel, I find the silhouette and on-brand kitsch factor of these sandals to be the perfect finishing touches. I do wish a few inches from the sleeves could be transplanted to the hem of the romper. When she accepted the Tour of the Year Award for the record-breaking reputation Tour while wearing what would become the symbol of her next era, it's no coincidence that Taylor cryptically said to her fans, "I love your passion, I love your attention to detail, I love how much you care. I just wanted to let you know that when there's new music you will be the first to know." Sure enough, those heels left footprints worth following.

On April 13, Taylor's website becomes awash with dreamy, soft pastels and a countdown that terminates thirteen (of course) days later, on April 26. The internet is on fire with speculation, and to fan the flames higher, Taylor posts a close-up of a pink-and-purple crystal heart on her Instagram with the caption affirming "4.26" as a new date on which to hang all your hopes and dreams.

If you wonder what those two events had to do with one another, you are not alone. Not even Kelsey was aware of the actual client that she was painting her mural for. When I asked her about the creative process, she said, "We were very excited to do something so big for ABC and shocked when it turned out not to be for the draft but instead for Taylor Swift herself!" I asked if there were any tip-offs that her client was not who it seemed. She said, "I was asked to include a few key items, like thirteen hearts and three cats—which was curious because that didn't seem very football focused."

With zero fanfare or formal announcement, suspicious fans gathered at the mural on a mission: to prove that the two events were, in fact, related to one another.

Sure enough, on April 26, Taylor Swift appeared at the mural in a lilac two-piece and dip-dyed pink hair. This was the day the internet got its wings: it was officially revealed that the mural was a planned effort to launch the lead single for *Lover*, "ME!" The title was swiftly added between the butterfly's two wings, just hours ahead of Taylor's appearance. The secret was so well contained that Kelsey didn't even know the true commissioner of her piece until Taylor arrived on-site during the reveal.

On Instagram, Taylor expressed gratitude to fans who had cracked the code and waited at the mural to see if she would show. "Thank you to everyone who showed up, I've never been more proud of your FBI level detective skills," read the caption beneath a photo of her in front of the painting, arms held wide.

One of the most memorable, if only through its sheer absurdity, moments during the *Lover* era was Taylor's pop-up appearance at a mural in Nashville. Her lilac Rococo Sand co-ord set may echo her favored matching, cropped style from the *1989* era, but the floaty fabric, midi-length skirt, bishop sleeves, and floral appliqués really soften the look and squarely place it in the fantastical world of *Lover*. The multicolor Stuart Weitzman Nudist sandals scream to me, as they're one of my favorite minimalist shoe silhouettes, but their sunrise hues bring a playful element that makes them perfect for *Lover*. For someone who has yet to significantly use hair color as an era differentiator (though let's pray for a redheaded Taylor one day), *Lover*'s dip-dyed tresses were a fun and fresh detail.

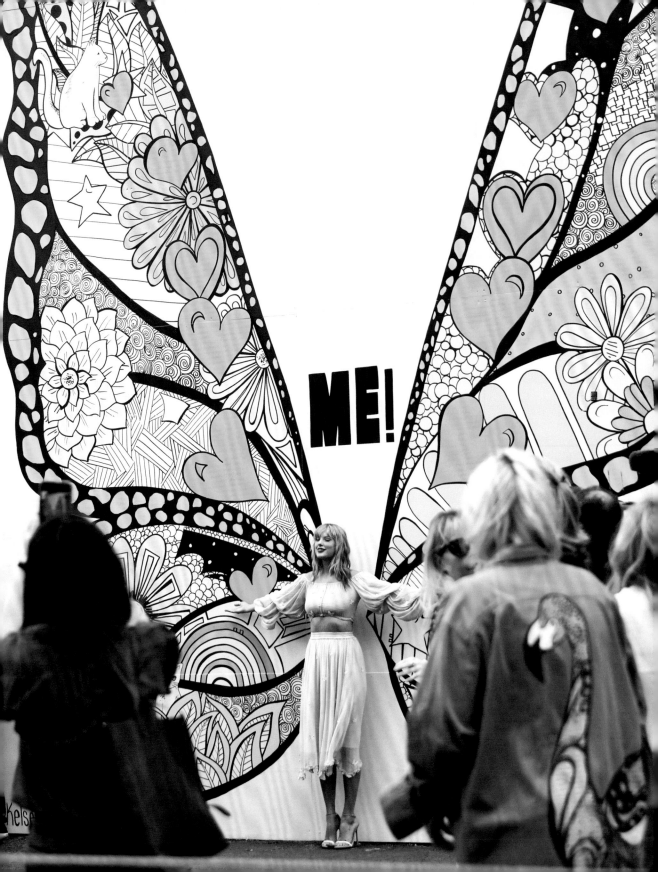

Silly Rabbit, Easter Eggs Are for Swifties

One of Taylor's best-known habits is embedding small hints and clues for fans to pick up on in her work, hints known as Easter Eggs. They're meant to offer an added layer to her art, something that only someone truly paying attention would notice.

The practice (and the term) predates Taylor, popularized originally as the placement of secret features in '80s video games for the unwitting player to joyfully discover. The Swiftian version involves a lot more hunting and mad deciphering by fans. And half the fun is being horribly wrong (like fictionalizing an unreleased album called *Karma*) or missing them entirely (the letter addressed to "Johnny" in the "Tim McGraw" video references the home where the video was filmed: the former residence of Johnny Cash and June Carter Cash). Taylor told *Entertainment Weekly* in 2019 that the development of Easter Eggs plays a huge role in her interaction and relationship with fans, who are rabid to decode even the most incongruous detail. "I've trained them to be that way," she said. "I love that they like the cryptic hint-dropping. Because as long as they like it, I'll keep doing it. It's fun. It feels mischievous and playful."

Taylor's initial foray into "egging" played out in the liner notes of her first five albums, where she would capitalize random letters in the lyrics of each of her songs to spell out a secret message, offering a new nugget of inspiration straight from herself. The practice transformed a CD booklet into an open-book test, guiding you to the answer about the song's original inspiration source—that is, if the test had been written like a crossword puzzle by a very crafty English teacher. The secret message of "Should've Said No," for instance, is the name of the song's philandering ex-boyfriend repeated over and over (talk about a scarlet letter). The message on *Red*'s "Everything Has Changed" is "Hyannis Port," a reference to the affluent coastal community that played host to her summer romance with Conor Kennedy. Taylor also isn't above getting meta, coding her own song "Forever & Always" into the secret message for *Speak Now*'s "Last Kiss," a reference to the song with the same name on *Fearless*, which she famously admitted on *Ellen DeGeneres* was a last-minute album addition about a certain Jonas Brother.

Eventually, this lyric play metamorphosed into a more literal version of wearing her heart on her sleeve. Every night on the Speak Now Tour, Taylor selected a different lyric from a song she had been listening to and transcribed it in curling, Sharpie-penned handwriting on her arm. It not only kept fans interested night after night, following the progress of the tour just to see what new lyric she had on her arm; it also felt like the offer of an emotional insight into her state of mind, emblazoned on her person like the sleeve of a blouse. It was almost an extension of her tour wardrobe.

Some of my favorite Easter Eggs are communicated through fashion, the stylish Morse code among those in the know.

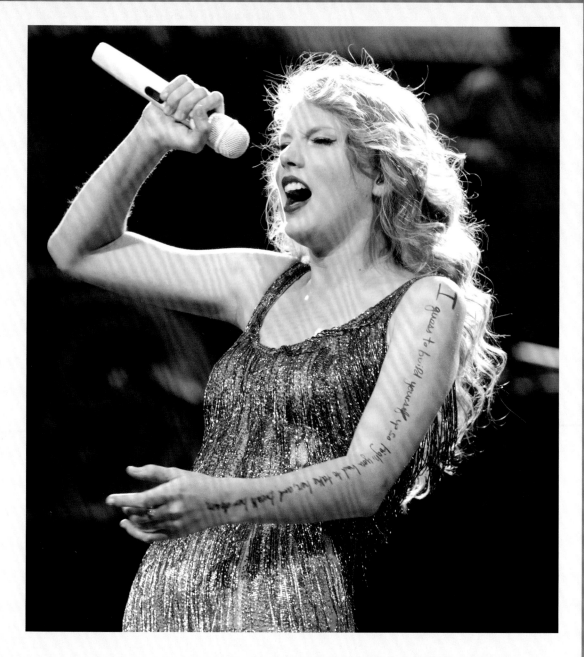

Taylor sometimes chose lyrics that felt cheeky and topical, like a line from the song "Baby Girl," by the country group Sugarland, while playing in Nashville, the epicenter of country music. The handwritten lyric on her arm highlighted her signature curly hair, a harkening back to her early ringlet-filled days, when she was breaking into the country music scene. Other lyrics, like the ones from Keith Urban's "Stupid Girl," which describes feeling haunted and torn by a toxic ex, felt like ominous bellwethers for the tumultuous on/off relationship that she would later depict in full on her album *Red*.

(LEFT) This pair of red velvet Christian Louboutin oxfords should be awarded as one of the greatest (and most underrated) sartorial Easter Eggs in Taylor's history. To mark her twenty-second birthday, Taylor posted a photo of herself wearing these shoes on Instagram, her feet kicked up crisscross on a studio soundboard with the caption, "Studio/Birthday/New Album/Red shoes." Her fourth album, titled *Red*, of course, would debut ten months later. The mark of a truly good Easter Egg is when you feel so dumbfounded by your own utter lack of deductive-reasoning skills that you watch *Scooby-Doo* reruns to make yourself feel better.

(RIGHT) This particular outfit, which Taylor wore during a run of styled outfits ahead of her New Jersey dates for the reputation Tour, felt very pointed and intentional. The platform Saint Laurent ankle boots are a nod to the many similar pairs she would wear during the era (and which I personally assume make her feel powerful and endowed with the ability to stomp out ugly rumors with a single step). But the more interesting component is the custom Fausto Puglisi romper, riffed from the Pre–Fall 2017 collection. The distinctive large-scale tropical palms are recognizable as the same fabric featured in another blink-and-you-miss-it scene from the "Look What You Made Me Do" music video, where Taylor is seen chainsawing the wings off a plane while the various past versions of herself bicker in the foreground. As the viewer is distracted by the row of other Taylors taking bows in the spotlight, parroting and parodying the various tropes that had dominated headlines over the years, the Fausto-wearing Taylor in the background quietly spray-paints the word "reputation" on the plane. Given that the romper was custom made and assigned to this candid by Taylor's stylist, there's no mistaking the intent here to transmit a message. To me, this was her cheeky way of distilling *reputation*'s key theme of what was really happening in her life in private while the world was distracted by fabrications that took the spotlight.

The music video for "Look What You Made Me Do" opens on a gravestone marking the remains of Taylor Swift's Reputation. The video features two Taylors who symbolize visual bookends of the first and last appearances of the *1989* era (and a third blink-and-you-miss-it Taylor reference with her songwriting pseudonym Nils Sjöberg—which she used for "This Is What You Came For"—listed on a headstone). A peacefully deceased Taylor, still in her grave, wears this pink Oscar de la Renta gown, which Taylor wore to the 2014 Met Gala—a very early, high-profile appearance of her newly shorn bob, now accepted as the start of the *1989* timeline. (The lead single, "Shake It Off," would debut just a few months after that event.) Meanwhile, her gravedigger is a zombified Taylor, scrabbling back to the surface from her crypt wearing a pleated blue J. Mendel dress—the same one she wore in the final filmed music video from *1989*, the one for "Out of the Woods." While *1989*'s actual curtain-call single and music video was the fantastic "New Romantics" (which was devastatingly relegated to the deluxe version of the album), its music video was given the "womp womp" tour treatment, comprised of only a montage of clips from the 1989 Tour.

The Power of Pastel

To mark the first album she owned, Taylor returned to embracing inherently, undeniably, unabashedly feminine silhouettes and colors, a move that felt poignant. Days before announcing *Lover*'s lead single, Taylor "announced" the next era's fashion while hitting the streets in New York City in a citrusy tie-dye ensemble: a pink-and-blue Zadig & Voltaire jacket melting like the fluffy strands of cotton candy into a pink tie-dye N:Philanthropy tee and a pair of yellow cut-offs by One Teaspoon. In the past, Taylor's choices to underline her femininity had seemed an attempt to communicate her value despite her lack of life experience. By contrast, *Lover* felt like pure play as an artist and an adult woman with nothing further to prove. Instead of making choices in response to criticism, she was in on her own joke and having fun. And if the ruffles seemed excessive, it's because she'd earned the right to comfortably spread her wings.

(LEFT) She was a skater Swift. At the 2019 Billboard Music Awards, Taylor appeared ready to spin into a triple axel in a Raisa & Vanessa lilac minidress. Wearing her hair up was a smart choice to make space for all that ruffled fabric around her neck. Tonal ankle-strap heels (of which I will always be a fan and supporter) by Casadei were also a good styling option as a minimalist foil to all of *that* going on up top.

(RIGHT) An obtrusive, heavy, black Vince Camuto hobo bag would not have been my choice to pair with an otherwise light and sweet all-pink outfit. The dip-dyed pink ends of her hair come across more as playfully fun experimentation than as an attempt to evoke Avril Lavigne's pop punkitude. The temporary dye was from a brand called Good Dye Young, founded by Taylor's friend Hayley Williams, the rock band frontwoman of Paramore. Taylor's decision to layer on the florals keeps the look consistent, if a little pattern-heavy. Her affordable Urban Outfitters shorts ($59) were the accessible counterweight to her Gucci sneakers ($650). But the icing on the cake is that Taylor served as her own best brand ambassador: her floral cropped sweater was from her very own not-yet-released line of merchandise.

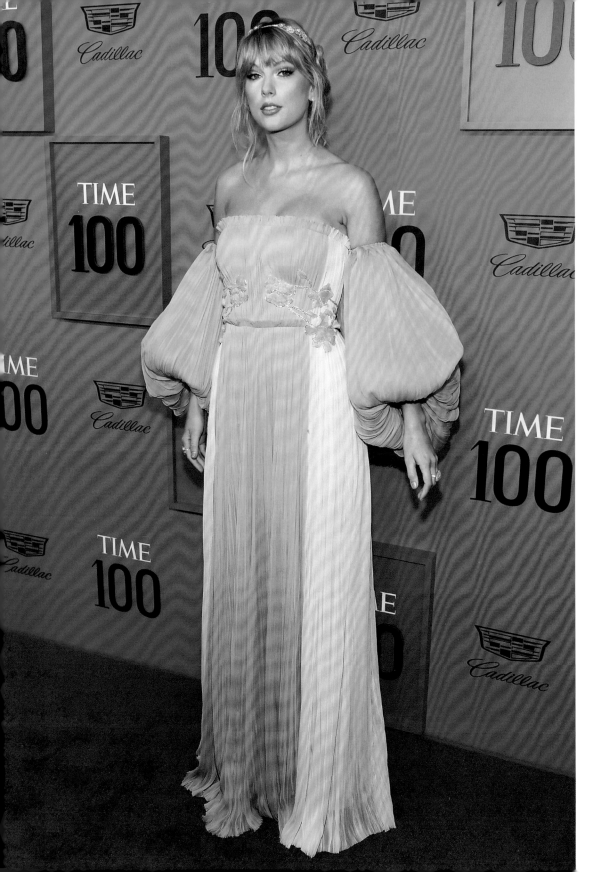

"This album is really a love letter to love, in all of its maddening, passionate, exciting, enchanting, horrific, tragic, wonderful glory."

—Taylor Swift, *Vogue*, 2019

One of my favorites from the *Lover* era and a leading example of the power in accessories. Without its bishop-sleeved bolero and Lorraine Schwartz floral headpiece, this J. Mendel moment would just be a Grecian strapless gown—albeit rendered in a sublime grapefruit/limoncello color combination. With the accessories? The gown becomes elevated and ethereal, like citrusy angel wings or cotton candy clouds gently enveloping her. Soft, but make it fashion.

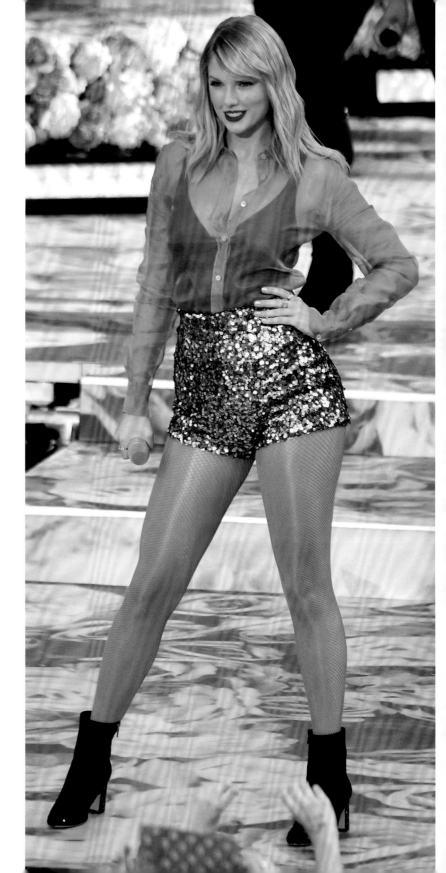

(RIGHT) This outfit, worn on *Good Morning America*, felt like a sassy spin on an office basic. A simple silk button-up suddenly becomes worthy of the stage when it's hot-pink, sheer, and by Helmut Lang. Taylor grounded the color pop of her blouse and the sequins of her custom Jessica Jones shorts with black pieces, like a bodysuit by Wolford and heeled ankle boots by Rene Caovilla.

(FAR RIGHT) Falling from the sky like Technicolor rain, Taylor and duet partner Brendon Urie of Panic! At the Disco premiered the performance of "ME!" at the Billboard Music Awards with full fanfare. This one-shoulder bodysuit (a joint effort between her stylist Joseph Cassell and longtime tour costumer Jessica Jones) was like glitter colliding with a Sweet Tarts package—a delightful snack for the eyes. I like how the fringe detail on the sleeve continued as a motif onto her skirt. The Stuart Weitzman powder-blue boots were a fun finish that almost felt like an homage to the baby-blue Liberty cowboy boots she wore as a teenager during her country years.

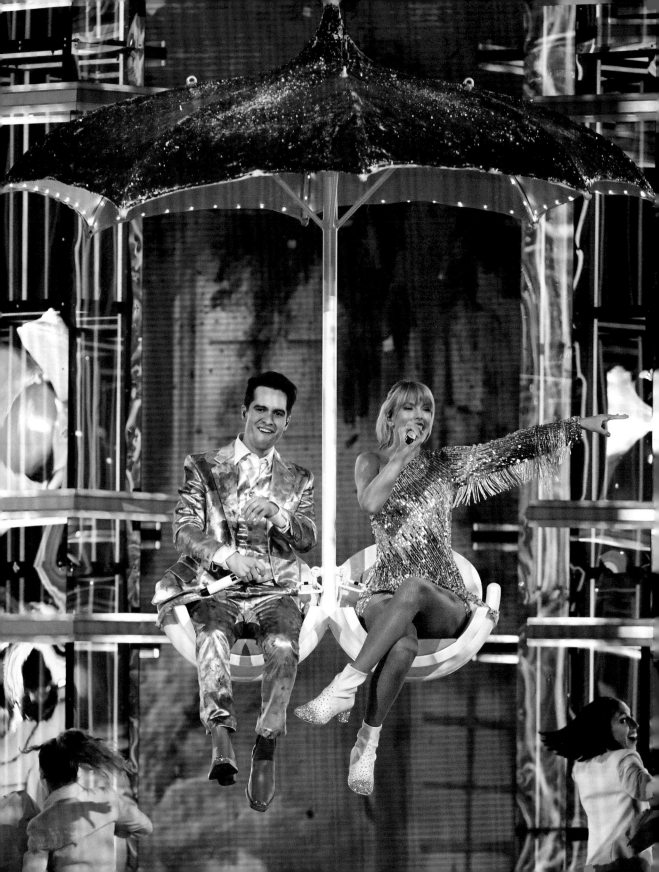

British (Designer) Invasion

The tie-dye and rainbow motifs of *Lover* fashion bled over into Taylor's first true fashion collaboration: with British designer Stella McCartney, whom Taylor mentions in her song "London Boy." The collection prominently featured graffiti-style typography of Taylor's and Stella's names, along with smears of tie-dye splashed on hoodies, jackets, sweatshirts, and T-shirts. To *Vogue*, Taylor divulged that her recent relocation to London put her in close proximity to Stella, and the line took off from there. "When I started spending more time in London, Stella and I would go on walks, have cocktails, and talk about life. So when it came time to write this album, I name-checked her in one of my songs, and when I played her the album, I said, 'Should we do something?'"

In typical Taylor Easter Egg fashion, the collaboration was first hinted at when she wore Stella's footwear to fan events as well as to her Wango Tango performance in June 2019.

As far back as her 2009 interview with *Flare*, Taylor had been adamant that any forays into the fashion world would have affordability as a core tenet. "Fashion doesn't need an expensive price tag to be relevant. . . . I never want to endorse something that all people couldn't afford," she said at the time. She repeated this sentiment to *Vogue* in 2016, saying any future clothing line would "be something that was relatable and accessible and everyday," adding, "I don't see it being couture. I would want it to be reflective of my style. And a lot of things I wear are not highly expensive." Her Stella x Taylor collection was priced in direct opposition to this philosophy, causing a stir among fans who for years had yearned for a Taylor-collaborated clothing drop. Dreams of wearable day dresses like those Taylor wore while out and about, or even of whimsical pastel sweaters were dashed when the collection debuted in August 2019. It was made up largely of cobranded merchandise that lay well beyond most of her fans' budgets and wasn't inherently wearable for the everyday. For instance, a silk bomber jacket emblazoned with rhinestones, pastel clouds, and rainbow-tinged wings that only a Lisa Frank fan could love retailed for $1,995. The prices and the aesthetic ultimately felt at odds with Taylor's own style and branding, which had always relied on the pillars of price accessibility for fans and wearability in daily life. In both appearance and cost, the collection fell short of expectations.

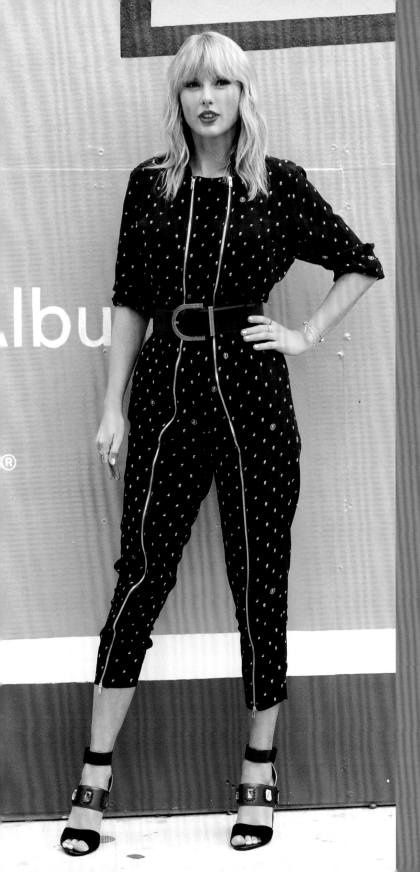

Throughout many *Lover* promotion opportunities, Taylor wore playful but unexpected pieces by Stella McCartney. Exhibit A: a black jumpsuit with a multicolor dot pattern (that coordinated perfectly with the gems on her Kat Maconie heels) and an edgy double-zipper treatment. The unintentional midcalf length of the jumpsuit on Taylor is real "tall girl problems."

When Taylor commits to an aesthetic overhaul, she commits. This aggressively rainbow ensemble was the result of another tag-team effort between Joseph Cassell and Jessica Jones. And, of course, it's not a Taylor outfit without some self-referential Easter Eggs. The fringed jacket gives a textural nod to butterfly wings, the *Lover* era's mascot. The Stella McCartney sneakers stand in as a hint at her pending collaboration with the designer. But not even I can crack the code for why a pair of corseted, tie-waist, rainbow hot pants needed to come to life.

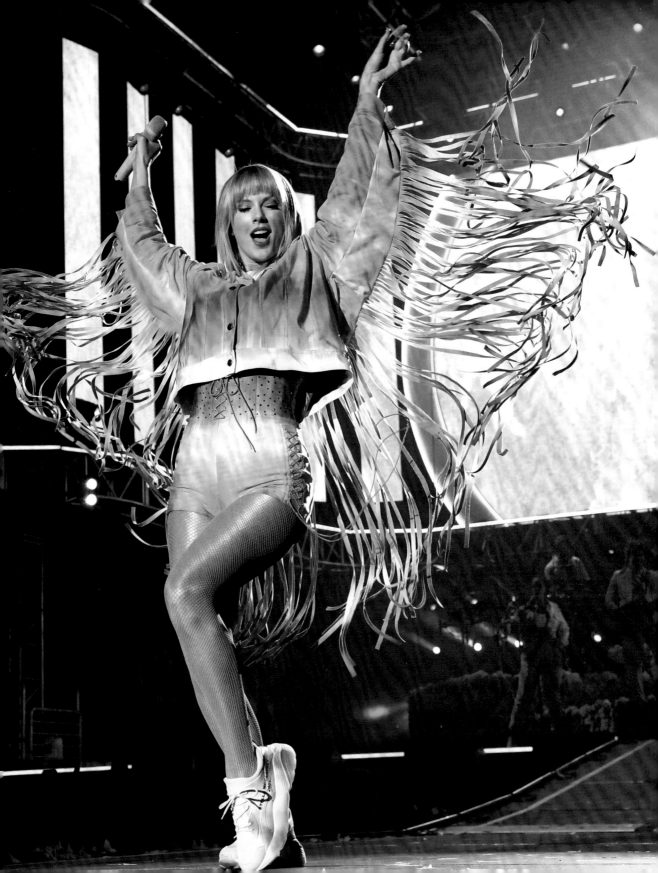

I Am Woman, Hear My Shoulder Pads

More than in eras previous, Taylor seemed to revel comfortably and confidently in her power during *Lover*. In addition to owning the masters of her work outright for the first time, she made her first official solo move into the director's chair with her music video for "The Man." She also performed a career-spanning medley at the 2019 American Music Awards as Artist of the Decade, and she accepted *Billboard*'s Woman of the Decade award with a moving fifteen-minute speech addressing the public scrutiny and misogynistic behavior she had endured in her decade in the music business. It was a period of vindication, a moment to bask in the sun, after having escaped the turmoil and quietly constructing a life away from the spotlight for so many years.

Taylor's metaphorical stepping into the light during the *Lover* era gave her the opportunity to reflect on her career thus far. For years, she had been emotionally out at sea, navigating the waves of girlhood and early adulthood and the raging tempests that came with it. For another few years after that she almost drowned in a riptide that threatened to pull her under completely. *Lover* felt like it was written from the safety of a sandy shore, looking out at the vista of what she had traversed. To *Rolling Stone* Taylor said, "I felt like I sort of gave myself permission to revisit older themes that I used to write about, maybe look

(LEFT) En route to performing at the Stonewall Inn's Pride celebration, which commemorated the fiftieth anniversary of the Stonewall Uprising, Taylor wore what was the best-executed look of the entire era. It strikes the perfect balance between fresh, modern, fun, and serious. The head-to-toe pink, the injection of sparkle from her IRO shorts, and the cartoonesque floral appliqué on her Kat Maconie heels bring the effervescence of *Lover*'s fashion. But her Saint Laurent blazer, sleek pony, and collared blouse tone things down from costume territory.

(RIGHT) I don't know about you, but I look at this outfit and feel confused (sing along if you know the tune). This ensemble is an example of something actually not being greater than the sum of its parts. But on Taylor? It's just wacky and kitschy enough to work. The lace-hemmed, floral Zimmermann dress and velvet blush Rupert Sanderson sandals say summer. The oversized Mango blazer (a fashionable high/low) says fall. And the powder-blue quilted Anya Hindmarch bag emblazoned with the face of an orange flat-faced cat says, "Put me back on the shelf where you found me."

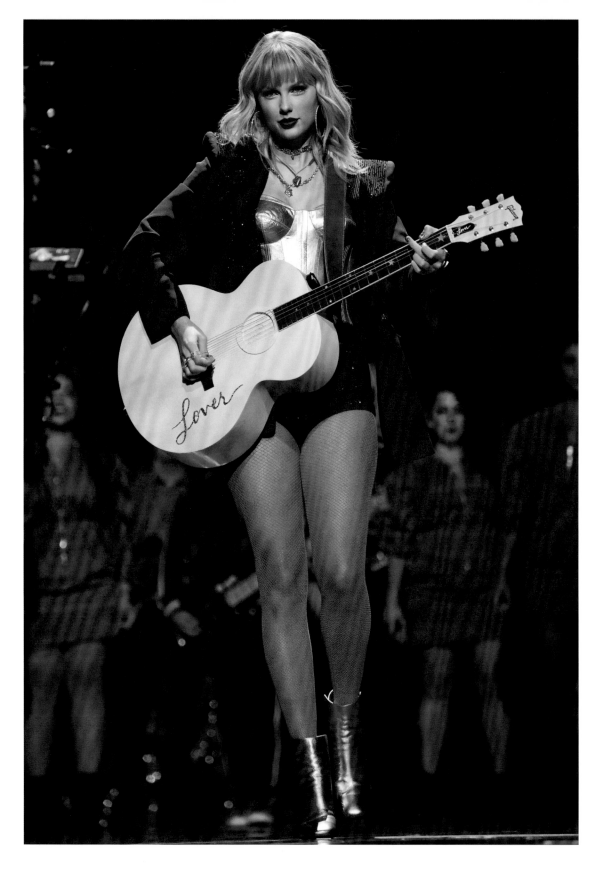

"I feel more comfortable being brave enough to be vulnerable."

—Taylor Swift, *Entertainment Weekly*, 2019

If Versace made gladiator costumes, this would be it. To perform "Lover" at the 2019 MTV Video Music Awards, Taylor donned an indigo blazer atop a gold bustier bodysuit and embellished high-waisted shorts (some silhouettes are truly forever). In the moments prior to this, Taylor had performed her version of a pride anthem ("You Need to Calm Down") sans blazer but with a plethora of backup dancers and choreography. Donning the blazer served as a simple costume change to distinguish between the two songs, thereby giving each its own "moment," but I find it interesting that to perform a vulnerable dance-worthy ballad about love, she opted for a shoulder-padded piece of armor.

at them with fresh eyes." *Entertainment Weekly* observed *Lover* as being "all about mending fences and being kind to the self."

This feeling was materialized in her career-spanning medley performance at the American Music Awards when she was crowned Artist of the Decade. It seemed like a set forged from joy, pride, and defiance. Taylor's performance began with her alone, a single spotlight illuminating her on center stage wearing a white button-up with the titles of her first six albums emblazoned on it in a prison-like font. This was appropriate: these were the albums that were sold out from under her during contract negotiations, her life's work held hostage from its rightful owner. With the sound of shattering glass—a reference, no doubt, to Taylor breaking through a ceiling—Taylor kicked off her set with "The Man," a song aimed at the double standards she'd been subjected to her whole life. When she was joined onstage by a group of little girls, it was easy to understand the reference to her young female fans, who look up to Taylor as a role model, as well as a reference to her lasting legacy as a powerhouse in the industry who is helping to inspire and mentor a new generation of female singer-songwriters. With a quick pivot on her gold Marc Fisher ankle booties to show off the word "Fearless" on her back, the title of her second album took on a whole new meaning.

With the exception of the requisite inclusion of her juggernaut hit "Shake It Off" from *1989*, Taylor's performance moved chronologically through the most iconic love songs of her career. By way of this juxtaposition of massive hits, it was fascinating to hear her opinion and experience with love take shape over time. From "Love Story" we see Taylor's tender teenage heart. At that age, your idea of love is shaped by naive optimism, romantic comedies, and belief in the happy endings of fairytales. The bitterness of dating in your early twenties starts poking holes in your idealized visions of love, as portrayed by the musical red flags present in "I Knew You Were Trouble." But we see those wary feelings dissolve into wry acceptance. On "Blank Space," Taylor gave herself the space to be in on the joke with a tongue-in-cheek parody song poking fun at her seemingly obsessive and dramatic dating life. Ultimately, each song is like a footstep on the journey to "Lover." Taylor performed the album's title ballad, about finding a love she had only once dreamed about, through the lens of a Shakespearean tragedy, at a pink piano adorned with crystals spelling out the names of her previous six albums.

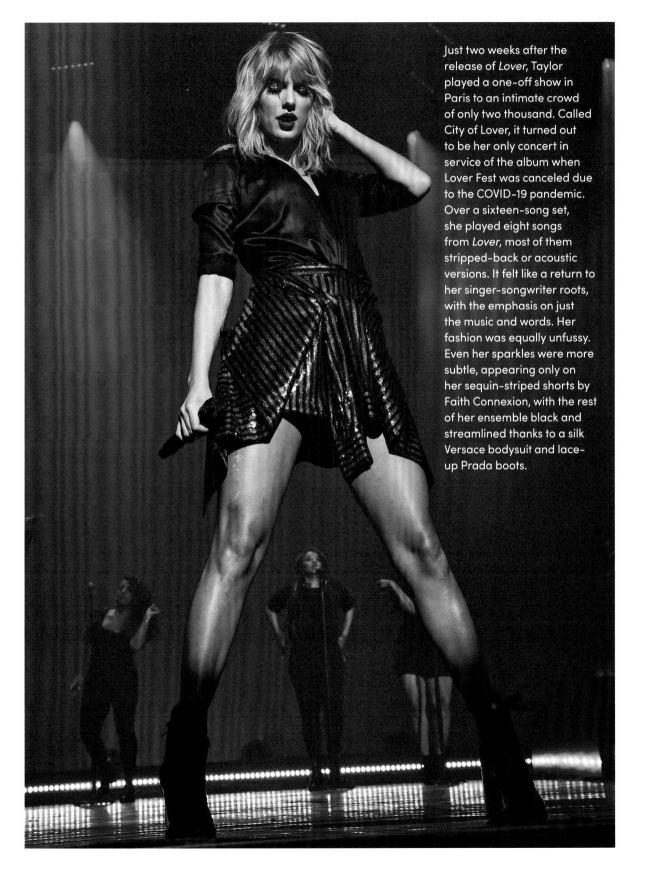

Just two weeks after the release of *Lover*, Taylor played a one-off show in Paris to an intimate crowd of only two thousand. Called City of Lover, it turned out to be her only concert in service of the album when Lover Fest was canceled due to the COVID-19 pandemic. Over a sixteen-song set, she played eight songs from *Lover*, most of them stripped-back or acoustic versions. It felt like a return to her singer-songwriter roots, with the emphasis on just the music and words. Her fashion was equally unfussy. Even her sparkles were more subtle, appearing only on her sequin-striped shorts by Faith Connexion, with the rest of her ensemble black and streamlined thanks to a silk Versace bodysuit and lace-up Prada boots.

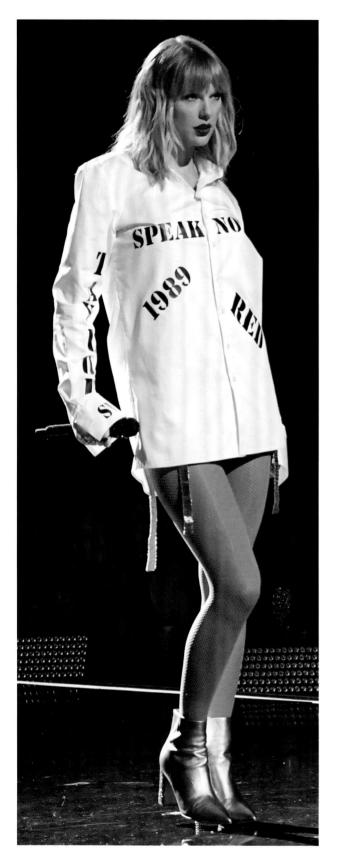
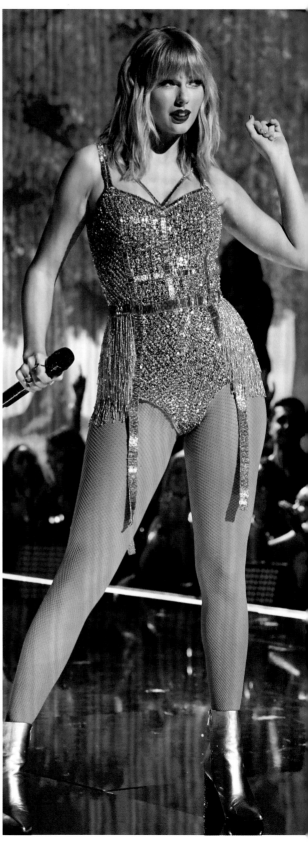

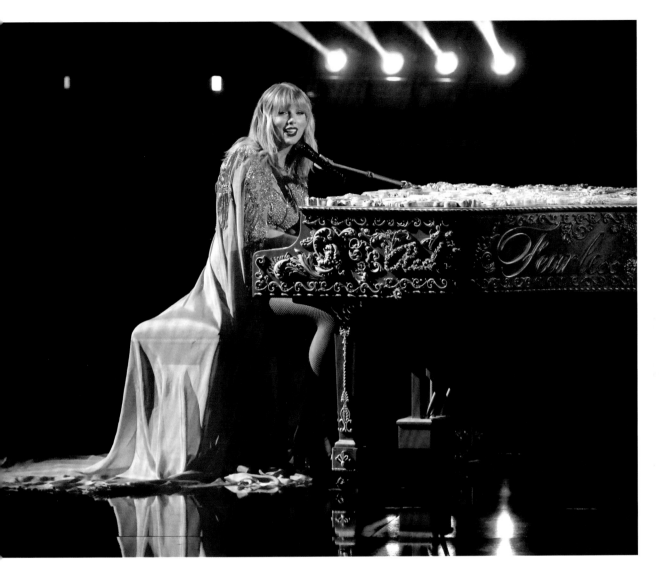

Taylor's career-spanning medley at the American Music Awards involved a few ensemble changes. The bulk of her performance was spent in a gold leotard number (left), custom designed by her stylist Joseph Cassell and costumer Jessica Jones. The most recognizable of her outfits, it was in line with her evolving sparkly stage style, with the loose-hanging, garter-like straps on the legs adding a subtle, sexy detail. What intrigues me most, though, is the addition of the pink cape (above) when she sat down at the piano to perform the set's final song, "Lover." In performing a romantic ballad, she was seemingly at her most emotionally vulnerable, but what I love is that one could interpret the cape as part theatrical costume, part superhero strength, part protective cloak.

She took more opportunities during this period to loudly and proudly highlight issues that she felt mattered. Her notable silence during the 2016 US presidential election had many wondering about her political allegiance. To *Vogue* she described her reasoning for—and her regret over—not being more vocal at the time. "Unfortunately in the 2016 election you had a political opponent who was weaponizing the idea of the celebrity endorsement. He was going around saying, 'I'm a man of the people. I'm for you. I care about you.' I just knew I wasn't going to help. Also, you know, the summer before that election, all people were saying [about me] was, 'She's calculated. She's manipulative. She's not what she seems. She's a snake. She's a liar.' These are the same exact insults people were hurling at Hillary." Her biggest concern: "Would I be an endorsement or would I be a liability?"

Two years later Taylor raised her voice politically. Her endorsements of Democratic candidates and advocacy for early voter registration resulted in a huge spike in newly registered voters in the eighteen to twenty-nine age bracket, according to the *Washington Post*. She told *Rolling Stone*, "I'm just focused on the 2020 election. . . . I'm really focused on how I can help and not hinder." Taylor's engagement in the political sphere became a main narrative of her documentary *Miss Americana*, directed by Lana Wilson and released in January 2020.

She also used her music videos as an extension of her political activity. In what felt like a supersaturated (perhaps overcompensating) advert for allyship, the music video for "You Need to Calm Down" is set in a trailer park whose residents are exclusively, and famously, queer (including the cast of *Queer Eye*, Ellen DeGeneres, RuPaul, and Laverne Cox, to name a few). The video called for support of the Equality Act, a bill that would prohibit discrimination on the basis of sexual orientation and gender identity. The video helped to spawn half a million signatures on a petition that was circulated to drum up support for the measure. When it won Video of the Year at the 2019 MTV Video Music Awards, Taylor—flanked by many of the video's stars—proudly said, "In this video several points were made, so you voting for this video means that you want a world where we're all treated equally under the law, regardless of who we love, regardless of how we identify."

One of her strongest visual and verbal displays of the era was her acceptance speech for the Woman of the Decade award from *Billboard*. She had already won *Billboard*'s highest honor for Woman of the Year twice: first in 2011 and then again in 2014. In 2019, receiving the top award marked a hat trick for

At the premiere of her documentary *Miss Americana* at Sundance, Taylor went plaid mad in a literal neck-to-toe glen plaid look by Carmen March. I personally think this is a chic and bold way to play with patterns and to cut a strong silhouette. Sundance, held in the mountain resort town of Park City, Utah, every January, necessitated the need for a coat. But rather than be swallowed up by outerwear, she chose to wear it over her shoulders cape-style, which allowed the crop top and high-waisted pants underneath a bit of space to breathe rather than melting into a continuous vision of plaid. The pointed-toe Manolo Blahnik boots were made in collaboration with Carmen March for that perfect match. This look is all about getting down to business when the temperatures get down to fourteen degrees Fahrenheit.

her—and in each instance she wore Oscar de la Renta, a designer whose most noteworthy historical contribution was dressing the iconic Jackie Kennedy, a major source of style inspiration for Taylor.

Taylor's speech was a display of harrowing yet well-adjusted self-awareness, packaged in a smart navy and gold jumpsuit. She touched on highlights from the first decade of her career, like releasing her debut album and the success of her first pair of number-one singles, "Love Story" and "You Belong with Me." But she mostly spotlighted the sexism, the double standards, and the cheap headlines written at her expense. While we were used to hearing the poetical versions of her experiences through her songs, this speech was the most unvarnished version of her truth not set to music. It was powerful but wry. Brave but bittersweet. "In the last ten years I have watched as women in this industry are criticized and measured up to each other and picked at for their bodies, their romantic lives, their fashion. Have you ever heard someone say about a male artist, 'I really like his songs but I don't know what it is, there's just something about him I don't like'? No! That criticism is reserved for us," she said. The event felt like a cosmic full circle. About her image being torn apart in the public sphere, Taylor said, "At that time I couldn't understand why this wave of harsh criticism had hit me so hard. . . . And now I realize that this is just what happens to a woman in music if she achieves success or power beyond people's comfort level."

As a woman who taught herself the art of the comeback, Taylor unsurprisingly had thoughts on reinvention: "I've learned that the difference between those who can continue to create in that climate usually comes down to this: Who lets that scrutiny break them and who just keeps making art. . . . It seems like the pressure that could have crushed us made us into diamonds instead." A moving testimonial from someone who had spent a lifetime building an aesthetic on the power of the sparkle, and more appropriate than ever for an album about rising from the darkness.

In two back-to-back events, Taylor served up a Versace doubleheader. Dizzying prints in saturated tones with a whole lot of leg kept these looks in step with one another, but the styling details made them distinct. While I love the teased half updo she wore at the Teen Choice Awards (left), my vote is for the long blazer and corset she wore to the MTV Video Music Awards (far left). The proportion play, thanks to those crystal thigh-high boots, makes the outfit more cohesive. And, pardon my bias, the green hoop earrings were an inspired choice.

(LEFT) Same event, same designer, different years. For the record-breaking three times Taylor has been named *Billboard*'s Woman of the Year (or Decade), she has worn Oscar de la Renta. It's fascinating to see the changes and the similarities in aesthetic that bond these looks together. Her 2011 (red dress) and 2014 (black-and-white dress) appearances both feature full skirts and proper, closed-toe pumps (Miu Miu and Christian Louboutin), and both nod to Taylor's signature hairstyle of the time (the bob and the bangs, respectively). They both also give a prim, "ladies who lunch" vibe. Her decision to go for a sleek, modern jumpsuit in 2019 feels stark in comparison to these ladylike looks.

(RIGHT) Taylor's navy jumpsuit, by Oscar de la Renta, was accented by gold accessories and, of course, her signature red lip. This trio of colors (red, blue, and gold) feels like an homage to their prominent presence in her lyrics when she translates the emotions of love into color. But what I find most fascinating are the chain details hanging asymmetrically around the neck and loosely around the waist. They seem to symbolize a woman breaking free while still choosing to wear her shackles as testament to what she's survived: elevation to a golden pedestal and entrapment in a gilded cage.

Lover was rebirthed as the opening segment of Taylor's return to the stage with the Eras Tour in 2023. It was an appropriate tribute to pick up where the unfulfilled dreams of the canceled Lover Fest had left off. Suitably, her performance evokes Sandro Botticelli's *The Birth of Venus*. Scalloped fabric undulates around Taylor in machine-generated wind, drawing very clear parallels to the emergence of the goddess of love from the sea. Her iridescent Versace bodysuit and crystal-strass Christian Louboutin boots (both works of art in their own right) that perfectly capture the cotton-candy-cloud paint of the *Lover* album cover make it easy to see why Taylor would feel a kinship to Venus. Not only for the goddess's patronage of love—the album's ethos—but because, as the myth goes, Venus came into this world fully formed. She wasn't molded or birthed by anyone; she emerged whole from the crashing waves of the sea. In the context of a comeback tour after the sale of her life's work, it's a powerful statement to reiterate. No one "made" Taylor Swift— except herself.

8

folklore and *evermore*

SINGLEHANDEDLY BRINGING COTTAGECORE TO THE MASSES

FOLKLORE—AND ITS SUBSEQUENT SISTER ALBUM, *EVERMORE*—REPRESENTED many things unexpected and, as was the trend during the effects of the COVID-19 pandemic, unprecedented for Taylor. It was her first (and then second) surprise album drop, giving fans and the entire music world less than twenty-four hours to emotionally prepare. It was her fastest (and then second-fastest) turnaround time between albums. And it was a significant genre

departure from the string of pop-forward albums she had been putting out since 2014. While her transition into pop music came over the course of many years, graduating in intensity over multiple albums, no one saw Taylor's indie-folk genre shift coming. Let alone two albums full.

Each album was announced, on July 23 and December 10 of 2020, respectively, in a three-by-three block of nine images posted to Taylor's Instagram, each tile in the series forming part of a mosaic to depict the album's cover art. The grainy, grayscale images of the *folklore* cover found her standing alone in a long plaid coat in the middle of a forest. *evermore* saw the tree motif falling into a blurred bokeh background to make her single, centered French braid and orange plaid coat the main characters. For a fandom raised on reliable album-release cycles and encouraged to search for cryptic clues, the shock of a surprise album was felt doubly for its sheer out-of-character decision. Taylor Swift, the careful and meticulous overplanner and savvy marketer? Releasing not one, but two albums with no artfully orchestrated schedule and associated marketing calendar of photo ops and television appearances? The two surprise albums, dropping in such quick succession and with so little notice, were a double pop-culture blindside we hardly knew we needed.

folklore and *evermore* were forged in the fires of the pandemic, fires stoked by the loneliness many people felt during mandatory isolation periods at home. In a time characterized by disconnect, the songs on the albums were a friendly hand reaching out to give us permission to wallow in the shared feeling of being so hopelessly untethered. In the live concert documentary *folklore: the long pond studio sessions*, Taylor said, "There's something about the complete and total uncertainty of life that causes endless anxiety. But there's another part that causes a release of the pressures that you used to feel. . . . It turned out everybody needed a good cry."

"There's something about the complete and total uncertainty of life that causes endless anxiety."

For the first time since *1989*, the albums looked exactly as they sounded. Although cottagecore—the term for a rustic aesthetic that romanticizes the bucolic, old-fashioned, and rural—had already been around for a few years (cemented in status on Tumblr in 2018, according to *Vox*), the release of *folklore* and subsequent *evermore* pushed the concept that much further into the zeitgeist. The grainy photographs from both albums' photoshoots of Taylor in the countryside wearing oversized plaid coats, Victorianesque lace nightgowns, and clomping leather boots brought cottagecore to the mainstream.

In addition to continuing Taylor's longtime collaboration with Jack Antonoff, *folklore* and *evermore* marked the beginning of her partnership with Aaron Dessner, a founding member of the indie rock band The National. Taylor had spoken for years about her love for The National, and Aaron's music provided the backbone over which her escapist lyrics were laid. Much of *folklore* was born from a folder of audio files that Aaron sent en masse to Taylor, who pored over each instrumental, replying via voice memo as lyrics came to her. The song "cardigan" was sent in its nearly completed lyrical state to Aaron five hours after she received the audio file. To the *New York Times* Taylor described writing to Aaron's music as "immediately, intensely visual." She said, "I've always been so curious about people with synesthesia, who see colors or shapes when they hear music. The closest thing I've ever experienced is seeing an entire story or scene play out in my head when I hear Aaron Dessner's instrumental tracks."

The remote nature of the work added a certain scrappy element to the making of *folklore* that feels distinct. To *Vulture*, Aaron noted this was "definitely different" from Taylor's past efforts. He added, "I prefer records when they have an element where the paint is still wet. We're allowing some paint to be human and raw. . . . That was important to me, and that was important to her, too." Aaron's hauntingly moody "dreamscape" arrangements were the exact right counterweight to the undercurrent of air that lifts a poppier-leaning Jack-produced track. Aaron described the difference in their approaches as "an archipelago, and each song is an island, but it's all related. Taylor obviously binds it all together."

The creative freedom of these projects gave Taylor the opportunity to mine new sources of material that weren't as directly tapped from her personal experiences. During *long pond*, she said, "This is the first album that I've ever

let go of that need to be 100 percent autobiographical." For so many years, the scrutiny of her songwriting for information about her dating life had eclipsed its celebration as craft. She once bridled in an interview with *Vogue*, "I wanted to say to people, 'You realize writing songs is an art and a craft and not, like, an easy thing to do? Or to do well?' People would act like it was a weapon I was using. Like a cheap dirty trick." Because the characters and situations in *folklore* and *evermore* were fictionalized, rumors and gossip no longer stole the limelight from Taylor's lyrical genius. She said, "I think that's been my favorite thing about this album is that it's allowed to exist on its own merit without it just being . . . something [that fans] could read in a tabloid." To Apple Music, she continued that train of thought: "There was a point that I got to as a writer who only wrote very diaristic songs that I felt it was unsustainable for my future. It felt like too hot of a microscope. . . . [With *folklore*,] I saw a lane for my future that was a real breakthrough moment."

In a way this was an artful dodge to sidestep the speculation. But in actuality, Taylor's entire discography is littered with daydreams turned singles. "Fearless" was once described as a song about "the best first date I haven't had yet." In the same breath, the eighteen-year-old Taylor opined, "I think sometimes when you're writing . . . songs, you don't write them about what you're going through at the moment, you write about what you wish you had." If masquerading these albums' songs as woodland fables was a way to safely explore new emotional depths under the guise of a mythical mirage, it did the trick.

That breakthrough led to a narrative highlight on *folklore*—a teenage love triangle written from three perspectives: those of a jilted girlfriend ("cardigan"), an unwitting paramour ("august"), and the person who toyed with both their feelings ("betty"). *evermore* explored the richly developed characters of two vigilantes finding their equal in each other ("cowboy like me"), a proposal gone awry ("champagne problems"), and the one-night mistakes made with a former flame over Christmas break ("'tis the damn season"). These albums also gave her the limitless space to create a tracklist without a to-do list. She posited to Apple Music that *folklore* and *evermore* answered her inner question of "What would my work sound like if I took away all of my fear-based checklisting?" Aaron corroborated these statements, saying to *Billboard*, "Taylor has opened the door for artists to not feel pressure to have 'the bop.' To make the record that she made, while running

against what is programmed in radio at the highest levels of pop music—she has kind of made an anti-pop record. And to have it be one of the most, if not the most, successful commercial releases of the year, that throws the playbook out."

> "*I think that's been my favorite thing about this album is that it's allowed to exist on its own merit.*"

She also took the opportunity to unleash her inner AP-literature kid, a move that likely prompted more than one listener to reach for their dictionary. In a shared interview with Paul McCartney for *Rolling Stone*, Taylor explained, "I [wanted to use] words I always wanted to use—kind of bigger, flowerier, prettier words. . . . I always thought, 'Well, that'll never track on pop radio,' but when I was making this record, I thought . . . 'Nothing makes sense anymore. If there's chaos everywhere, why don't I just use the damn word I want to use in the song?'"

These seemingly fictionalized songs were interspersed with more traditionally intimate Taylor tracks, including tributes to her grandparents on "epiphany" and "marjorie," the mournful rage over the loss of her masters on "my tears ricochet" and "it's time to go," and painfully vulnerable worries about her celebrity being a burden to her loved ones on "peace" and "ivy." But the albums' real bait and switch are the songs that disguise themselves as myths but are just as—if not more—telling of Taylor's real life. Songs like the Rebekah Harkness–inspired "the last great american dynasty," off *folklore*, which spends its first two-thirds documenting the life of a divisive member of the Rhode Island upper crust who, as revealed in a country music–approved third-verse plot twist, Taylor feels a special kinship to because she purchased and lives in her home in Watch Hill. During the *long pond* documentary, Jack described the song as "such a [quintessential] *folklore* moment . . . because it's not about you but it is all about

you." To *Vulture*, Aaron proposed "seven" as the thesis statement of the album. "It has one of the most important lines on the record. . . . It's [about] passing down . . . memorializing love, childhood, and memories. It's a folkloric way of processing."

Taylor dropped *folklore* and *evermore* with only one day's notice each. A solitary single with accompanying music video premiered in tandem with each album—for *folklore*, "cardigan," and for *evermore*, "willow." Each video does an excellent job of capturing the ethos of its album. Set in a quiet log cabin in the woods, the "cardigan" video depicts Taylor following a shimmering golden thread into her piano to discover a magical forested world filled with crawling moss and waterfalls. A little further, and she struggles in a raging, steely sea until she finds her faithful piano bobbing in the waves and picks up the golden thread to return, wet but safe, to the same log cabin. As a continuation of the story, the "willow" music video picks up that golden thread just where she left it. In the shade of a willow tree (obviously), Taylor

> *"What would my work sound like if I took away all of my fear-based checklisting?"*

jumps into a reflective pool that sends her down a rabbit hole into a glass-enclosed cage, ultimately sinking into the pool's depths until it opens up to a wintery forest scene, where the same thread leads her back to the log cabin.

If *folklore* was the life raft that kept her clinging to sanity in the wake of the pandemic, then *evermore* is a submarine that plunged her further into the creative depths, allowing her to experiment with production, flowery language, and mythology. In her Instagram post announcing *evermore*, Taylor said that the album "feels like we were standing on the edge of the folklorian woods and had a choice: to turn and go back or to travel further into the forest of this music. We chose to wander deeper in."

It marked the first time between albums that Taylor hadn't sought to significantly differentiate her efforts. To Apple Music she said, "*evermore* was the first time I didn't discard everything after I made something new. I actually had to fight off anxiety that I had in my head that you need to change." *USA Today* called *evermore* a "sister album that only crystallizes Swift's strengths as a songwriter."

A Pandemic Hath No Determination
Like a Woman in Isolation

So much about *folklore* and *evermore* felt like pure artistic expression. In the emptiness that the pandemic created in Taylor's schedule, creativity bloomed. On her Instagram post announcing the release of *folklore*, she said, "Before this year I probably would've overthought when to release this music at the 'perfect' time, but the times we're living in keep reminding me that nothing is guaranteed. My gut is telling me that if you make something you love, you should just put it out into the world."

Throughout the quarantine, Taylor wasn't able to meet in person with any of her usual collaborators. The album itself was recorded in silos by each of its contributors. In the *long pond* documentary, Taylor can be seen setting up a home studio in her bedroom while producers Jack and Aaron and sound engineer Laura Sisk worked from their spaces to create the album piecemeal. This sense of individualism also impacted her wardrobe choices. Unwilling to put her glam team of stylist (Joseph Cassell), makeup artist (Lorrie Turk), and hair stylist (Jemma Muradian) at risk, Taylor opted to make all style and beauty choices on her own for the first time since her early teen years.

Texas-based photographer Beth Garrabrant was responsible for capturing the images of Taylor for both *folklore* and *evermore*. It marked her first occasion shooting an album cover, setting quite a high professional bar for her. Beth's earlier photography had primarily focused on rural tween Americana, with many of her youthful subjects captured in shiny prom taffeta, staring sullenly into a mirror. Other images reveal teens in garish blue eyeshadow (an unflattering beauty rite of passage to try at least once) or tie-dye shirts, breaking in a fresh baseball glove or sipping fountain drinks while seated in a vinyl diner booth. Even as she shifted genres to capture one of the world's biggest pop stars in the woods, Beth's talent for photographing something eerie yet familiar remained strong. To the magazine *i-D*, Beth described the creative process as primarily stemming from Taylor herself: "From the very beginning Taylor had a clear idea of what she wanted for the album's visuals. We looked at Surrealist work, imagery that toyed with human scale in nature. We also looked at early autochromes, ambrotypes, and photo storybooks from the 1940s." With

Translating an album's visuals to stage often involves opting for the biggest, grabbiest, and (almost always) sparkliest iteration of style possible. In the case of *evermore*, an album centered on yielding to the deepest wells of unforeseen creativity, Taylor elected for a dress so grounded she nearly looks like she wandered onto the Eras Tour stage from a walk in the woods. If one were prone to forested strolls in custom Christian Louboutin suede boots, that is. The ruffles and embellished emblems on her custom Etro dress fall somewhere between Bavarian and wiccan. But the real question: Is it orange or yellow?

photos shot entirely on film and mostly in black and white, the effect is almost like a ghost tape.

Because they were sister albums, the aesthetics for *folklore* and *evermore* were intentionally familiar but distinctly separate. Follow along and drag out your copies of *folklore* and *evermore* to compare and contrast. Taylor's penchant for undone beauty, plaid outerwear, and frolicking in nature all remained at play—but with slight tweaks. In an interview for Apple Music, Taylor noted that during the pandemic, nature began to symbolize a strange comfort for many people. Lyrically, both albums feel and sound like an exploration of the shadows cast by evergreens. So it only made sense to extend that feeling visually and tap into the collective cabin fever wrought by the pandemic and throw herself wholeheartedly into the freedom of the outdoors.

Enviable plaid outerwear served as the basis of the signature looks for both *folklore* and *evermore*, and both were by Stella McCartney. Despite the designer tag, the coats worked simultaneously as fashion and function. They represented a chic way to bundle up before heading into the depths of the shadowy woods. The structure of a thick, wool coat also offered a nice interplay with the lacy nightgowns worn underneath.

Over the course of *folklore* and *evermore*, Taylor wore many lacy, flimsy nightgowns that looked like preserved antiques, an inclination she had no doubt been dying to fulfill for years. According to her friend Cara Delevingne, who spoke to *Vanity Fair* in 2015, Taylor had an entire cupboard full of "white Victorian nighties" picked up in Nashville antique stores which she would whip out as a festive slumber party activity. Taylor described her original vision for the *folklore* cover as a "pioneer woman sleepwalking at night." Most of the ghostly Victorian nightgowns were sourced from Texan brand Magnolia Pearl. Founder Robin Brown notes that "each Magnolia Pearl piece . . . is a story. The kind you think you know inside-out, but find new details revealed with each telling. Snippets of fairy tales overlay Huck Finn imagery, bolts of myth underpin psychedelic legends, and beneath it all, within it, resides you, the most glorious story of them all." Sounds familiar. Upon learning of Taylor wearing so many of her pieces, Robin posted to the Magnolia Pearl Facebook page, "Female singer-songwriters are true heroes and life-savers and we need their art more than ever right now. All of us are just struggling to stay afloat and I am

so grateful [Taylor] clung to her piano amid this deluge and gifted us with her words."

Most of Taylor's interviews were given virtually, naturally, during this time period. But in December 2020, Taylor was named *Entertainment Weekly*'s Entertainer of the Year. The feature article was published alongside a new photo shoot. She once again used Beth Garrabrant as photographer and returned to pastoral imagery as a backdrop. This time, she infused a bit more glam into her wardrobe, balancing the rural nature of her setting with more pieces by Stella McCartney, including a tiered, gold lamé dress. Accessorized with a horse, of course. During the interview Taylor cryptically said, "I have this weird thing where, in order to create the next thing, I attack the previous thing. I don't love that I do that, but it is the thing that has kept me pivoting to another world every time I make an album. But with [*folklore*], I still love it." The feature was uncoincidentally published forty-eight hours prior to *evermore*'s release—when she would, once again, shock the world with another surprise album.

To prove that Taylor had a finger on the pulse of what we all needed in the pandemic, the most iconic garment of this era was an oversized cardigan. The creamy-white, button-up cable-knit with contrast trim down its front and at its cuffs also featured embroidered stars at the elbows, a reference to one of the loveliest lyrics in its namesake song, "cardigan." Slouchy and sweater-paw approved, the cardigan felt like a totem for the comfort we craved while also conveniently serving to power the narrative of *folklore*'s lead single. To *Rolling Stone*, Taylor said that it was part of the catalyst for making *folklore*. "I . . . wanted to make an album that felt sort of like a hug, or like your favorite sweater that makes you feel like you want to put it on. Like a . . . good, worn-in cardigan."

This outfit, styled by Taylor herself, has all the mismatched chaos of a girl getting ready for a first date and hodgepodging an outfit together because she's already fifteen minutes late. How else could a sequined burgundy turtleneck, khaki zippered pants, and black-and-gold chain sandals (all by Stella McCartney) end up in the same ensemble? Individually, each piece is fun and unique. Together, they make me grateful for Taylor's glam team. But you can't help but admire her spunk and DIY streak.

Or something that makes you reminisce on your childhood. I think sadness can be cozy. It can obviously be traumatic and stressful, too, but I was trying to lean into sadness that feels . . . enveloping in not such a scary way. . . . Because I don't think anybody was really feeling like they were in their prime this year. Isolation can mean escaping into your imagination in a way that's kind of nice."

Taylor used style as both a lyrical device and a marketing effort. To complement the release of "cardigan," the namesake item from the music video was launched to Taylor's website as official merchandise, where it sold out almost instantly. Subsequent restocks and the addition of new colorways also drove up demand, and once again it sold out. Social media posts from celebrity friends in Taylor's circle who had received gift packages including the famed cardigan further added to the frenzy.

The Necessity of "Head" Styling

Connecting to other people while in isolation meant a lot of video conference calls. As we all learned early in the pandemic, the biggest hack of video calls was ditching stiff denim or trousers and sporting sweats on the bottom, while giving the illusion of put-together polish with a nice blouse on top. As a result of being limited by the view of a front-facing camera, and in the absence of red carpet moments and street-style candids to help support the visual narrative, the defining styles of *folklore* and *evermore* were iconified most through Taylor's hair.

Using a new 'do to define an era isn't new for Taylor. In the past, she had used ringlets (*Fearless*) or bangs (*Red*) or a chic bob (*1989*) as a visual aid to denote a new creative era (not to mention the blink-and-you-miss-it second of *reputation*'s Bleachella). But there was something uniquely "undone" to her hair from this time period that felt relatable and easily doable for even the beauty novice.

In imagery from the *folklore* photo shoot, Taylor wore her hair in two low, symmetrical buns on the sides of her head. It was a riff on what's referred to as "space buns," of *Star Wars*' Princess Leia fame. There's a certain sense of irony and intrigue in the knowledge that as Taylor was crafting a fantastical, fictionalized world of her own in an unexplored genre, she may have drawn

inspiration from a far-flung series about charting unknown planets and worlds.

To immediately distinguish *evermore*, on the cover Taylor opted for a single French-braided plait down the center of her head. It evoked strength and felt like an homage to Katniss Everdeen, the protagonist of the *Hunger Games* series—another strong-minded woman who often found herself wandering through the wilderness. We know from Taylor's two contributions to the film franchise's soundtrack in 2012 ("Safe & Sound" and "Eyes Open") that it's a mental role she'd stepped into before. But what felt most significant about *folklore* and *evermore* is that they were Taylor's first albums that lacked any text on the front cover. Without her name or an album title attached to either project, it seemed that she was placing all her confidence in the strength of her imagery and fashion to pull people into her mystical, forested world, and in the quality of the songs to get them to stay.

At the height of the pandemic, flaunting wealth and glamor wouldn't have hit the right chord with most people. To match the novice hairdos, Taylor's makeup was equally sparse and understated. Softly flushed cheeks and the faintest whisper of mascara made for a very natural, barely touched beauty moment—not a signature red lip or winged liner in sight. To *Entertainment Weekly*, Taylor described her efforts as very DIY. "The photoshoot was me and [Beth] walking out into a field. I'd done my hair and makeup and brought some nightgowns. These experiences I was used to having with 100 people on set, commanding alongside other people in a very committee fashion—all of a sudden it was me and a photographer. . . . There's something really fun about knowing what you can do if it's just you doing it."

There's language in beauty culture that tries to diminish exertion and encourages women to hide their work. "No makeup makeup." "Everyday natural beauty." "Effortless." "Simple." "Easy." For once, "effortless beauty" wasn't being used as a catchall to make trying seem cringe. Refreshingly, it was an accurate descriptor of the beauty in being truly natural and relatively unkempt. Taylor, once again, was subtly pulling her relatability card. At a time when ChapStick and hand sanitizer constituted self-care on a good day, seeing her sporting the same bare face, bedhead curls, and undone braids we all were wearing was comforting.

MOST POPULAR INTERNATIONAL ARTIST
TAYLOR SWIFT
EVERMORE

A lot of Taylor's appearances over the course of 2020 and 2021 looked much like this: a talking head on a screen. Here, she accepts an international artist award for the Australian-based music awards show the ARIAs. It's not a stretch of the imagination to wonder if her chic red lip and black turtleneck were paired with a ratty set of gray sweatpants and house slippers.

I'm Not Crying. I Just Have *folklore*'s Grammy in My Eye.

Several music publications included *folklore* on their lists of top albums of the year, lauding it as "the definitive quarantine album" (*Rolling Stone*), "a respite from global events" (*The Guardian*), and "the perfect accompaniment for the weird loneliness that permeated 2020" (*NME*). The world had truly embraced Taylor's work as musical therapy during a rough period of time. And yet I was still a bundle of nerves on the night of the 2021 Grammys when *folklore* was nominated for the coveted Album of the Year slot.

Having already won in that category for *Fearless* in 2010 and *1989* in 2016, it felt like wishful thinking to imagine an AOTY hat trick. But if there is one thing Taylor Swift is always going to do, it's rise to the occasion and defy the odds.

Taylor's historic AOTY win for *folklore* made her the first woman to win the category at the Grammys three times. And as a testament to her genre-spanning career, it also meant that each of her AOTY wins were for albums in different genres: country, pop, and alternative.

Accepting the award during a pared-back ceremony—in keeping with pandemic guidelines for gathering—Taylor said, "I want to thank the fans. You met us in this imaginary world we created, and I can't tell you how honored we are by this."

Thus far, the only time that Taylor has gone short at the Grammys was in this sweet floral minidress by Oscar de la Renta. The Ophelia-esque 3D appliqué of the flowers gave the appearance that she was sinking into a garden and becoming one with nature. My favorite details are the delicate bell sleeves, which continue the appearance of flowers enveloping her entire body. Her hair, neatly done by her professional hair stylist, Jemma Muradian, was twisted into two low and loose space buns reminiscent of Taylor's self-styled effort on the *folklore* album cover. The sweetest finisher, though, is those bubblegum ankle-tie Christian Louboutin heels. Not one to miss an appropriate accessorizing moment, Taylor wore a matching custom floral OdlR mask as part of the COVID safety protocols for the evening.

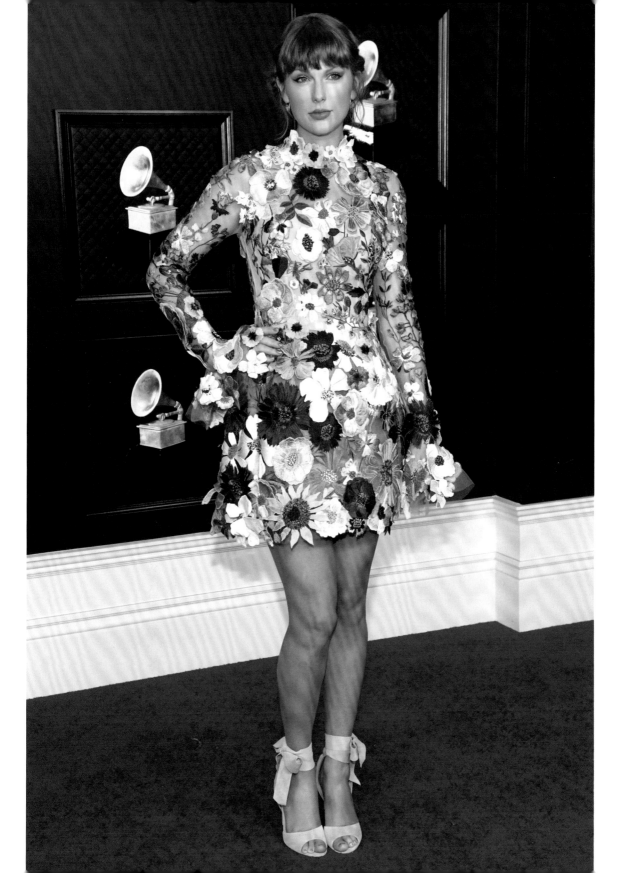

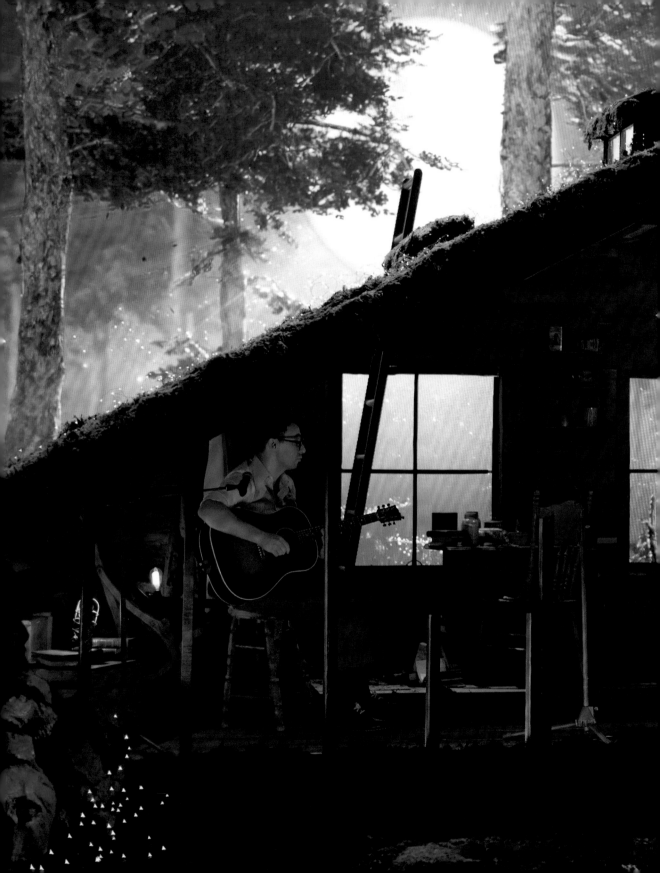

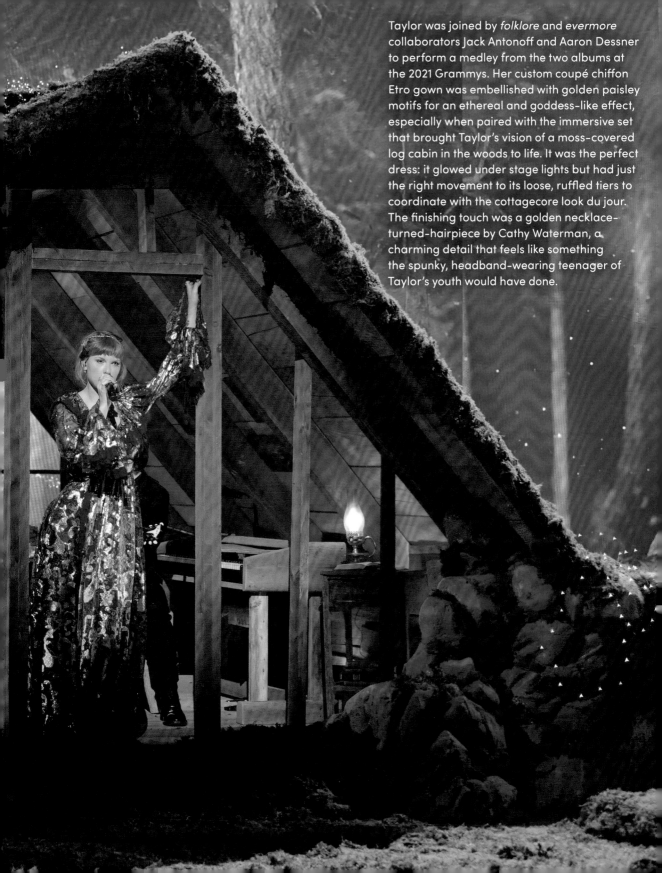

Taylor was joined by *folklore* and *evermore* collaborators Jack Antonoff and Aaron Dessner to perform a medley from the two albums at the 2021 Grammys. Her custom coupé chiffon Etro gown was embellished with golden paisley motifs for an ethereal and goddess-like effect, especially when paired with the immersive set that brought Taylor's vision of a moss-covered log cabin in the woods to life. It was the perfect dress: it glowed under stage lights but had just the right movement to its loose, ruffled tiers to coordinate with the cottagecore look du jour. The finishing touch was a golden necklace-turned-hairpiece by Cathy Waterman, a charming detail that feels like something the spunky, headband-wearing teenager of Taylor's youth would have done.

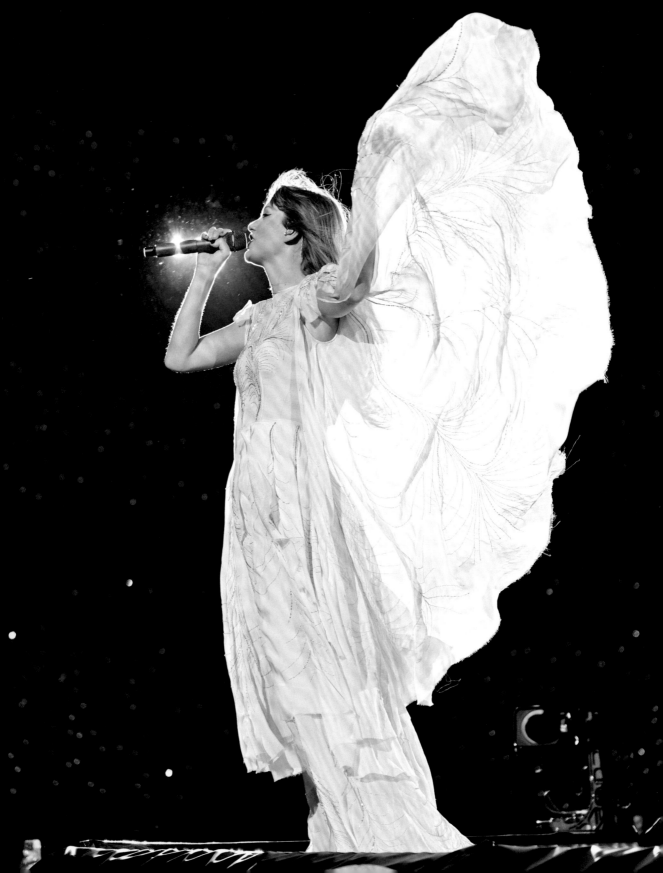

From the depths of the literary woods imagined by these albums, it was hard to see what path Taylor would take next. Her former clockwork-like approach to album releases had been completely thrown out the window with these surprise drops. Rumors of a third sister album, *woodvale*, were squashed by Taylor herself. Ticketholders for the defunct Lover Fest were in financial purgatory as the pandemic's effects were lengthened and the prospect of cancellation seemed inevitable. Following her bitter exit from Big Machine Records, her audacious threat to re-record her first six albums, creating duplicates that would successfully devalue their stolen counterparts and bring her body of work back under her complete ownership, seemed labor intensive with an unknown release timeline.

In typical Taylor fashion, her next step was to carve out an unexpected path and kick into a new gear of productivity.

The log cabin set from Taylor's 2021 Grammys performance was reincarnated to live another life on the Eras Tour stage. For her *folklore* set, a change of pace from glitter overdrive felt necessary. Toned down significantly to match its cottagecore energy, this white custom Alberta Ferretti had just the right amount of moon goddess vibes while still flowing beautifully on stage thanks to those cape-like flutter sleeves.

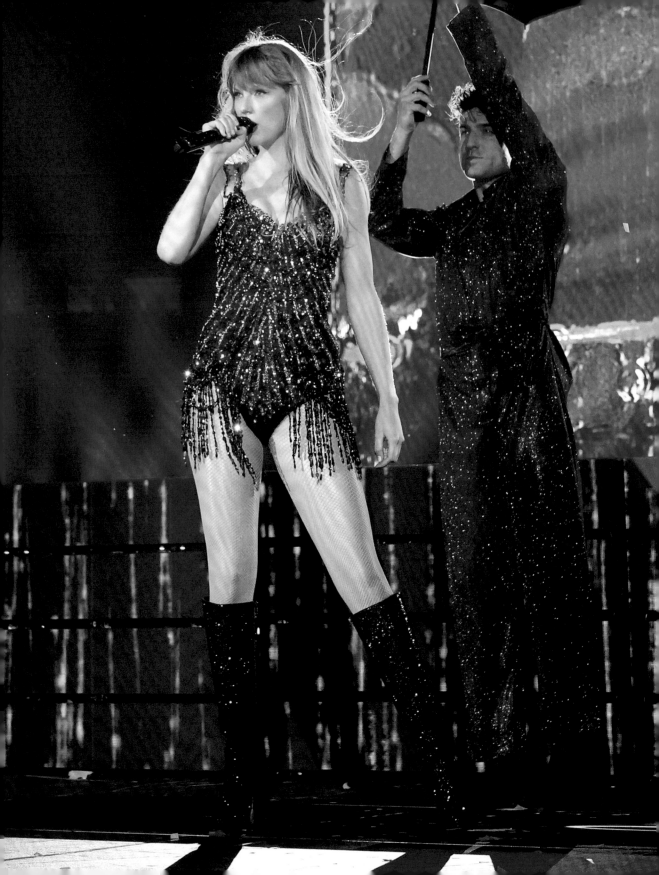

Midnights

DAWN OF A LEGEND

THE MAGIC OF *MIDNIGHTS* IS IN ITS PERSPECTIVE: THAT OF A THIRTY-TWO-YEAR-old superstar looking back at her life's most harrowing moments. At the time of the album's release in October 2022, Taylor had already written and rewritten her art into the pages of music history. She had nothing left to prove to the music industry, but she still had, evidently, a lot to reconsider about her own life. She returned to emotional—and even traumatic—moments that had been excavated over her previous nine albums and gave them a fresh assessment, made possible only through maturity and hindsight. At the peak of a career built upon self-reflection, Taylor proved there are truly no limits to how much we can continue to learn and relearn about ourselves.

In the album announcement posted to her Instagram, Taylor described

Midnights as "a collection of music written in the middle of the night" that represented "the stories of 13 sleepless nights scattered throughout my life." It was a compelling, dark, and ruminating concept album. Thanks in large part to the fact that she worked exclusively with longtime collaborator Jack Antonoff on all the songs' standard tracks, the album was her tightest and most cohesive yet. *folklore* and *evermore* contributor Aaron Dessner again played counterweight to Jack's woozy synths with his sparser production on three of the album's deluxe song slots. In familiar hands and with a state of mind clearer than ever, Taylor described the joy that went into crafting an album so haunting.

To Jimmy Fallon on *The Tonight Show*, she said, "This is a pretty dark album, but I had more fun making it than any album. I don't think art and suffering have to be holding hands all the time. I think you can write songs about . . . hard things that you go through in life. But with time, and the more albums I put out, making albums . . . feels like a way to suck the poison out of a snakebite." Having recruited a new contingent of fans to her music by way of *folklore* and *evermore*, which were painted with a more fictionalized brush, with *Midnights* Taylor returned to autobiographical form and reintroduced herself to those unfamiliar (or, at least, less intimately familiar) with her history.

Midnights excels in its late-night stream of uncensored, nightmarish anxieties, giving Taylor the space to explore nuance and self-contradiction. The lead single, "Anti-Hero," lays bare a lifetime's worth of insecurities. It paints possibly the most honest self-portrait yet of a woman layered, complex, multifaceted, and flawed. Whereas in songs like "Blank Space," Taylor had displayed self-deprecating grace to "shake off" criticisms about her dating life and public persona, in "Anti-Hero" she joins the firing squad, proving she is her first, and worst, critic. After years of Taylor rebuffing tabloid slideshows that speculated whether she was the problem in her history of failed relationships, it was extra painful to hear her admit she'd thought that about herself even before it became a punchline.

The promotional single, "Bejeweled," is the polar opposite of "Anti-Hero." It's a "going out" track for the ages and should be listened to exclusively while applying lipstick in your entryway mirror as you're about to hit up a string of clubs in the most obnoxious, sparkliest ensemble imaginable. It's a pump-up song asserting one's value (and hotness) in the face of a relationship that has gone past its expiration date. When the romance has soured into ambivalence, "Bejeweled"

> *"In the last six or seven years I've just been constantly making things. And the more things I make, the happier I am."*

is the hot-girl kiss-off that all but kicks your ex out the door with one bedazzled heel in order to admit the queue of potential suitors waiting in line. Its correlating music video quickly latches on and campifies the Cinderella fairytale. Who better to act as spokesperson for the roles we step into (or out of) at midnight than her? Long gone are the idealized fairytale and corseted gown of "Love Story." In "Bejeweled," a corset takes on a second, saucier life as a bedazzled bustier with the help of a fairy godmother: iconic burlesque performer Dita Von Teese.

The second single, which is also the album opener, "Lavender Haze," blows smoke and takes shots. It exudes a satisfied pride at the successful way Taylor and her longtime partner had managed to cultivate a private life away from the spotlight while also voicing displeasure at the public scrutiny and intense focus on her marital status, rightfully bristling at having escaped the "serial dater" box only to find herself put in another. Other dualities on the album explore simultaneous beliefs in cosmic destiny ("Karma") and meticulously planned force of will ("Mastermind"); the happy disbelief of finding a love like an unnatural gift from nature ("Snow on the Beach") while feeling immediately wary and mistrustful of that love based on past burnouts ("Labyrinth"). She even acknowledges dualities in her persona, cosplaying as a lawless rebel ("Vigilante Shit") while admitting to being a peaceful homebody ("Sweet Nothing"). It calls to mind the breadcrumbs her work first dropped in 2012, when she discovered the emotional range of feeling happiness, freedom, confusion, and loneliness all at once. But what at age twenty-two may have been interpreted as the fleeting uncertainty and chaos of early adulthood becomes more nuanced and weighty a decade later. The only permanence is in impermanence, it seems, and in *Midnights* Taylor fully owns the conflicting thoughts that dance through her brain in the wee hours of the night and articulates them in the barest, most exposed lyrics of her career.

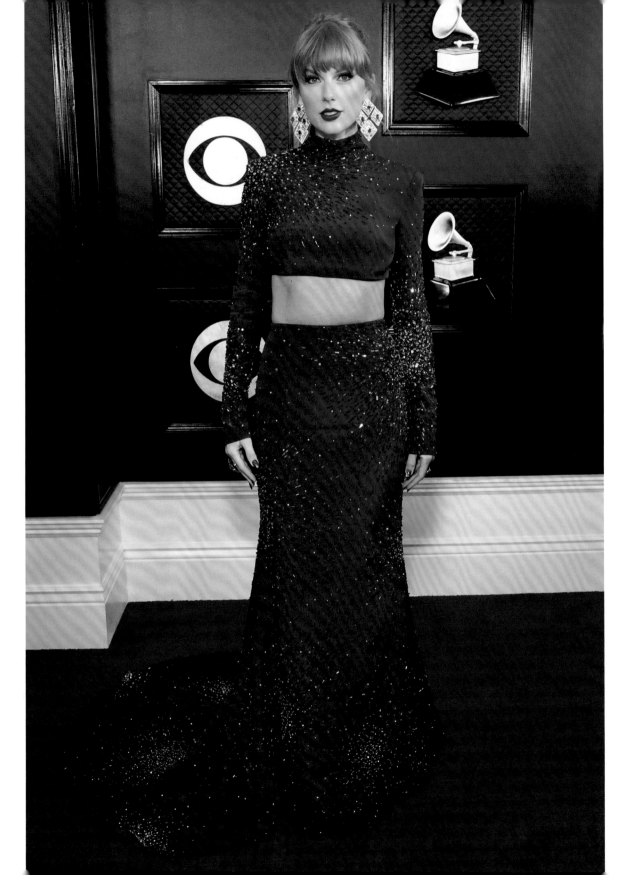

That '70s Showgirl

Taylor is not typically a trend chaser, nor does she actively try to be a trendsetter. Like most things Taylor-related, her general disregard for fads means she struts to the strum of her own guitar. But for an album thematically built on the passage of time, its aesthetic timed out perfectly with the cyclical nature of fashion, which brought a resurgence of '70s styles back into popularity. Bell bottoms, paisley, corduroy, crochet, and fringe returned in full force on runways and in celebrity street style. For once, Taylor joined the trend and easily looked at home in cropped, striped knits from Mother Denim and wide-legged brown corduroys from Urban Outfitters in the "Lavender Haze" music video, and ruffled, striped Chloé blouses in the *Midnights* album booklet. Her full fringe—which she had first introduced back in 2012—felt less perfectly coiffed and more effortless. Bedhead but better. She gave fans an engaging glance at '70s fashion in a series of kitschy, game show–styled videos posted to social media and titled "Midnights Mayhem with Me." Complete with cheesy elevator music and assisted only by a vintage bingo cage, Taylor revealed in (supposedly) randomized order the song titles of *Midnights* while wearing plaid sweater vests by Re/Done, corduroy skirts by Acne Studios, and an assortment of authentic, period-correct graphic tees. One of which may have had cartoon cats on it.

(OPPOSITE) Capturing the allure, the contrast, and the glamor of the *Midnights* era, Taylor appeared at the 2023 Grammys in this night-blue two-piece designed by Fausto Puglisi for Roberto Cavalli. It's a look that thankfully calls to mind flowing celestial, not figure skater. The hand-cut, silk cady fabric features a scattered starry illusion via embellished silver Swarovski crystals that I appreciate as an overt and beautiful reference to the late-night themes of the album. What gives her look that *Midnights* edge are the spellbinding sensual details: an overly smoked eye, the red lip, a slash of midriff, and oversized doorknocker Lorraine Schwartz earrings (that were valued at a whopping $3 million). It's an ensemble that flirts with coquettish fancy and aloof elegance. It was also an Easter Egg: Roberto Cavalli later contributed costuming to the Eras Tour, including more spangly two-piece sets.

Reaching for vintage pieces and pairing them with forehead-covering bangs wasn't new for Taylor (as seen in the mod stylings and prim apparel of the *Red* era in 2012). But the way she executed this reliable formula felt different for *Midnights*, perhaps mostly because Taylor herself was different. There was a sense of ease and, dare I say, swagger. Peaceful confidence replaced anxious earnestness to please and to prove something. The hair was less keratin smooth; a smudged-out shadow usurped a precisely drawn winged liner. Images of her depicted a portrait of a lady on a fire-hot streak in her career—one she hadn't expected. To Jimmy Fallon on *The Tonight Show*, Taylor jocularly admitted, "I'm feeling overwhelmed by the fans' love for the record. I'm also feeling very soft and fragile. The two can exist at once. . . . I'm thirty-two, we're considered geriatric pop stars. They start trying to put us out to pasture at twenty-five."

(OPPOSITE) After Carole King presented Taylor with the Artist of the Decade Award in 2019 at the American Music Awards, Taylor returned the favor in 2021 when she inducted Carole into the Rock and Roll Hall of Fame. For her performance and presentation, Taylor layered two catsuits, a gold one by Greta Constantine and a black lace one by Sarah Regensburger. It was her own shimmering take on rock star leather and lace. Coupled with hair that felt bigger and wavier than we'd seen in years, the look felt like a tribute both to Carole and to the tangle-headed teen of Taylor's formative years. The two of them share beginnings as staff songwriters before hitting their big breaks, Carole in New York, Taylor in Nashville. As evidence of the twin tracks of their careers on a one-way train to world renown, each tapped into the same demographic in the same way, a generation apart. Taylor described Carole's album *Tapestry* as "like listening to a close friend, intimately sharing the truths of her life so you can discover the truths of your own." I know the feeling. Carole, likewise, said of Taylor, "Her lyrics resonate across the generations, her songs touch everyone, and her impact around the world is extraordinary. The past decade has been incredible . . . and the best is yet to come." It wasn't a torch passing so much as a torch sharing—two female songwriting luminaries basking in the warmth and light their works had brought to the world. Vestiges of Taylor's masterminding were at play when she remarked, "The purity to the music [Carole] creates exists between two worlds: The mysterious, magical inspiration, and decades of hard-earned and hard-learned craftsmanship. Just because Carole King makes what she has accomplished look so effortless, doesn't mean it has been."

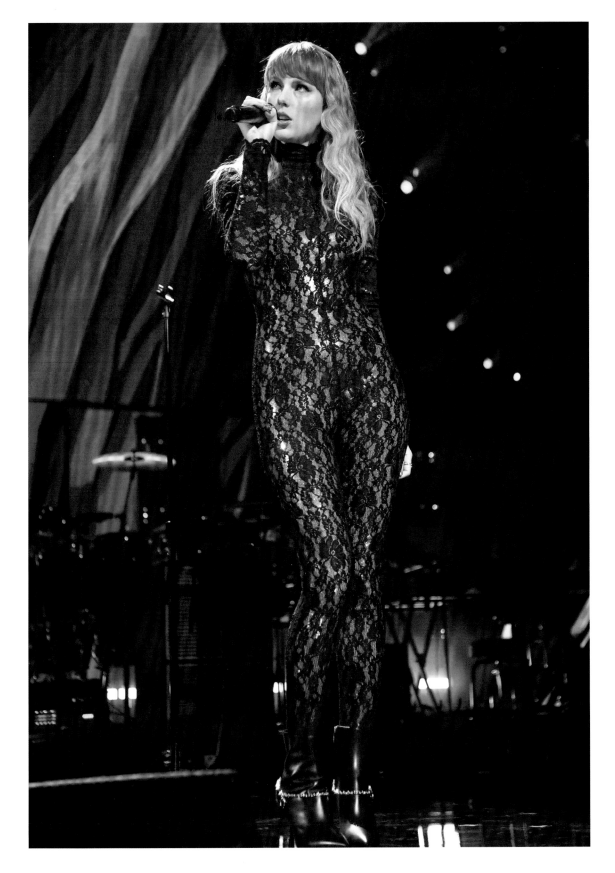

Midnights played target practice with previous records that may have stood in its way, leaving tattered remnants in its blazing trajectory. It shattered Taylor's own 2017 record for *reputation* with a million-unit sales week (1.6 million), broke Spotify's single-day streaming record for an album (186 million), became the best-selling vinyl of the year (575,000), "Anti-Hero" delivered Taylor her ninth and longest-standing number-one single (previously held by "Blank Space," which spent eight weeks atop the chart), and saw her become the first act to occupy the entire top ten of the *Billboard* Hot 100 simultaneously. When Taylor released her first true pop album in 2014, the *New York Times* prognosticated, "On this new stage, [Taylor] is thriving. And crucially, she is more or less alone, not part of any pop movement of the day. She has set herself apart and, implicitly, above . . . aiming somewhere even higher, a mode of timelessness that few true pop stars . . . even bother aspiring to." Those words were written at the midpoint of her current discography and now read as shockingly accurate in terms of the heights she had yet to achieve.

In its review of *Midnights*, *Slate* observed that the album's performance was "mind-blowing for someone in her 17th year as a recording artist" and firmly placed Taylor within another stratosphere of musical peerage. "Forget the Beatles, who barely lasted a decade together. To find parallels, you have to point to acts like Barbra Streisand, Michael Jackson, Stevie Wonder, or Diana Ross, all of whom started young like [Taylor] and were still achieving personal bests on the charts deep into their second decade as recording artists. All of these artists—[Taylor] too, I'd argue—were geniuses, and in the balance of art and commerce that is hitmaking, their ability to read the room culturally and shift artistically was essential to their endurance." Is it any wonder that Taylor aesthetically has rarely mirrored her contemporaries? When your artistic peers make up a legendary echelon, the only inspiration source to draw from is yourself.

If the heart of *Midnights* is a '70s hotel room—air heavy with patchouli and smoke, scratched vinyls half in their sleeves on a mahogany table, the subtle crackle of a wood-wick candle—then the face of *Midnights* is that of a glam showgirl: diamond bustier corsets and garters attached to flimsy silk socks, razor-sharp eyeliner and a come-hither red lip, the alluring click of a stiletto on the floor. Our first glance of Taylor's *Midnights*-era fashion was of the latter. The high-shine allure of a glam pinup girl was a smart visual for an album that

explores conflicting light and dark emotional themes, highlighting an aesthetic defined by a beautifully coiffed exterior laminated over a seedier underbelly.

Taylor presented this face when she made an appearance at the 2022 MTV Video Music Awards. Of the five awards she was nominated for, Taylor won three. The biggest of the night was Video of the Year for the "All Too Well" short film. Before presenter Nicki Minaj could even crack the envelope declaring the winner of the category, the crowd was chanting "Taylor" over and over. The roar elicited from the crowd in anticipation as the nominees were called would have made a viewer wonder if they'd accidentally turned up the volume. The frenzy frothed over once she was actually announced as the winner and she made her way to the podium in a glittering bejeweled mini by Oscar de la Renta. With a satisfied smirk of her signature red lips and a coy glint in her eye, she used her speech to thank fans for their support for her re-recording project, the reason the winning video even existed in the first place.

Though she was holding the coveted Moon Man trophy, what she really had in the palm of her hand was the audience; you could feel from the tension and the held breath of anticipation in the room that something was about to happen. Taylor wrapped up her speech with a revelatory announcement: "I had made up my mind that if you were going to be this generous and give us this"—cue cable watchers once again checking the volume button on their remote amid fresh shrieks—"I thought it might be a fun moment to tell you that my brand new album comes out October 21. And I will tell you more at midnight." Trick Swifties once, and then twice, with a surprise album drop, shame on you. Trick Swifties three times with a surprise album drop, shame on us. Either way, the result left fans lying on the cold, hard ground.

"Forget the Beatles, who barely lasted a decade together. To find parallels, you have to point to acts like Barbra Streisand, Michael Jackson, Stevie Wonder, or Diana Ross." —*Slate*

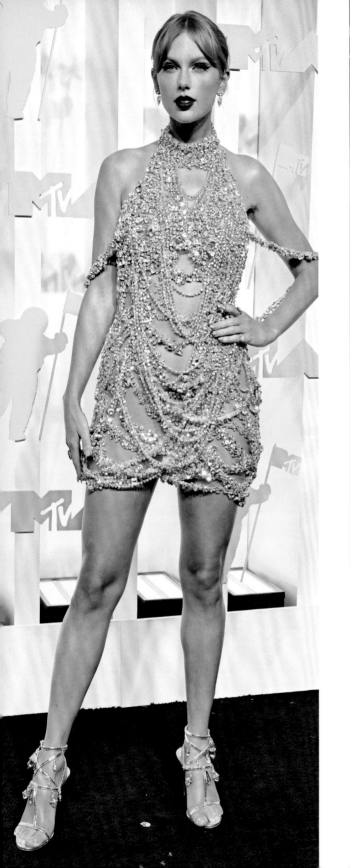

(FAR LEFT) Princess Diana might have called this a "revenge dress"—but I like to go one step further and refer to it as Taylor's best "fuck you money" outfit. Elegant expletive aside, the term, originated by John Goodman's character in *The Gambler*, refers to having enough money to live life on your own terms. In 2015, Taylor famously countersued (for one dollar) a radio DJ who had sexually assaulted her. He had originally sued her for allegedly getting him fired and ruining his reputation in the wake of the assault. After the case was decided in Taylor's favor, in the music video for her comeback single "Look What You Made Me Do," a dollar bill appeared next to her as she reclined in a bathtub filled to the brim with diamonds. It's in this Oscar de la Renta dress, worn to the 2022 MTV VMAs, that Taylor seems to have fully emerged from that bathtub, diamonds artfully arranged on her body to lavish her in excess. Is it a surprise that this moment came thirteen years after she first won Video of the Year while wearing a similarly embellished (albeit far less revealing) dress, the same night a certain someone robbed her of her moment by asserting that she didn't deserve the trophy? The 2022 ensemble represents a closing of the loop that also neatly connects the stories of two enragingly entitled men hell-bent on taking her down. To see her rise as the sparkling embodiment of a winner—as someone confident and proud and at ease in her skin—is the ultimate crown jewel.

(LEFT) When the clock strikes twelve, the '50s housewife turns into a '70s showgirl. Taylor's initial experimentation with vintage styles was a way of accelerating her perception as a woman by leaning heavily into prim and modest silhouettes that exuded maturity. Here, the pinup-girl aesthetic, when placed in the context of an album that juxtaposes anxious thoughts and secret highs, is the perfect carrier device. The starry embellishments and midnight-blue hue of this custom Moschino romper are a stroke of *Midnights* genius that interplays with the album's moody tone. And the glam, fluffy, faux-fur shrug foreshadows future outfits she wore in music videos and on tour.

Swift, Table for One?

The Eras Tour wardrobe demonstrated not only that Taylor is an artist who fully understands the visual legacy she has created, but also that she will extend that legacy while also paying subtle homage to precedent. Her comfort in navigating the exhumation of her past selves felt like a natural extension of the theme of *Midnights* rather than a tipoff to a greatest-hits final bow. It's a tough line to balance, but she does so, of course, delicately. Taylor has toed that line her entire career, boldly transforming her image with each iteration of her work in ways that are distinctive while maintaining a semblance of familiarity that doesn't compromise her brand or alienate her growing audience.

The Eras Tour costumes were a veritable designer royal flush with custom looks ranging from Versace to Oscar de la Renta to Alberta Ferretti to Etro and beyond. Some felt entirely new and fresh, like a midnight-blue, spangled Zuhair Murad leotard that evoked the corsetry and glam of the "Bejeweled" music video, with a saucy garter to boot. Or a sequined T-shirt dress by Oscar de la Renta with a faux-fur shag jacket layered on top as a reference to the styling in the "Lavender Haze" video. Other costumes seemed like modern successors to looks of eras past, like a Roberto Cavalli matching co-ord set to represent *1989*, or a double dose of nostalgia pairing a cold shoulder plissé dress by longtime tour collaborator Jessica Jones with the koa wood Taylor Guitar of her teen years, or bringing back Ashish, the designer of the sequin shirt first seen in the "22" music video, to replicate the cheeky T-shirt design for the opening ensemble of her *Red* set. The exact messages displayed on her shirt changed from show to show, but they often acted as tongue-in-cheek billboards for inside jokes within the fandom.

This Oscar de la Renta bodysuit required over 315 hours of construction to carefully apply about fifty-three hundred embroidered crystals on its midnight-blue base. For the tour performance of the song "Midnight Rain," I love that the spangles of the design mimic the scattering trails of raindrops running down a windowpane (Taylor is no stranger to a rain-soaked performance on tour; see "Should've Said No"). The use of fringed hip tassels serve triple duty: they move in an eye-catching way for the stage, throw extra sparkle around, and feel simultaneously western and showgirl-esque.

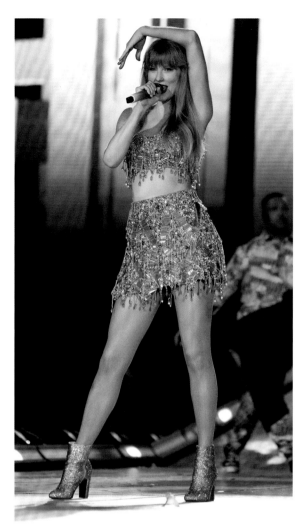

Taylor made a point to reference and refresh her previous headlining tours in her Eras Tour costumes. Some were overt references, refined and modernized. A Nicole and Felicia couture ball gown was a volumized duplicate of the tulle Valentino number worn for the Speak Now Tour's finale (left). A fringed, glittering, green Roberto Cavalli two-piece elevated by diamond-patterned sequins with coordinating Christian Louboutin booties felt directly lifted from the 1989 Tour costuming (top right). Other allusions were more subtle, like the asymmetric Roberto Cavalli jumpsuit sprawled with the coils of red-and-black diamond snakes. The reptilian motif is a clear nod to the reputation Tour and to the duality of the album itself, which documents the tension between her public and private selves. Its one-arm silhouette symbolizes a shedding of snakeskin, as if the memories from that time period remain an inseparable part of her identity and her lived experience, even as she continues to heal from past wounds. It also calls to mind the black sequined Jessica Jones leotard that opened the reputation Tour, which also featured an asymmetric sleeve.

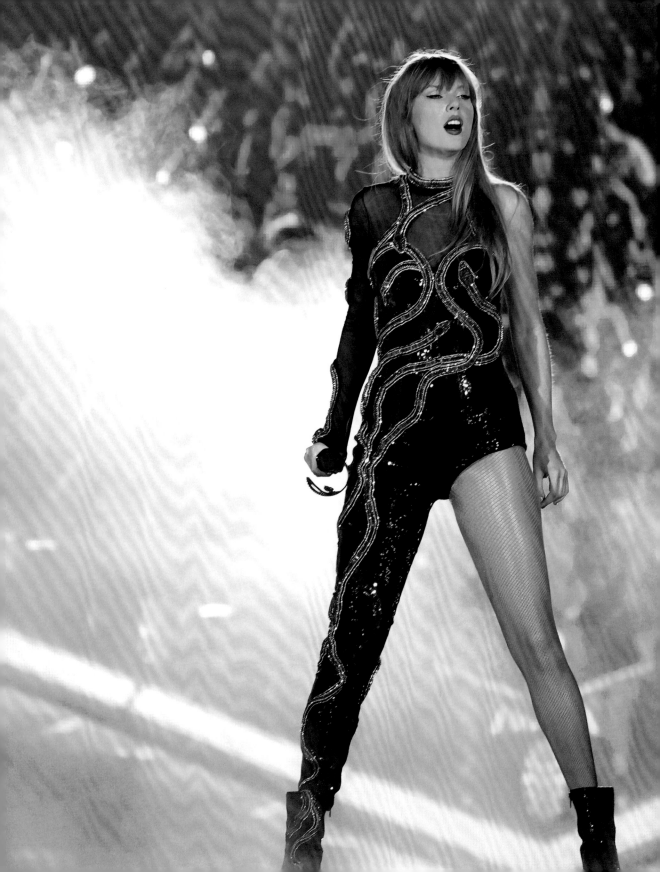

"Making albums . . . feels like a way to suck the poison out of a snakebite."

In an age where the internet has opened a bottomless chasm in which musical artists can "make it" while also inversely downsizing attention spans, the idea of the monolithic pop star can feel like a relic of the past. But Taylor has always been the exception. She does not move goalposts; she creates entirely new foundations upon which to build her empires. Having spent the first decade of her career releasing six albums, since 2019 she's done just as much in half the time. "In the last six or seven years I've just been constantly making things. And the more things I make, the happier I am," she said of her frighteningly impressive production speed. Ahead of the 2024 Grammys, *Rolling Stone* aptly said, "Few things in life are certain: Death, taxes, and Taylor Swift Album of the Year nominations." Backed by the stratospheric success of the Eras Tour, *Midnights* triumphed to take home the Album of the Year trophy. Taylor became the only artist to win the award four times—hurdling over hat-trick winners Frank Sinatra, Paul Simon, and Stevie Wonder. The success of *Midnights* makes clear that her brand of personalized pop causes many to regard her as the last of her kind: a true superstar.

This custom Oscar de la Renta sequined T-shirt dress and faux-fur jacket, which opened her *Midnights* set on the Eras Tour, is most obviously a direct pull from the costuming for the "Lavender Haze" music video and more quietly an archival throwback to the sequined tank dresses of her early touring days. But what I love most about Taylor's journey through the eras—each album of her discography (with the exception of her debut—not that this debut fan is holding a grudge or anything) getting its own neatly cleaved part of the setlist—is that her hair and makeup remained unchanged for the entire three-hour show. In the past, she'd distinguished different parts of a show, and their respective costumes, with a fun ponytail or a messy side braid. On the Eras Tour, the show's static centerpiece—as we bounced across the years of her career and she flitted between iconic visuals associated with each part of her life's journey—was her polished hair and full fringe. It was as if the real Taylor—who had found her beatific baseline in a red lip, long loose hair, and bangs—was peeking out from behind the curtain of her past selves.

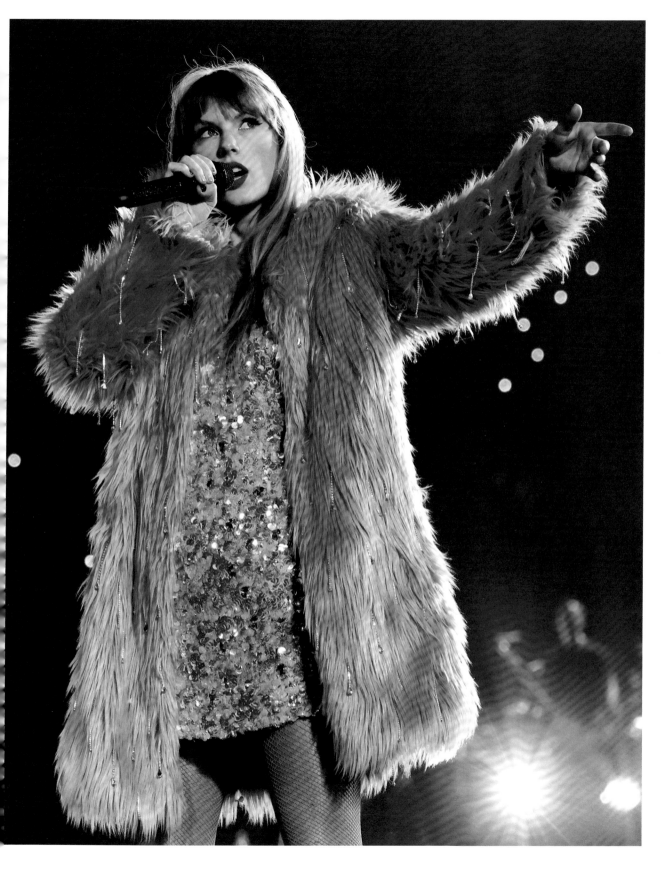

Part

IV

FROM THE VAULT
(BOOK VERSION)

10
Bloopers

SEVEN TIMES TAYLOR SHOULD'VE SAID NO

FASHION IS INHERENTLY PERSONAL AND THUS SUBJECTIVE. I THRIVE IN THE differences of opinion and the diversity in thought over what is en vogue and what is passé. The goal of *Taylor Swift Style* is to provide critically kind thoughts on Taylor's fashion. This is easy to do when she nails it and (speaking as a well-seasoned commentator) reasonably manageable when she's only slightly off the mark. If I were an animated rabbit in the world of *Bambi*, I would simply not say anything at all about the following looks . . . but baby, that's not what we came for. And if you came here only to find one of your favorite ensembles included in this list—let's just agree it hits different for you than me.

So without further ado, bloopers!

(PRECEDING PAGE)

One Step Forward, One Sweater Backward

In November 2014, Taylor stepped out to enjoy a New York Knicks game confidently rocking a cutout 525 America burgundy sweater, mustard Paige Denim jeans, and a pair of trusty Rag & Bone booties she had on frequent rotation at the time. Taylor has always loved a unique color combination, and maybe she had hot dog condiments on the brain. In any case, between leaping to her feet during pivotal moments of the game (yay sports!) and delicately sipping a beer courtside, Taylor wore her lovely bordeaux knit backward—a fact that I personally brought to her attention via my blog. In fairness to Taylor, the piece is advertised as reversible, so her choice to expose her collarbones is understandable. During what I have to assume was a late-night social media scroll, Taylor reshared my post, slow realization dawning. "I think what they're trying to say politely is . . . I wore the shirt wrong, didn't I," read her caption. One of us was mildly embarrassed, and the other one gained a fun icebreaker factor at parties. I'm sure you can tell who is who.

(OPPOSITE, LEFT)

Elvira

Taylor wore this sad vampire gown by the designer Elvira to her very first CMAs in 2006, coincidentally on my fourteenth birthday. And, no, you really cannot make up that kind of tragic fashion serendipity. If the shiny fabric and the image of her shuffling in heels on the red carpet in that tight mermaid silhouette didn't do it for you, please direct your attention to the matching elbow-length gloves. I wept over the candles on my cake.

(OPPOSITE, RIGHT)

The Incident

Over the years, I have only been able to refer to this outfit, which she wore to the 2014 MTV Video Music Awards, as simply "The Incident." Its infamy has necessitated its own hashtag, because when you wear a long-sleeved Mary Katrantzou baby onesie replete with a spilled-Alphagetti print and mismatched burgundy cutout heels by Elie Saab, you get your own dedicated hashtag. According to the designer, who told *InStyle*, the letters were "inspired by turn-of-the-century school books which felt appropriate because her songs have such a strong sense of narrative." Personally, I can't give this outfit a passing grade. So the kindest thing I can summon up to say amid all this criticism is that her famous legs look incredible.

I Mean, What Does Coco Chanel Even Know About Fashion Anyway

Coco Chanel once famously advised taking a final look in the mirror before heading out the door, and removing one accessory. On this particular day, Taylor chose to mishear those minimalist words and add not one but two superfluous accessories. The first being a collaboration bag between Louis Vuitton and Christian Louboutin (the studs on the front and the hidden bright-red panel on the back are both tributes to two of Louboutin's most famous signature designs). The second being a horse-girl-approved harness by Free People. Why did either of those two items come anywhere near what is otherwise a perfectly cute outfit of band tee, shorts, and ankle boots? Well, Coco Chanel also once said that "accessories make or mark a woman." This particular one marks Taylor as sometimes chaotic when styling a look.

Everything Is Awful
and Everything Hurts

This was a day when I have to assume
that every person on Taylor's otherwise
impeccable glam team was replaced by
a vengeful robot set on wreaking havoc.
Target: Taylor Swift. Objective: Heavy
hand everything. Mission: Accomplished.
The overly worked curls and the garish
makeup do her no favors. And neither
does that dated bandage dress by Hervé
Léger, a design that was inescapable
in the mid-2000s, relentlessly worn by
a bevy of reality-TV stars, and seen by
the dozen in any line snaking out of a
nightclub.

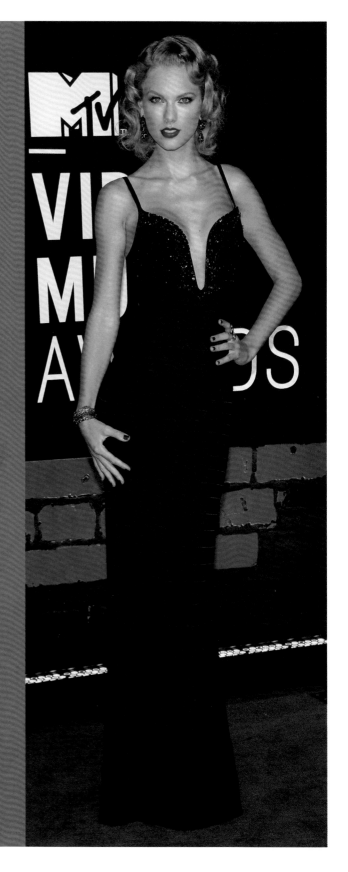

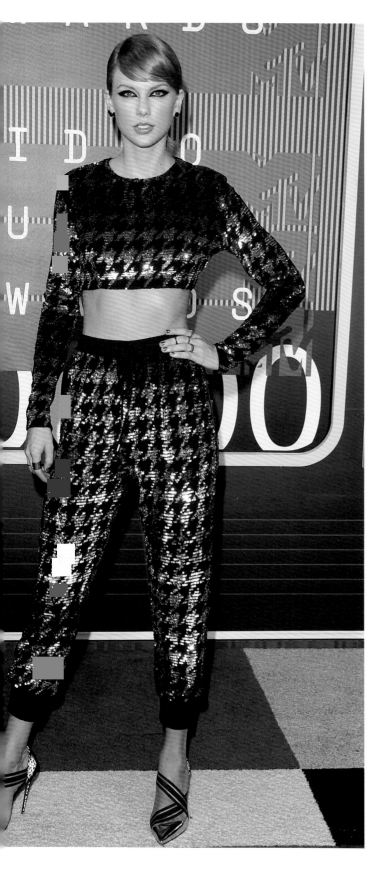

(FAR LEFT)

My Daydream's Fit Like a Baby

The extra length from the sleeves likely went into volumizing the sides of her hair in this powdery-blue Osman romper. The shrunken-onesie silhouette, the wrinkles, and the pairing with pink, chunky Saint Laurent sandals give the impression of a disgruntled toddler in too-small clothes on picture day.

(LEFT)

Four Words: Sequin Houndstooth Jogger Set

That phrase should send shivers of fear down your spine. Sure, the MTV VMAs, where Taylor wore this Ashish set, are the most appropriate place for a fun, ridiculous look. But why must it be a SHJS? Elasticized cuffs have no business on a red carpet. Especially not when they come up short— literally—and hit the wearer midshin. That said, I've recently come to the conclusion that perhaps the striped, elasticized straps on Taylor's Christian Louboutin heels are meant to be a nod to a sportier shoe, like basketball high-tops, to befit the athleisure nature of the jogger set. I am nothing if not someone who can get behind intentional, thematic style choices. Even when those choices result in . . . this.

"I love writing songs because I love preserving memories, like putting a picture frame around a feeling you once had."

—Taylor Swift, *Elle* (UK), 2019

Epilogue

WRITING YOUR HISTORY IS HISTORY-MAKING

THE TWANG OF A TWELVE-STRING ACOUSTIC GUITAR SET THE TONE, BUT A SWEET sundress and cowboy boots set the scene. From the outset of her debut single, "Tim McGraw," Taylor planted the lyrical seed to intertwine music with style, foretelling even as a teenager how much she would rely on merging memories with clothing. In the nearly two decades since, Taylor has continued to wield the power of her closet with the same savvy she does her pen.

In a personal essay for *Elle* (UK) magazine in 2019, Taylor wrote, "I love writing songs because I love preserving memories, like putting a picture frame around a feeling you once had." If her songs are the frame, her wardrobe is the picture, the two working in tandem not only to capture moments, but to remember them as well. Secret messages and little details, whether a glittery "13" traced on the back of her hand or her name embellished on a pair of cowboy boots, may not have started off to inspire fan conspiracies or serve as a launch pad for eventual reinvention. But Taylor knew, from the very first night, that her songs would be stronger, her lyrics clearer, and her brand bolder when amplified through intentional dressing.

Taylor employs fashion as a medium to send messages, stories crafted from fabric and not just words. She recast femininity as a strength in her self-written album *Speak Now*, wielding girlish tulle to validate her success amid doubters. She co-opted a vicious attack and bravely reclaimed it, slithering into snakeskin on *reputation* to flip an insult into an emblematic superpower. She remade

The 2023 Eras Tour served as Taylor's grand return to the stage. She was armed with four new, original LPs (*Lover*, *folklore*, *evermore*, and *Midnights*), which she referred to in a speech as "new members of the family." She displayed unparalleled—even freakish—stamina over the course of a forty-plus-song performance, mining her previous albums for dedicated, parceled sets that stretched out over three hours (and thirteen minutes, of course). The performance of *reputation*'s "Look What You Made Me Do" expanded on the music video's caricatures of her past selves. Behind a snake-covered Taylor in a Roberto Cavalli jumpsuit were life-sized Barbie boxes imprisoning versions of her previous eras' looks. It was a strong visual that was, by its nature, highly personal. It isn't a stretch to link the lineup to the withholding of the masters of her back catalog. The ultimate comeuppance, of course, was seeing this tableau come to life following an unprecedented period of productivity in her career, especially after her previous label had banked on her past instead of her future. This visual loudly proclaims that behind every successful woman is herself. As *Rolling Stone* astutely put it, "There's something funny about a greatest hits concert for someone who's never been more in her prime." It turns out, revenge is a dish best served in couture and shared with seventy thousand of your closest friends.

stuffy suits in her signature romantic optimism, washing tailored blazers and trousers in pastels to synchronize power with effervescent joy upon the release of *Lover*, the first album that represented Taylor's full artistic ownership of her work.

British designer Katherine Hooker, whose chic wool coats Taylor wore throughout the *Red* and *1989* eras, told me, "She's notoriously confident in herself, but she also isn't afraid of being vulnerable as well." Taylor's stylist Joseph Cassell said to *InStyle* in 2014 that his role has always been to hone and guide the ship, not captain it. "Taylor has such a clear vision of who she is and how to reflect that in what she wears. She isn't afraid to try new things, like combining separates in a cool way or choosing accessories that are interesting or different." As always, from the start Taylor knew what she wanted to communicate and how it would set her apart from the crowd.

Her distinctive, feminine style has made it easy for fans to translate their love for her music into a real-world Bat Signal to silently communicate their Swiftie Status. A well-placed red lip, a vintage accessory, the self-possessed smirk of a woman who has the power to send the internet into chaos at the drop of her latest single—these are the little things we can all aspire to inject into our day-to-day ensembles.

Taylor's clothes have become not just definitional but emblematic of the passage of time. Beyond the trappings of trendiness, Taylor has had the bird's-eye foresight to preserve her different eras in amber through the distinctive styles she has cultivated for each. Even before her past selves all stood in line on the tarmac in the "Look What You Made Me Do" video, Taylor had used clothes to create identities for them. Today, it's impossible *not* to characterize each style by era, but the term was shorthand for Swifties for years before it became the thematic unifier of her 2023 tour.

*Red*emption Arc

In 2019, the masters for Taylor's first six albums were sold out from under her, including not only the lyrics and melodies that were painstakingly poured from her heart, but also the visual components of each album: booklet designs, photo shoots, and, in Taylor's words, "videos I dreamed up and paid for from

the money I earned playing in bars, then clubs, then arenas, then stadiums." In reclaiming her work—which she did by systematically duplicating her back catalog album by album to create versions that she owned outright, a move that also devalued their sold-off counterparts—she had to complement each "Taylor's Version" album with fresh visuals. Vestiges of the original album covers bleed through the new ones like double exposures.

She reinvented the *Fearless* hair toss, loose waves billowing in what looks more like a natural breeze than the original wind machine that whipped her Conair curls around. The neck ruffles and loose tie on her Ulla Johnson blouse feel positively thespian, a look that rewrites her role from damsel in distress to her own version of the Romeo in "Love Story."

The whimsy and girlish effervescence of the *Speak Now* cover is more somber and battle-scarred on (Taylor's Version). The tulle of her voluminous Giambattista Valli gown retains the fanciful froth of the original. But the low drape of sleeve exposing her back and arms reads more womanly and sensual— if surprisingly unguarded—than little girl playing fairytale dress-up in her mother's closet. Rather than glancing nymph-like off-screen into an optimistic future, as she did on the 2010 cover, this version of Taylor stares directly into the camera, eyes soft but present—if a little careworn. It's a fourth-wall break that's direct and intentional, centering a vulnerable artist as she reclaims her first entirely self-written body of work. One errant curl, like a first crack in the girlish veneer, is a harbinger of her falling out with fairytales, a theme that would be more thoroughly explored on *Red*.

Further cementing its status as a perennial fall album, Taylor evoked an autumnal color palette on her new version of the *Red* cover. A rust velvet hat by Janessa Leone and a taupe Stella McCartney coat were the cozy complements to the artful red pout that maintained a throughline to the original cover. But a twisting, foliage-lined road in the background, a reference to scenes from the "All Too Well" short film—Taylor's cinematic directorial debut—and a customized twist on the Cathy Waterman ring first seen in the original *Red* photo shoot, combine to reveal the new elements she brings to the table. The delicate balance between reference and replacement creates full-circle style moments for fans to pick up on, as well as drawing attention to the old parts of herself she left behind.

The coolly detached, painstakingly put-together city girl of *1989*'s original iteration is replaced in (Taylor's Version) by a woman windswept and carefree. Save for her signature red lip, Taylor skipped the meticulously applied eyeliner and carefully smoothed bob in exchange for a relatively bare face and undone tresses, her hair lifted by what one can only imagine is the salt air off an East Coast shoreline. The cover is a poignant reclamation of one's try-hard twenties to come out the other side gentler, more at ease, and happy to accessorize the scars on your heart with a knowing smile—something Taylor had admitted to fans on Tumblr she was nervous to display in 2014 in favor of appearing mysterious. The seagull motif she once wore on a vintage sweater for the 2014 cover now appears as a part of the endless sky behind her.

Fearless (Taylor's Version) and *Red (Taylor's Version)*, both released in 2021, and *Speak Now (Taylor's Version)* and *1989 (Taylor's Version)*, both released in 2023, each came with a vault of songs left off their original tracklists. These tracks offer additional perspective—a treat for longtime fans who had already been listening to the prototypes for a decade, and an enticing draw for new fans unfamiliar with the original versions. Taylor's matured vocal delivery displays improved technique and mastery over use of her instrument in ways that skillfully communicate emotion. The grown-up outlook lends poignant credence to the life advice she gives her younger self on *Fearless*'s "Fifteen." And you can practically hear the disdainful eye rolls on the newly added track "Mr. Perfectly Fine," an amusingly petulant Joe Jonas–era brush-off that also gives a peek into the songwriter's process, evoking a line that would later be reworked to describe a casual and cruel Jake Gyllenhaal on *Red*'s "All Too Well." And, of course, the ten-minute version of "All Too Well" catapults the ballad into true legendary status, a songwriter's magnum opus. The additional verses and extended bridge add fresh layers of frustration and bitterness that rightfully earned the track a 2023 Grammy nomination for Song of the Year.

It's almost assured that Taylor's fashion will continue to evolve alongside her art. "Looking back on my career, there have been so many different musical phases and different things I wanted to wear at different times, and they fit my life at the time," she said in an Apple Music interview. "I think that you've got to allow yourself that grace to put on a certain lifestyle or a certain outfit or a certain creative mantra, and then discard it when you outgrow it."

Perhaps because a maroon suit would have been a bit too on the nose, Taylor stuck within a similar color family in this plum velvet suit by Etro, which she wore to the New York premiere of the "All Too Well" short film. The rich fabric gives a fashionable and fall-appropriate twist on a business suit. The corporate-adjacent ensemble feels befitting of her new professional venture behind the camera as the film's director.

The Story of Us:
Fandom, Love, and the Future of Taylor Swift

Taylor is already a living legend whose career has ascended in three different genres and whose album sales continue to set records—even in the age of streaming. She's left an indelible legacy on the pages of music history. The proof is in the singer-songwriters who are emerging from her shadow and will name-check her as an influence for decades to come. Gracie Abrams called her "one of the blueprints for vulnerability as a young woman" in an interview with *Teen Vogue*. Conan Gray said to *GQ* of her impact, "Taylor raised an entire generation of songwriters. She taught a lot of people how to write pop songs." Griff said to *Nylon*, "There's this new wave of young pop musicians that you can hear Taylor Swift in their writing and you can tell that they're Taylor Swift fans." Phoebe Bridgers, feature artist on 2021's "Nothing New" from *Red (Taylor's Version)*, a track lifted from Taylor's vault, cited Taylor's presence as a young, female songwriter as what gave her permission to write her own songs. "One day, I was listening to country radio . . . and Taylor came on. I heard a girl, not much older than me, singing a song she had written about her own life. . . . I'm grateful to have grown up in a world with Taylor Swift in it, or, 'The World: Taylor's Version.'" It's appropriate that Phoebe's vocals on "Nothing New" gave the song

Red (Taylor's Version) won Favorite Pop and Favorite Country Album at the 2022 American Music Awards, almost a decade after its original release won the same latter category. The bookend win was a chef's kiss and middle-finger moment that gave credence to her crossover success, the lasting legacy of *Red*, and her labor of love in embarking on the re-recordings. If the trophy weren't enough, the styling says it all. Her teased, volumized hair and The Blonds jumpsuit (far left) mimic the textured, backcombed waves and gold plunge of the Julien Macdonald dress (left) she wore to the 2013 ceremony, notably without the modesty of the illusion mesh—a nod to a decade's worth of growing self-confidence. Her accessories for the night also neatly spelled it out: the Unchain My Art Ring by Delfina Delettrez paired with White Space Jewelry's Continuity Ring. The Delfina ring seemed like a blatant reference to her acceptance of an award for an album she re-recorded in order to regain ownership of her work. The White Space ring was an homage to the full-circle honor of being rewarded in two genres for a body of work she feared would never be fully recognized on the awards circuit due to its lack of sonic cohesiveness.

new life as a prophetic duet, exploring and exposing Taylor's fears about her future and the frailty of fame—and the long line of younger talents who would seek to replace her. Instead, their success acts as a testament to her own and to the impact of her artistry. From Kelsea Ballerini, to Gayle, to Maisie Peters, to Camila Cabello, and the Haim sisters, Taylor has inspired and nurtured— through opening-act opportunities, mentorship, and friendship—countless female songwriters.

> *"I think that you've got to allow yourself that grace to put on a certain lifestyle or a certain outfit or a certain creative mantra, and then discard it when you outgrow it."*

Will her work to re-record her early discography lead to her launching her own label to spare future artists the same plight she went through with her masters? She hinted as much to Apple Music in 2020: "I'm having lots of conversations behind the scenes with record labels trying to help them understand . . . what you do to an artist when you separate them from their work—you break something. Artists should never have to part with their work. They should own it from day one." She continued, "If I can do anything to change that for a young artist in the future or many or all of them, then I'm going to keep being loud about it." Perhaps she'll take a leaf out of Stevie Nicks's book, who, since the 1970s, has famously bestowed moon necklaces to her inner coven of friends and admirers, Taylor among them. When Taylor gave her reworked "Red" Cathy Waterman ring to teenage pop starlet Olivia Rodrigo (who proffered songwriting credits to Taylor on two of the songs from her debut album, citing her as "the best storyteller of our generation"), I couldn't help but wonder if, in her wardrobe choices, Taylor's visionary approach has long been to emulate icons—like Stevie. Perhaps as she continues to help bolster the careers of others, she'll take on an earth-mother, bohemian-meets-rock aesthetic to match.

Taylor normalized and validated the young, female voice and experience through her perspective on life and love, and in how she chose to show up in this world. She made us want to pick out the very best dress in our closet and dance in a rainstorm. She gave us the push we needed to try a classic red lip. She demonstrated the realness of our tender experiences and memories, even if all we have left of them is a careworn scarf. She made us feel like a favorite cardigan, plucked from the dusty graveyard under someone's bed to live a second life of being loved and cherished again. She made us feel all those things while also catering knowingly to those of us who live and die by a cathartic bridge placed at a song's crescendo between the third verse and final chorus.

Her story of healing heartbreak through song is what imbues her work with a delicate equilibrium between vulnerability and strength. Her openness to the world and to fans, and her detailing every minute facet of her experience in life and love, are what make her so fascinating and alluring as a person and a public figure. Her unassuming gestures of kindness so she can maintain a genuine connection with her fans has created an unbreakable bond with them. There are countless examples of Taylor's random acts of kindness—from visiting fans in the hospital, to hand-delivering Christmas presents to fans' homes, to bringing fans into her own homes, to hosting a free thirteen-hour meet-and-greet so she could talk to as many fans as possible. I'm sure there's a book out there filled with paragraphs on the plights of parasocial relationships with celebrities. But para-so what? This is not that book. Throughout her career, Taylor has thoughtfully fostered—and prioritized—a genuine relationship with fans at every turn.

Taylor's triumphant return to the touring circuit with the Eras Tour created the space for Swifties of all cohorts to once again come together and celebrate her art in person. The electric energy of the concert venues was charged equally by the undulation of uninhibited dancing bodies, the friction of millions of sequins from handmade costumes months in the making, and tens of thousands of bracelets (both light-up and friendship) filled stadiums with euphoria and the music of the one person who had brought us all together.

The hive-mind collective of living through a shared experience is meant to be felt, not spoken. Having survived the despondency and isolation of the pandemic to then bask in the unfettered joy of the same music that had helped

to dull the pain was like undergoing communal healing. To live in the same era and to have the privilege of growing and learning alongside someone whose art has informed the foundational truth of your life and how you ascribe meaning to your feelings is a gift that has yet to stop giving. Concert tickets should be marketed as medicinal.

These gatherings are the final puzzle piece demonstrating how Taylor's fashion transcends her. Every artist experiences a catch-and-release rite of passage: their work and life are shared with the world and become greater than the sum of their parts as they are embraced, interpreted, and reimagined by their listeners. This is how Taylor's dramatic red carpet couture, memorable music video outfits, relatable street style, and eye-catching stage costumes are reincarnated in her fans. Her lyrical and fashionable journeys walk forward in tandem, creating emotional anchor points for fans to tether themselves to earth. Taylor once described music as something that "is only right for [it] to be passed down like precious heirlooms. . . . These songs come to you from somewhere else and then, suddenly, they are partly yours." And then they become ours.

The only thing I know with certainty is that Taylor will always pave a path forward that is individually her own. Sometimes it will sparkle. Sometimes it will be delightfully grannyesque. Sometimes it will reveal a slice of skin via a cheeky cutout. Sometimes it will be accessorized with an unexpected item, meeting at the junction between cute and kitsch. With each new venture, she will continue to expand and enhance the visual legacy she's spent almost two decades crafting. Each ensemble is an opportunity to communicate messages beyond the clothes, whether overtly or subversively, for those fluent in fashion to pick up on.

That, and she truly never will go out of style.

Acknowledgments

THERE ARE A FEW PEOPLE THIS BOOK, AND I, OWE A LOT TO.

The first is my fearless editor, Brigitte Dale—and by extension everyone at the wonderful St. Martin's Press, including Alexis Neuville, Meghan Harrington, Anne Marie Tallberg, Jennifer Enderlin, Brant Janeway, Althea Mignone, Shubhani Sarkar, Jonathan Bush, Olga Grlic, Chrisinda Lynch, Michael Clark, and Kelley Blewster—who worked tirelessly to take these pages from my hands to yours. It was under Brigitte's encouragement and belief in this project that it became the balance of analysis and wry observation I had hoped it would be. Thank you for your gentle support, thoughtful insight, and Swift puns. (Thanks also to Brigitte's sister Juliet, who masterminded our fateful connection.)

The second is my partner, Dustin, who, over the course of my writing this book, filled many roles. First fiancé, then husband, always calm caretaker. He was witness to many afternoons and evenings spent prioritizing words over meals and editing over air. He saw the woman and the author and believed in both, wholeheartedly, unwaveringly. Thank you for a love that is peaceful and present, changing but constant. And for everything I never knew I needed but feel grateful and lucky every day to have. I'm proud to have my new name transcribed on the cover.

The third is my best friend Breanna. It was during her thirtieth trip around the sun—and a mystical drive down Highway 101—that the very first sketches of this book came to be, imbued by the salt air (and rusty doors) of this little

slice of the world we love so much. My life, and this book, wouldn't be the same without the impact of her always-open passenger seat and honest feedback. Thank you for a soul-affirming friendship that reaches the deepest oceans and densest forests.

The fourth are my parents, Stan and Shirley. They are the twin pillars of my life whose support has been unrelenting and unconditional. Their sacrifice and bravery to leave behind their respective native countries to move across the world in search of new lives inspires me every day. As their only child, I singularly and wholly feel the weight of their choices and expectations. It's my sincere hope this book lives as validation of everything they had dreamed and hoped for.

The fifth (and more) are the TSSers. You make me believe in the beauty of the internet and the decency in people. Your commitment to critically kind conversation and nuanced discussion, and your openness to (even joy in) the diversity of opinion is a gift to witness and an honor to play a role in fostering. Thank you for proving there is goodness in the world and in the connection between digital strangers who become a community.

The last, of course, is Taylor, whose "sharp pen, thin skin, and open heart" have been my North Star for over half my life. Her music has scored almost all of my most significant "firsts": My first kiss. My first breakup. My first real heartbreak. And, most recently, my first (and hopefully only) time walking down the aisle in the perfect white dress. My life would not look—or sound—like it does without her vulnerability, strength, and skill for turning her life into art. Her relentless determination to walk bravely forward amid wreckage, to find diamonds in dust, to traverse a limitless sky, phoenixlike, as often as it takes is an inspiration to me and millions of others. Thank you for creating worlds with your music, and for letting those of us who need a soft place to land find it.

Photo Credits

Alberto E. Rodriguez via Getty Images: page 109

Alessio Botticelli via Getty Images: pages 186 and 196

Alexander Tamargo via Getty Images: page 185

Alo Ceballos via Getty Images: pages 90, 93, 141, 146, 148, 149, and 167

Amy Sussman via Getty Images: page 316

Axelle/Bauer-Griffin via Getty Images: page 288

Bauer-Griffin via Getty Images: page 89

BDG/Shutterstock: page 93

Beretta/Sims/Shutterstock: page 91

Bob Levey/TAS23 via Getty Images: page 292

CBS Photo Archive via Getty Images: pages 124–125

Charles Eshelman via Getty Images: page 87

Christopher Polk via Getty Images: pages 129 and 135

Christopher Polk/TAS via Getty Images: page 162

Christopher Polk/TAS18 via Getty Images: pages 174, 212–213

Dan MacMedan via Getty Images: pages 59

Daniele Venturelli via Getty Images: page 190

Dave Hogan via Getty Images: pages 81, 215, and 245

Dave J Hogan via Getty Images: pages 111 and 130

Dave M. Benett via Getty Images: page 130

David Crotty via Getty Images: pages 209 and 210

David Krieger/Bauer-Griffin via Getty Images: page 200

David Mepham via Getty Images: page 36

Denise Truscello via Getty Images: pages 10, 23, 34, and 134

D Dipasupil via Getty Images: pages 74, 111, 117, 234, and 252

Dimitrios Kambouris via Getty Images: pages ii, 49, 57, 107, 229, 250, 299, and 315

Dimitrios Kambouris/LP5 via Getty Images: page 150

Donna Svennevik via Getty Images: page 114

Erika Goldring via Getty Images: page 182

Ethan Miller via Getty Images: pages 1, 2, 14, and 235

323

Ethan Miller/TAS23 via Getty Images: pages 128 and 293

Evan Agostini via Getty Images: pages 17 and 21

Frazer Harrison via Getty Images: pages 22 and 127

Frazer Harrison/ACMA2011 via Getty Images: page 77

Fred Breedon/Nashville Rising via Getty Images: page 44

Fred Duval via Getty Images: pages 37 and 41

Frederick Breedon IV via Getty Images: pages 40 and 60

Gardiner Anderson/Bauer-Griffin via Getty Images: page 147

George Pimentel/LP5 via Getty Images: page 163

GONZALO/Bauer-Griffin via Getty Images: page 89

Gotham via Getty Images: pages 194, 195, 226, 237, 241, and 288

Gregg DeGuire via Getty Images: pages 202 and 316

GVK/Bauer-Griffin via Getty Images: page 164

Ignat/Bauer-Griffin via Getty Images: pages 152 and 161

James Devaney via Getty Images: pages 39, 103, 186, and 300

Jamie McCarthy via Getty Images: pages 232 and 305

Jason Kempin via Getty Images: pages 24, 31, 32, and 33

Jason LaVeris via Getty Images: pages 109 and 198

Jason Merritt via Getty Images: pages 142, 173, and 307

JC Olivera via Getty Images: page 247

Jeff Kravitz via Getty Images: pages 46, 56, and 71

Jeff Kravitz/AMA2014 via Getty Images: page 171

Jeff Kravitz/AMA2019 via Getty Images: page 246

Jeff Vespa via Getty Images: page 132

Jeffrey Ufberg via Getty Images: page 95

Jemal Countess via Getty Images: page 49

Jesse D. Garrabrant via Getty Images: page 5

JJ/Bauer-Griffin via Getty Images: page 121

John Shearer via Getty Images: pages 128, 197, 199, 206, 297, and 310–311

Jon Kopaloff via Getty Images: pages 13, 47, 48, 70, 76, 133, 137, 172, 193, 199, 220, 292, and 303

Jun Sato via Getty Images: pages 118–119

Karwai Tang via Getty Images: page 160

Kevin Mazur via Getty Images: pages 113, 126, 151, 152, 184, 238–239, 242, 250, 273, 285, 293, 291, and 294–295

Kevin Mazur/AMA2010 via Getty Images: page 51

Kevin Winter via Getty Images: pages ii, 82, 85, 99, 113, and 254–255

Kevin Winter/ACM2015 via Getty Images: page 52

Kevin Winter/ACMA via Getty Images: page 51

Kevork Djansezian via Getty Images: page 168

Larry Busacca via Getty Images: page 67

Leah Puttkammer via Getty Images: page 223

Lisa Lake/TAS23 via Getty Images: page 276

Marc Piasecki via Getty Images: page 121

Mark Metcalfe via Getty Images: pages 270–271

Mark Robert Milan via Getty Images: page 91

Masatoshi Okauchi/Shutterstock: page 226

Matt Winkelmeyer/TAS18 via Getty Images: pages 204–205

Michael Buckner via Getty Images: page 73

Michael Stewart via Getty Images: page 157

Michael Tran via Getty Images: page 159

Mike Marsland via Getty Images: pages 46 and 133

Natasha Moustache/TAS23 via Getty Images: pages 202–203

NBC via Getty Images: page 179

NCP/Star Max via Getty Images: pages 89 and 201

Neil Mockford via Getty Images: page 95

Neilson Barnard via Getty Images: page 249

Papjuice/Bauer-Griffin via Getty Images: page 304

Raymond Hall via Getty Images: pages 88, 89, 147, 166, 193, and 195

Rick Diamond via Getty Images: page 303

Rick Diamond/ACM2009 via Getty Images: page 41

Robert Kamau via Getty Images: page 230

Royce DeGrie via Getty Images: page 68

Samir Hussein via Getty Images: pages 100 and 104

Scott Gries via Getty Images: pages 13 and 18

Shutterstock: pages 30, 37, 69, and 225

SIANDERSON/Bauer-Griffin via Getty Images: page 108

Skip Bolen via Getty Images: page 72

Startraks/Shutterstock: pages 94, 96, and 196

Stephen Lovekin via Getty Images: pages 71 and 81

Steve Granitz via Getty Images: pages 78, 82, 230, 253, and 306

TAS Rights Management 2021 via Getty Images: pages 256 and 274–275

TASRIGHTSMANAGEMENT2020 via Getty Images: page 267

Taylor Hill/TAS23 via Getty Images: page 264

Theo Wargo via Getty Images: pages 28 and 252

Theo Wargo/TAS via Getty Images: page 112

TOE/Bauer-Griffin via Getty Images: pages 96, 117, 118, and 122

VCG via Getty Images: pages 162 and 202

Vittorio Zunino Celotto via Getty Images: page 87

XPX/Star Max via Getty Images: pages 164, 167, and 200

Index

About the Author

PHOTO: JADE HUYNH

SARAH CHAPELLE is the fashion writer and creator of the blog *Taylor Swift Style* and the Instagram account @taylorswiftstyled. Her thoughtful, thorough, and witty approach to style commentary has been featured in *The Wall Street Journal*, *Harper's Bazaar*, *Coveteur*, *People*, and more. She lives in Vancouver, Canada, with her husband and their cat.